Take Your Photography to the Next Level

Take Your Photography to the Next Level

From Inspiration to Image

George Barr

rockynook

George Barr, george.barr@shaw.ca

Editor: Gerhard Rossbach
Copyeditor: Joan Dixon
Layout and Type: Almute Kraus, www.exclam.de
Cover Design: Helmut Kraus, www.exclam.de
Cover Photo: George Barr
Printer: Friesens Corporation, Altona, Canada
Printed in Canada

ISBN 978-1-933952-21-5

1st Edition
© 2008 by Rocky Nook Inc.
26 West Mission Street Ste 3
Santa Barbara, CA 93101

www.rockynook.com

Library of Congress catalog application submitted

Distributed by O'Reilly Media
1005 Gravenstein Highway North
Sebastopol, CA 95472

Table of Contents

Foreword

There is a story that Pablo Picasso is reported to have once commented that photography isn't an art, because anyone with a camera can take a photograph. With all due respect to Mr. Picasso, that's like saying that anyone that owns a piano is a pianist.

Photography is an art form that relies heavily on equipment for its actualization, maybe more so than any other. This turns out to be both a blessing and a curse. Certainly today's auto-everything digital wonder-cameras do indeed allow almost anyone to take a well-exposed, properly focused image. But whether the photograph has any artistic merit beyond being simply a record of what was in front of the camera at the moment the shutter was pressed, is totally reliant on the person that pressed the shutter.

That is what lies at the core of *Take Your Photography to the Next Level*. Not the equipment, (though the right equipment for the task is an important ingredient), and not necessarily any pre- or post-exposure techniques used, though these too are important. Rather, it is that almost ephemeral connection between art and craft that defines the level at which one practices photography.

Practice is indeed the right word, because as with any art or craft it is practice which informs excellence. There is a story that the virtuoso violinist Jascha Heifitz, still performing publicly in his 80's, was visited in his hotel room during a tour. When the reporter entered the room he found Heifitz practicing, and asked why, after a half century as one of the world's greatest performers on that instrument, he still needed to practice. Heifitz's reply was telling. He said that if he didn't practice almost every day it was unlikely that anyone in the audience would notice. But, after a few days of not practicing, he, Heifitz, would hear the difference. And it is that type of dedication to art and craft that leads to greatness.

I met George Barr when he attended one of my field workshops. During the print review session it was immediately clear that George's work stood apart from that of his contemporaries. There was a depth of visual perceptivity that goes beyond experience and practice, but is found only when a photographer has thought long and hard about their work and its goals.

After a half century pursuing his art, a couple of years ago George started writing a series of articles for *The Luminous Landscape* website. These proved to be among the most inspirational essays to appear on my site, and have received wide praise. Now, this new book takes the germ of that series and expands them into a comprehensive guide for photographers who wish to grow as creative artists through a better understanding of their art, as well as their craft.

Michael Reichmann
Luminous Landscapes
Toronto, Canada
August 2007

Introduction

In 2006, after publishing a popular series of articles on the website OutbackPhoto.com, I started writing my own photography blog. I discovered that I could explain things clearly, and with more than 40 years of photographing I could contribute some useful ideas to the craft.

I could have written my blog about technical matters, but there was already a lot of that kind of material out there. And so, from the beginning, I leaned towards tackling the more difficult questions in photography; issues such as making great images, finding inspiration, working the scene, and pitfalls to avoid (usually learned from personal experience). This year, I wrote a three-article series on Taking Your Photography To The Next Level, which formed the basis for this book. What follows are a series of essays on specific solutions to common creative problems, followed by that three-part series.

My background is as a family doctor, a profession that can involve a lot of teaching and explaining. It is a part of my career that I especially enjoy. For years I wrote a patient newsletter. I have taught sailboat racing and computers and photography. I seem to have an ability to explain things clearly—something that medical specialists often don't possess—and patients come to me to translate what the specialist said.

That is all very well, but I strongly believe that before you pay attention to any advice I might have, you need to satisfy yourself that here is a photographer who makes images worth looking at. It's possible to teach without actually doing, but most good teachers are good doers, as well. I would guess you already flipped through this book, but if you haven't, take a few moments to check out the portfolio of images following this introduction. You can

then decide if you can relate to my images, and if you like them enough to fork out the money for this book, to invest the time to read it, and especially, to act on some of the advice and suggestions this book has to offer.

Were this just a reprint of my articles and blog entries, with a few pictures tossed in for

show, it could still be a nice book to have—easier to flip through and read than online text. Fortunately though, it's much more than just that. I have taken the best from over 500 blog entries and rewritten them, providing specific helpful illustrations and examples. I have added text where helpful, pared down when appropriate, and clarified as needed. Some of the essays are completely new, while all have been improved upon. The essays included in this book, while not specifically forming a point A to point B textbook, do in fact cover much of the process of being a photographer and of making great images.

The title suggests that I'm going to handle the difficult issues. So just what the heck does that mean? Well, for a start, this isn't a book about f-stops and shutter speeds: It's about making art, dealing with frustrations and disappointments, and how to grow as a photographer. In this book you will learn how to work the scene, what some of the pitfalls are and how to avoid them, and what the characteristics are of great images. I discuss what photographs well and I go into the whole topic of good composition and how to create it. There are many books that talk about creativity in a vague or general sense, or they simply discuss it philosophically. I take some of those same difficult questions, and suggest practical and specific strategies for solving these problems.

Be forewarned though that while my advice is specific and practical, it doesn't imply that all solutions can be carried out on a weekend.

Some, in fact, such as studying the work of those who have gone before us, could potentially take a lifetime. I do think though, that with a bit of effort on your part, it's quite reasonable to expect a significant improvement in your image making within a few months. The degree to which you will improve has more to do with how hard you are willing to work, than with any possible natural "talent" you might have.

When I was young, I would have been considered a geek, had that term been coined yet. As it was, I was strong on the sciences, poor in the arts, didn't have any artistic skills (couldn't draw), had no musical talent, and was even hopeless at athletics. A less likely artist would have been hard to find. In some ways, that makes me the perfect person to teach you ways to improve: If I could become a creative photographer with my lack of natural talent, there is nothing to stop you from achieving greatness.

We photographers, as a group, are poor at analyzing our problems, often ascribing the problem to the wrong explanation. Most of us find it much easier to talk technical, and so it's no surprise that when a photograph fails to impress, we blame our equipment or technique rather than our "seeing". That is unfortunate, because working on the wrong thing is a complete waste of time. If "seeing" is our problem, better equipment is not the solution. I hope to help you identify the correct reasons for your images being less than you'd hoped, so you can apply the right strategies to fix the problem.

To illustrate each essay, I have chosen one or more of my "keeper" images as an example of how I dealt with a specific problem. In addition, small images are sometimes included, which may show the overall view from which I selected an image; or which may show an earlier attempt at a good image, and what was added or removed to make the final image stronger.

Feel free to read the book in any order, or simply to flip through and enjoy the book.

May your photography flourish!

Elbow Canyon

Half an hour west of Calgary is Elbow Falls which is very nice, if a bit touristy. Downstream though, the river goes through a very pretty canyon, with huge boulders which have fallen down the cliff face to the water. The rocks are strongly colored, with both orange rust and hints of purple and maroon. Our Black Lab loves to swim while I am busy photographing.

I had visited this local spot before and got what I thought was a good image, but it was a significant crop from the longest lens I owned and I was desperate to rephotograph with better equipment, a new camera, and a longer lens. Problem was, the rocks in the foreground are significantly closer than those in the back, and I didn't feel this was an image in which the background rocks could be blurred. This was before multi-image blending for depth of field, but I did think that perhaps I could blend two images—near and far manually in Photoshop. I also wanted to stitch for highest possible resolution. What to do?

The result was a four image combination, stitching side to side and blending fore and aft, and it saved the day. You will note the much cooler light on this occasion compared to the original (see page 95). I like both, though of course this is the only one that will make big prints.

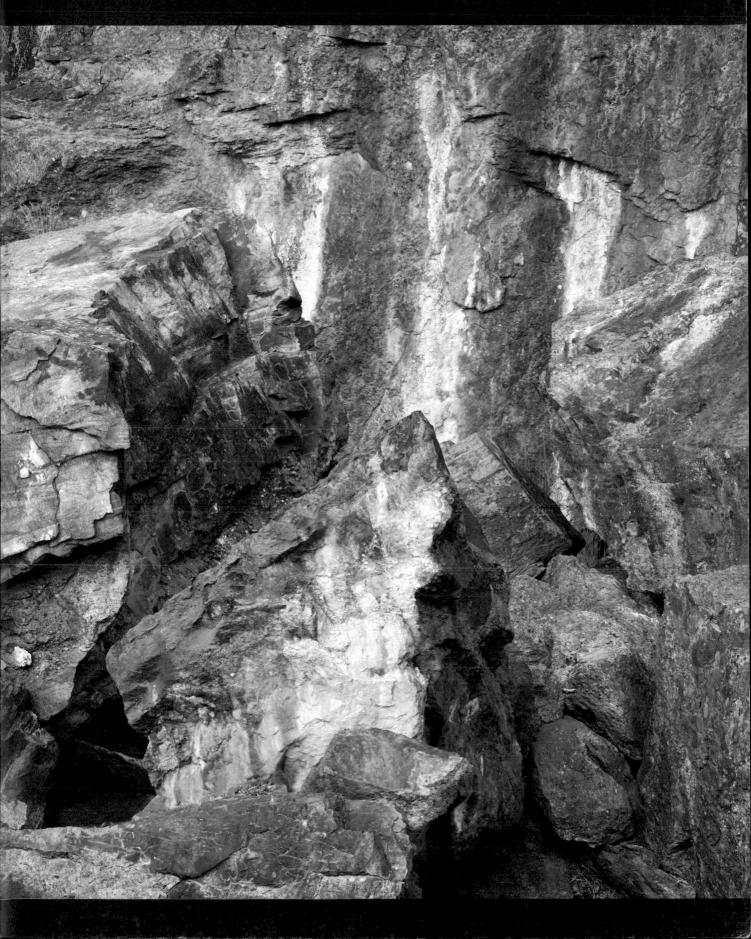

This was a "luck" shot. I'd actually finished photographing for the day and was on my way home when I noticed a pond between the highway and a railway line. The water level had dropped after the surface froze, leaving the edge ice hanging. Lit by a bright western sky (but just after sunset), I was able to wander up and down the edge until I found a good composition.

This photograph makes a good basis for a discussion of whether an image should be black and white or not—in this case one would assume that there was little color and therefore a black and white version (adjusted as necessary) should be every bit as good—but in fact, I much prefer the color version shown.

Color isn't just a matter of choice—it is information, and when you remove that information, the image may be harder to understand. On the other hand, it may be further from reality and that can be good. When we remove that color information, it may be necessary to make up for that loss either by choosing subjects in which tonalities, textures, and patterns play a prominent role, or we may need to manipulate the image in the editing process so that these features are emphasized.

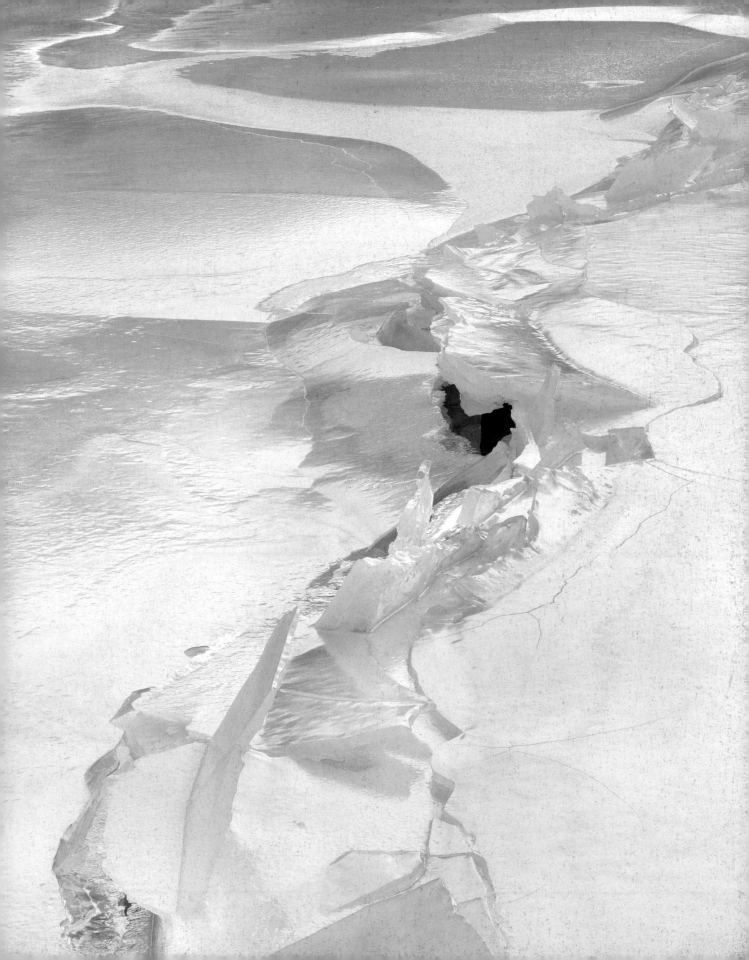

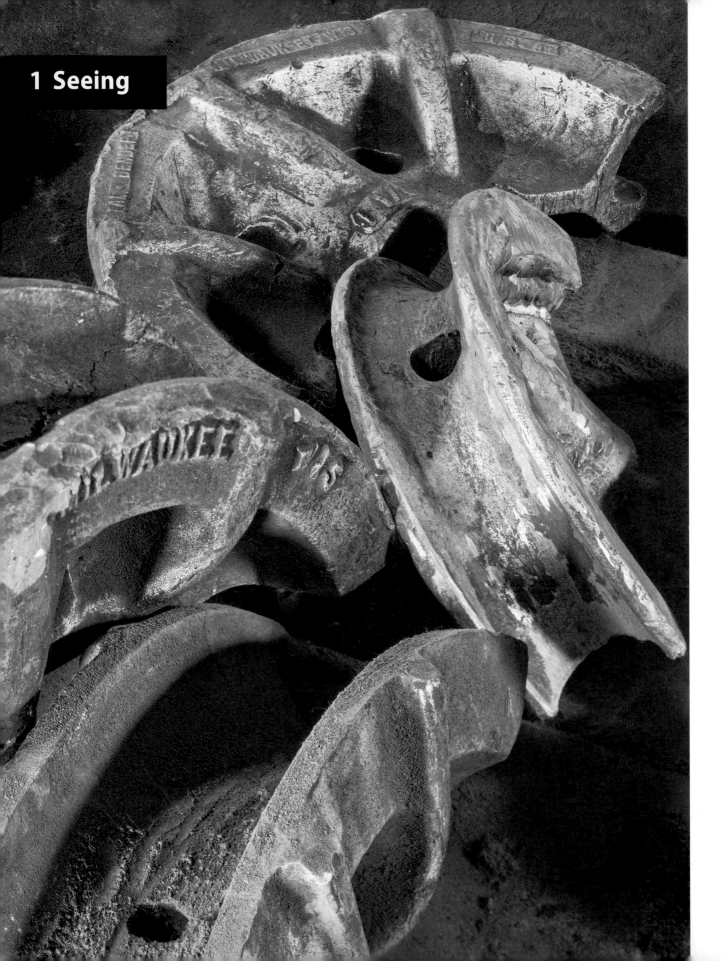

On Reading Photographs

I believe the single most important exercise for any photographer is to study the work of the masters, whether of your own particular interest—say landscapes—or of other kinds of photography. I'll go further and say it is just as important to study paintings and even sculpture. There is much to be learned by a close study of great artistic works. It could be argued that a cold and clinical analysis of these works takes some of the enjoyment out of them; but this isn't about enjoyment, it's about becoming a better photographer. We're talking sweat equity here—putting some effort into improving.

Before you can creatively and intelligently compose an image, you can either learn a number of rules by rote—you know, divide the image into thirds, and so on—or you can study enough great images that you develop both a strong sense of what works and an eye for finding such compositions in your own photography. Rules are for beginners. Real photographers simply put the image together in a way that works, learned through experience and instinct developed from all those images they have studied and made.

Most of us read text left to right, then top to bottom, but there are no hard and fast rules in photography: Each viewer will read an image in their own fashion. That being the case, the questions are as follows: What did the

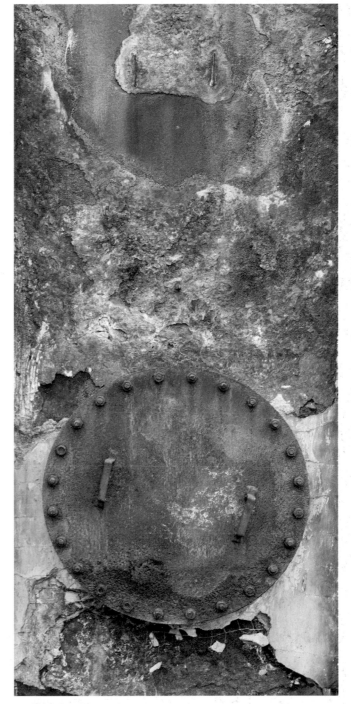

◄ Pipe Benders
In this image, I had the task of arranging the objects on the workbench pretty much as I chose, which was a lot more challenging than simply finding a good composition.

▲ Circular Door
In a very tall image like this, I find it works best to center the main object horizontally, rather than vertically, as was done here.

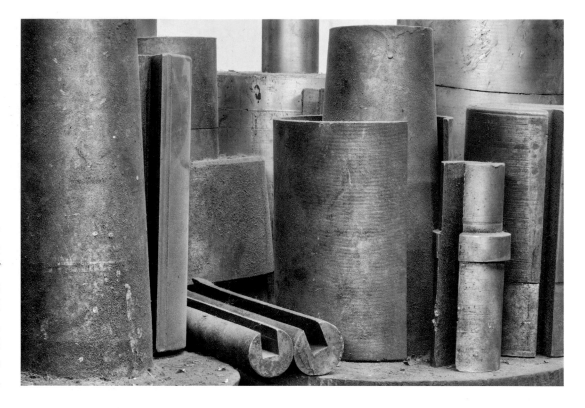

Steel Columns ▶
This is from my "Independent Machinery" series, which has encompassed a total of six trips thus far, and I still get excited with the new images I find.

photographer do to make you first notice the image, then to stay with it and really study and absorb it, and finally to leave it feeling just a little bit different? If we can unlock the secrets of the great images, perhaps we can apply the same "tricks" in our own images.

Following is a list of image attributes with questions for your further study. By asking yourself these questions as you study great photographs, as well as all great art, you will begin to learn the answers.

1. Center of Interest

It would be an exceptional viewer who systematically looks at an image, always starting at the edges then working their way into the center of the image. I would hazard a guess that 99% of us zoom in on the main subject of the photograph; we then zoom out to its

surroundings, and then perhaps back to the center. Or maybe our eyes simply wander around the image as we are lead by the lines within the image.

Most images do have a center of interest; but if one doesn't, how does the photographer manage to capture your attention and keep you looking at the image? Does he leave markers for the path your eye should follow, or does he build barriers so your eye won't leave the image?

2. What is the Image About?

How do you know what the image is telling you—is it obvious? Did the photographer leave clues? Is its uncertain substance part of what catches your interest, making you look further to identify what it's a picture of? Too many hobbyists' pictures don't make it clear

what the image is about: When it comes to adding bits and pieces to the image, "If it's nice, add it to the image" seems to be their motto.

3. What is the Photograph About at a Deeper Level?

The subject of an image may be easily identified as a pond, but perhaps there is more to it. Is it a beautiful, pristine pond with great reflections? Or perhaps it is a pond with pollution or junk, dead trees, or uncharted depths. The image could make you feel excited or calm, scared or disgusted, sad or discouraged.

4. What are the Parts of the Image and How do they Relate?

Identify the main parts of the image, including such parts as significant, deep shadows. Do these main parts create interesting shapes? Do the spaces between the parts make interesting shapes themselves? Are there parts that relate to each other in some way, i.e., through proximity, tonality, shape, or substance? Are there interesting lines in the image? Are the lines parallel, radiating, or converging to the horizon?

Consider the overall balance of the image. Does it have a sense of rightness that is pleasing? Are there parts that appear to be in opposition, adding to a feeling of tension in the photograph? Are left and right in balance; top and bottom? Perhaps a very heavy-appearing part to the left is balanced by a small part off to the right. A heavy part above a light part (either in tonality or size) adds tension, making the viewer feel as if the heavy part could fall at any moment.

Is there repetition in the photograph? This can be a powerful tool. This repetition can be the shapes, the angle at which lines are set, or

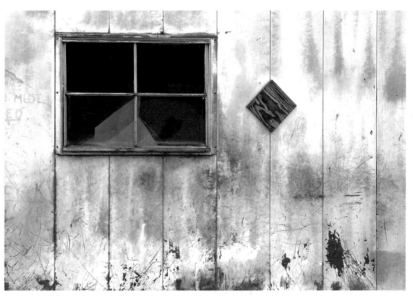

▲ **Tin Shed**
Note the repetitive diamond shapes both on the wall and through the window.

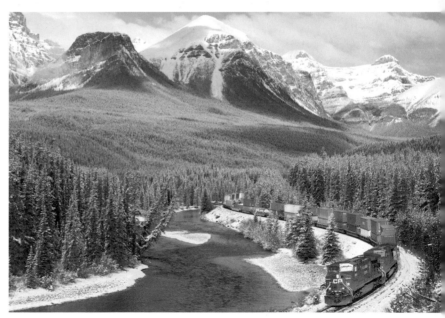

▲ **CP Freight**
Had my viewpoint been a bit higher, more of the S-bend in the train would have been visible in the distance. Position is everything (as well as being there in time).

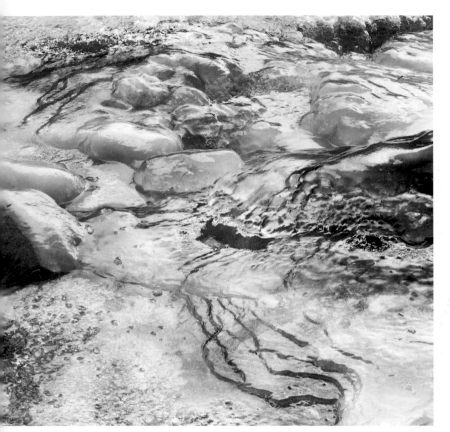

▲ Bow Falls Ice
Color saturation is frequently overdone, but in this case I feel it adds to the sense of an abstract image, creating an image that is more like a painting than a photograph. This is not meant to be "real".

center of the image, which again implies quiet and stability, or is the center of interest well off to one side to add drama?

Are there lines that direct your eye throughout the image while keeping it from leaving the image? A line leading to and suddenly disappearing off an edge invites the viewer's eye to just keep going right off the page. Conversely, a line that curves back into the image keeps your attention. That being said, radiating lines around a center of interest are essentially a series of arrows pointing toward the center of interest, in which case they draw the viewer's eye inwards.

5. Tonalities

What has the photographer done with the various tones of the image to capture and keep your attention? A pure black shadow is bold, a thin shadow may be ugly, and a deep shadow with lots of detail seems good enough to dive into. Are the highlights handled nicely, maybe progressing ever so close toward (but not quite) pure white? Then, perhaps there are some small areas of pure white, which then look blazing by comparison.

Are the tonalities attractive? Original prints by master photographers have the most amazing tonalities, and I would encourage you to do whatever it takes to get your hands on some really good prints. If humanly possible, look at them in their "bare" state, without glass or plastic hiding the surface. If you've never had this opportunity, you are in for a treat. This is particularly applicable to large and medium format prints from film days, but a wonderful job of tonality can also be achieved in prints of a reasonable size from digital single lens reflex (SLR) images.

even the tones of certain parts. Is there a progression, such as a part that gets smaller and smaller in one direction; or perhaps a balance of sizes with a large object flanked by smaller ones? A single large part of the image with two smaller parts on either side is very static, but what about two small parts on one side of the large object and only one on the other?

Don't forget that the edges of the image are lines in themselves, and anything next to the edge becomes a shape. We talk about negative space as the "empty" parts of the image that surround important parts, (often the center of interest). Are those surrounding parts interesting shapes in themselves?

How has the photographer handled the center of interest, if any? Is it located in the

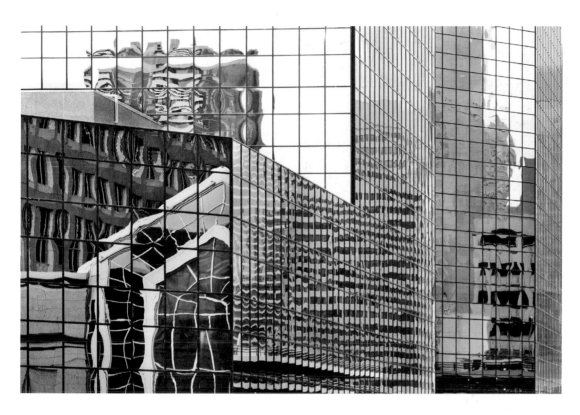

◄ **Building Reflection**
Shot from a parking garage roof (hardly a glamorous location), I got three good images, each about 120 degrees apart, and each completely different in character.

6. Emotional Impact

When you look at a great photograph, do you get a visceral reaction? Great photographs can grab you deep inside and not let go. You want to cry with the exquisiteness of some images, gasp with the beauty of others, or shed a tear at the pain in another.

What has the photographer done to produce that reaction in you? Could you possibly do something similar in your images? Look hard at these wonderful gifts. Is it the lighting or the subject, the viewpoint or the arrangement, the framing or the tonalities that make it a masterwork? Understanding what made this image powerful will surely help you with your own images, regardless of the subject matter. You might be doing a series on barbers, and the image you have just been studying is Weston's Pepper #30. You might think there is little to compare, yet perhaps there are comparisons to be made. What about the chrome of the chairs, the globe lights hanging from the ceiling, the sunbeam coming in the window? Are there textures in the old hair cream ads stuck to the wall? The tones in the black drapes, which the barber placed over his customers, might be where you want those deep but detailed shadows. Do the elevated arms of the barber create interesting shapes in the negative space between arm and body?

7. Flaws

This exercise is about image analysis, not admiration, so you should identify anything in the image that you don't like, or you feel is out of place, unbalanced, disturbing, or awkward. Noticing that an object actually touches the edge of the image, when perhaps it would have

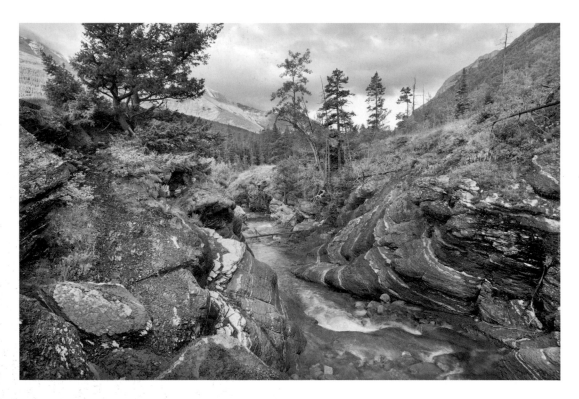

Red Rock Canyon ▶
Good landscape photographs require effort, timing, positioning, and more than a little luck. Usually, you make your own luck with repeated visits until everything falls into place.

been better with a bit of breathing space, will alert you to set things up in your own images in ways you like. When looking at works of uncertain provenance, and you don't know whether you're supposed to admire them or not, this sort of analysis really comes into its own. With that said, I know that I don't like every so-called "great" photograph. Some simply don't work for me even though experts may rave about them. This same concept holds true in music. You are not expected to equally like every genre of music, and it's perfectly OK to hate some kinds. The same philosophy holds true with photographs.

Reading My Photographs

Below, I will share with you my own analysis of four of my images. It is entirely possible that you think I'm completely off base in my comments, or that you may not even notice the

features I point out. However, comparing your analysis of my images to my analysis is a useful exercise, as you discover that what I think works may be different from your ideas: The lines and shapes I see may not be perceived by you in the same way, and the message I think I am sending with the image may differ dramatically from your interpretation.

If two people interpret a painting in different ways, one is not automatically right while the other is wrong. Paintings and photographs do not come with artist-generated explanations against which you can check your interpretation. Often, art critics will tell you what it's all about, but keep in mind that this is strictly their opinion, and their's is no more valid than your own. In this case, though, I'm going to point out what I believe to be the strengths and weakness of my images, and you can see if you agree.

What is the Photograph About?

Well, in this case, it's a picture of a presumably old, broken headlight (it's perfectly round and the body of the vehicle is very rusted, making it appear fairly old). The subject matter might or might not interest you. If you were into old vehicles, you might wonder what the year, make, model, or even what kind of vehicle this is. Perhaps you'd ask yourself where such a vehicle was found; on the street, in a junk yard, or wherever? Curiosity about the subject is an important component of an image. If it doesn't generate curiosity in anyone, then it has failed at a fundamental level. Another way to look at this image is as a semi-abstract. Sure, it's of a real object, but it is largely about shapes, tones, and lines. That it happens to be a headlight is, to a large degree, irrelevant to the image.

What is the Photograph About at a Deeper Level?

For those of you who are of a philosophical or analytical bent, you might wonder what the photograph says about aging, permanence, design, functionality, or any number of other aspects of the image. It isn't even necessary for the photographer to have been aware of those aspects of the image, and certainly not to have deliberately inserted them into it. Whether or not the photographer was aware of it at a subconscious level really doesn't matter. If the photograph makes you think, does it matter if the photographer didn't? Can a blind person bake a cake that looks nice? Why not?

What are the Parts of the Image and How Do They Relate?

Well, the hanging, broken headlight is obviously a major part of the image, but so is that dark, interestingly shaped shadow of the bulb

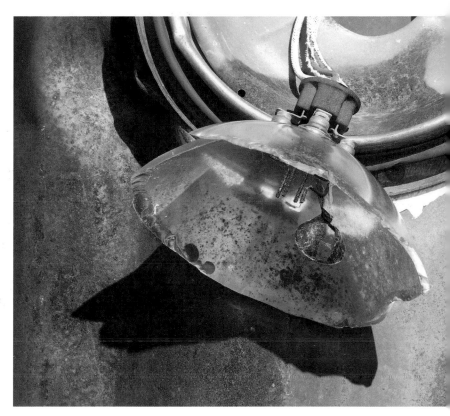

▲ Broken Headlight
An image being popular is not the same as being good. Do you know which is more important to you? The answer to this question significantly affects the kind of photographs you take.

sitting below it. Note the filament nicely located over a highlight, which stands out a bit even though it is quite small. The body of the vehicle has several textures and colors from fairly rusty to quite smooth. Note the color tie-in from almost purple in the rust on the left, to the bluish-gray on the right; and the bluish tinge in the glass of the bulb, contrasting with the orangey-rust of the headlight socket.

Also of note are the repeated semi-circular shapes seen on the inner part of the bulb base, the outer part, and the bright white rim around the headlight (part of which can be seen through the glass of the bulb), as well as the curve at the bottom edge of the bulb; that's four matching curves—always a strong design element.

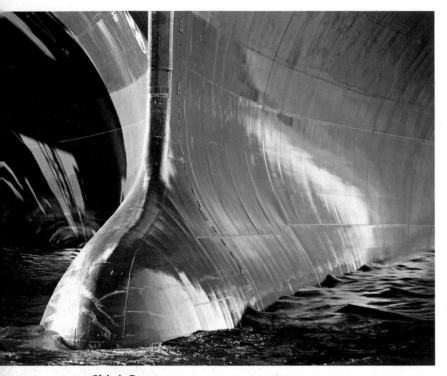

▲ Ship's Bow (black and white)
Many of the images I take are so tightly framed that edges, horizons, and skies; as well as clues to size, location, and even subject matter are missing. All this is deliberate.

The wires curving downward are important, particularly for their bright white shade.

Tonalities
There are some subtle tonal gradations in the body of the vehicle and in the way the light plays off the old metal. There's just enough variation in tonality in the body of the vehicle to provide interest without adding distraction. The dent in the body even provides a bit of a specular highlight in the upper left where we notice a bit of shine on the rusted metal. The texture of the rust varies from almost smooth to quite rough; perhaps you think you can feel it.

Negative Space
If you look at the shapes surrounding the headlight and its base, they are quite interesting in and of themselves. If you cover the base

and headlight, leaving only the shadow and body of the vehicle, you still have some interesting shapes and textures, colors and tones.

Balance
The image appears to be well-balanced, with the base in the upper right, the bulb in the middle, and its shadow reaching to the lower left. Note the darker edges in the upper-left and lower-right, which tend to direct one's eye to keep looking towards the center of the image, almost acting as a frame to the parts of the image that are arranged in a bottom-left to upper-right sequence.

Framing
There isn't much to complain about regarding the framing of the image. The bulb has breathing room: Sure, I could have cropped to the edges of the bulb, but the background works nicely and gives a hint of the old vehicle, so it is justified. Would the image have been better had the entire circle of the headlight base been included, or possibly more of the body (fender?) of the vehicle, perhaps to help identify the vehicle? Well, as it stands, it has more of an abstract feeling to it. A wider shot, even if it were well composed, would be more illustrative, but is certainly not the effect I wanted to portray. I don't care at all what vehicle it was from, even though the viewer might.

Emotional Impact
Come on guys, it's a picture of a broken headlight, not a grieving widow after a massacre. Still, to me it has a sense of rightness, and I believe the elements in the image work together. I would like to think that someone might react with surprise that such an ordinary subject could make an interesting photograph. If the emotional impact is nothing

more than, "Well, isn't that neat," that's quite sufficient. I don't suppose anyone is going to say that this image altered their lives, but perhaps it will spur someone to remember their dad tinkering with rusted old vehicles, or that beat up old truck on Grandpa's farm they played in as a kid. Did I think of this as I took the picture? No, of course not! We don't even know what Da Vinci was thinking when he painted the smile on Mona Lisa; he may have reacted to it at a gut level rather than an intellectual one. Perhaps he had no idea of all the guesswork he would engender as people over the ages try to figure out what it's about— perhaps she had gas after the spicy sausage at lunch. It doesn't really matter. Da Vinci saw it (or created it from memory), thought it was interesting, and painted it in.

Flaws

There isn't a lot in this image that I am unhappy with. The white of the wiring and of the surround for the headlight base is glaring white—overexposed—no detail recoverable. Does it matter? It bothers me, but I don't know if it bothers anyone else. I did use highlight recovery in an early version of Camera Raw, but with minimal results. It's possible that the latest version might work better, but probably, over the top is still over the top. I can live with it. None of my images is perfect in every way. If we only read perfect novels, watched perfect films, or listened to perfect music we wouldn't have much to enjoy. After reading, viewing, and listening to the few true masterpieces we would quickly run out of material. "Two thumbs up" means a movie is worth watching, not that it's perfect in every aspect. It's too bad the filament isn't 10 times bigger and shown against a white background so it would really stand out. Yet, there is

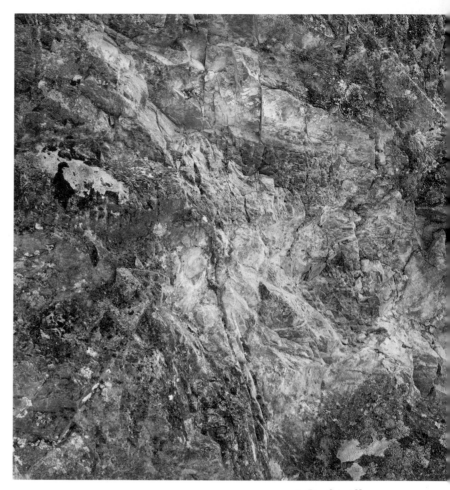

▲ Rockwall
Light and shadow were created later in image editing, lending a relatively random pattern, as well as strengthening the flow and organization of the composition.

something to be said for offering persistent viewers more to see after their first cursory look. In fact, I would say it's essential to give them more. It would be a very shallow picture that could be consumed in a glance.

With this second example, I'm not going to systematically go through the same criteria as in the previous image. Rather, I'm simply going to point out the parts that I believe work, as I think of them. First off, it's a rather striking image, which displays strong contrast while also having subtle gradations of tone. The subject matter is probably interesting simply because it's unusual: The bow of a

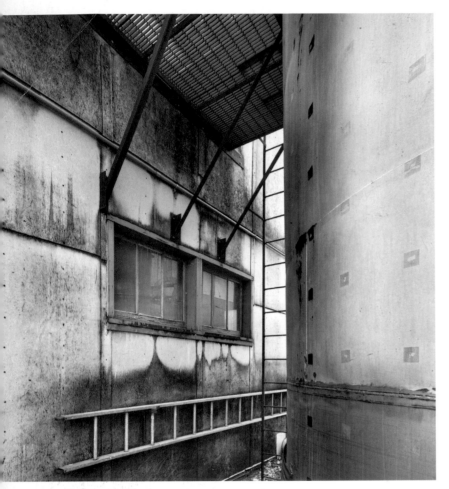

▲ Ladders and Tank (color)

In the color image, the right side of the tank appears weak despite the increase in contrast and "burning", yet the red platform works well against the blue in the shadows.

container ship, with that bulbous projection used in modern ships to lengthen waterline and alter the bow wave to reduce resistance. Since we usually see ships from a long way off, this closeup viewpoint is rather unusual. The lighting on the two sides of the hull is catching. On the left side (of the print), the hull is a detailed dark tone, with angular shapes leading away from that bulbous bow. On the right side, there is that luminous, silvery, curved reflection which seems to frame the bulb from the other side.

Note too that the line of that reflection matches the more angular shape on the left

side of the print. There are matching highlights on the bulb itself. Can you imagine if it were entirely dark? Notice the arched lines of the steel sheets on the hull as they curve away from the bow, both left and right.

One could argue that the main feature is the bow and the bulb, which is located off center and balanced by the smaller, dark part of the hull on the left and the larger, light side on the right.

There are great "textures" in the sheet steel itself, which copy the curve of the bow and are perpendicular to the horizontal seams. The lightning bolt-shaped scrapes on the bulb are both visually appealing and tell a story of past encounters. The tones in the water on the right side of the image are lovely—strong, but neither pure white nor pure black. Note the radiating reflections on the dark hull on the left side of the print and at the base of that triangular bright area; these, too, complement the curves in the bulb. The numbers up the side of the bow add interest. The complex pattern of light and dark on the left side of the print makes you wonder what might have caused such complex shadows.

There is a lovely gradation of gray tones from the highlight on the hull on the right side, as it transitions from almost pure white to quite dark in the upper-right corner.

I do see flaws in the image. The specular highlight on the left part of the bulb is, perhaps, a bit much (though it obviously hasn't stopped me from showing you the image). The water around the bulb and toward the bottom-right is a lighter gray and somehow seems a bit weak, though obviously that is something I could easily correct next time I make a print. For that matter, it would be fairly easy to take the highlights on the right (your right) side of the bulb, copy them to a blank image, flip

them, lighten them substantially, and use that to paint into that white highlight on your left of the bulb. I'm not sure if it's needed, but I don't have any compunction against doing it. We shall see.

Well, that is my interpretation. How does it vary from your's and how could you use that information in making your own images?

This image is a bit more difficult to analyze, for me and probably for you too. For a start, there isn't an object that is the center of interest, since the whole thing is a relatively flat rock face. There are certainly separate shapes—the light colored vein of rock near the top and sloping down to the right, the orange rock, and the radiating streaks in the darker rock around the edges. To me it appears to have balance, but I might well be reading too much into it. I have variously thought of this image as showing an exploding star, a galaxy, or a nebula. I've just had a look at the image without my glasses. My left eye sees it as very blurred and can't make out any interesting patterns at all, so maybe I am deluding myself. My right eye, which is only moderately compromised, sees a gentle blur, and definite, interesting patterns. Sometimes having poor vision can be an advantage. If you have perfect vision, you can at least squint at a scene or an image, which will allow you to see only the major shapes.

This image risks being so complicated that it looks like a jumble to viewers, though some have liked it, and they apparently see something of the patterns and shapes and lines I see in it.

This image has a lot going for it; the radiating diagonal lines, the window and its reflections, the weathering on the wall, the roundness of the tank on the right, the triangles made by the walkway above with its red

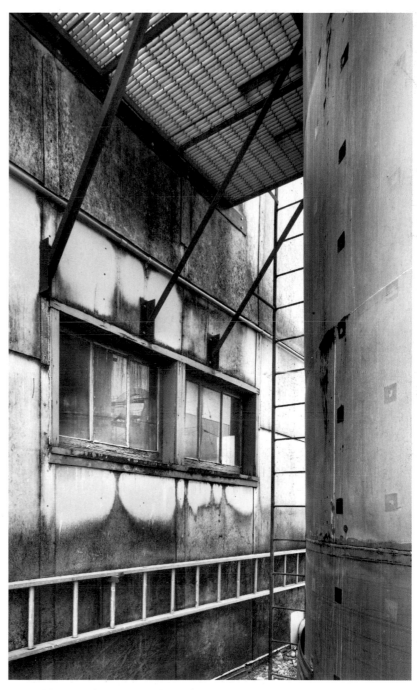

▲ Ladders and Tank (black and white)
Cropping tightly and eliminating the distraction of color strongly emphasizes form.

▲ Tank Bottom
Beauty may be found in the oddest places. After climbing a rickety ladder and then peering over the top of this 20-foot high tank, I discovered sheer magic. Totally unexpected!

against the blue of the tank and above the blue of the window. Note the wall-mounted ladder is white and is nicely set against the dark part of the wall. Were this part of the wall pristine, the ladder wouldn't have nearly the impact. In the end though, my own feeling is, "Clever composition, but so what?" It leaves me completely cold. This points out that it's not enough to be clever, you have to be inspired, excited, motivated, and interested. I made the best of an iffy subject, but frankly, it wasn't enough. Others appear to agree with me as no one has ever purchased this image, where they have purchased many of my other industrial shots. I can't see a message in this image.

OK. Having written the above, I wondered, "Would it be better to eliminate the colors? And, what would happen if I cropped out the large white areas on both the right and left

edges? I'd lose the end of the ladder, but would that matter?" I definitely think these changes make it a better image. The window is much more emphasized with its reflections. There is a sense of wondering what's around that corner, past the vertical ladder. Inspiring the viewer to ask questions about something in a photograph is usually positive. It's good to stimulate their curiosity. Of course, there is no way for the viewer to answer what is around the corner, so they have to use their imagination: What could be there? By cropping more tightly, it's less obvious what the objects are, creating more mystery. Note that I chose to crop the left edge so the bottom of the walkway meets the upper-left corner. Good idea? Perhaps I should have cropped the bottom so the ladder comes to the bottom-left corner. Is it too cute now? Hmmm... Some have

suggested that getting rid of the color was a mistake, but what do you think?

Well, you have now discovered what my thoughts are about four and a half of my images. You have experienced me radically altering an image simply because I was trying to describe it to you, which made me think about other possibilities. None of these images is amongst the dozen I would stake my reputation on or wish to be remembered for, but I did put effort into finding, composing, framing, and then editing them. Do you have similar thoughts about any of your images? If the best you can say of your own image is, "It's pretty", then you have work to do, and hopefully this will give you a start, because the flip side of reading images is writing or creating them. To work with you!

Is Beauty Essential to Great Photographs?

The question of whether beauty is essential to great photographs is more than simply a philosophical debate. If it's true that the best photographs come from photographing beautiful things, then it has serious implications as to where we look for things to photograph.

To begin, let's think about some classic images. Who hasn't had an Ansel Adams calendar, at some point or other, filled with beautiful scenes, many shot in national parks? That works. What about Weston's nudes? No argument there, though perhaps the ideals of beauty have changed since he created those works. Certainly, the modern works by Barnbaum, Sexton, et al., are generally from beautiful things, therefore we would be forgiven for thinking that beauty may not be essential,

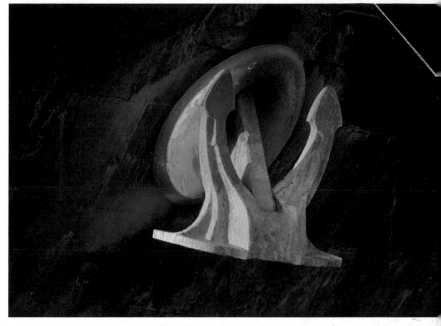

▲ **Anchor**
The low angle of the sun, the orange rust, and the dark blue shadowed background come together here for a simple design. Sometimes simple is best.

but looking at their work may convince us that it surely must help.

It starts to fall apart though when we look at the work of others. David Plowden's small town and industrial images weren't beautiful to start with, though one could certainly argue that they appear so in the photographs.

How about Brett Weston's patches of rust, or the work of Paul Strand? There is a Paul Strand picture of a mudguard and spokes of a motorcycle wheel, which has beautiful curves and shadows and is a very nice photograph. The motorcycle might have been beautiful to some people, but I doubt anyone would have thought the wheel itself was all that exciting. Rather, it is only in the way that the spokes,

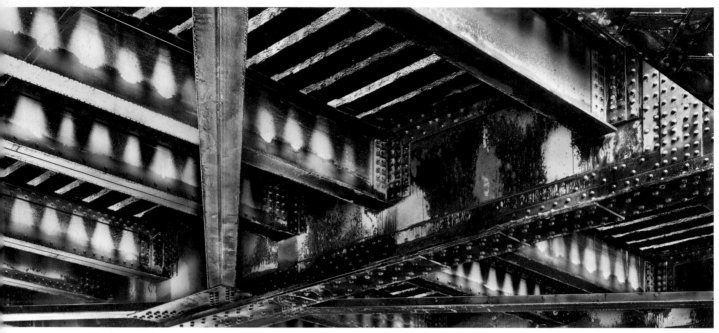

▲ Horizontal Railway Bridge

Who looks up at the dark, dirty, underside of a bridge? With a proper exposure and an ability to look for the unusual view, a reward may await.

shadows, and mud flap come together that make it an interesting photograph.

My picture of the underside of a railway bridge is beautiful, in my opinion. There was a bicycle path running under the bridge, and I'm sure thousands have passed under it, and perhaps many have even looked up briefly. I doubt any of them saw anything beautiful there. In reality, it is dark, dirty, and ordinary. With the correct exposure and composition (emphasizing the wear patterns and light coming through the railway ties), it makes an interesting picture.

Many of Michael Kenna's images have a simplicity that makes them beautiful, but were you to look at the scene as a whole I suspect most often you would not see beauty.

The late, great photographer, Carlos Clark, known for his fetishist and outlandish fashion images, none the less, made a project of rescuing objects from the mud of the Thames river in London. He photographed old cutlery,

complete with a patina from years of submersion. His image of two forks facing and touching each other is absolutely wonderful on several levels. They were just forks, not even clean or new ones at that. There was nothing to lead you to think it would be a magical image, yet the photographer was creative enough to collect them in the first place, then pose them together, light them, select a background, and print them in a way that was unquestionably beautiful.

It's a little harder to pick examples of not needing beauty when we talk about the grand landscape, but think of your drive through the mountains on holiday. Sure they were pretty enough, but hardly the stuff of famous photographs. What make the mountain pictures exceptional are the photographers' selection of wonderful light or unusual weather conditions, and perhaps shooting during a different season. Though even here, it is often the way in which all the elements are put together that

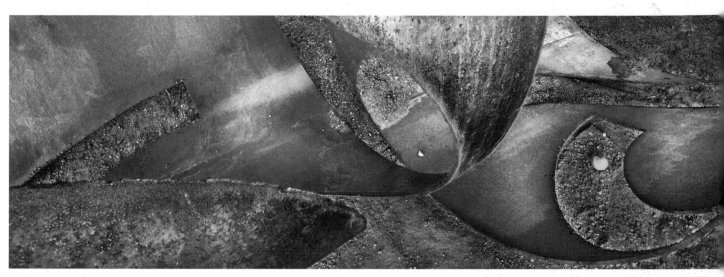

▲ **Cut Pipe**

Without a clean background in any direction,
I set the camera up on a tall tripod, aimed it
downward, and then raised the center column.
Aiming was by guess and by checking the
LCD, because, at eight feet above ground the
viewfinder was out of reach.

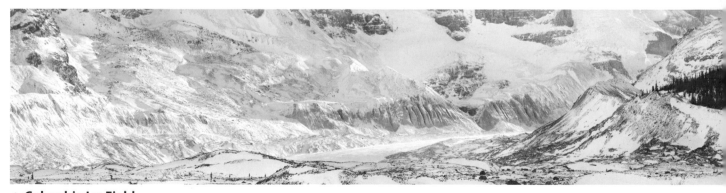

▲ **Columbia Ice Field**

Very wide panoramas often fail, but this
seems to work for a lot of people. This was
stitched, of course.

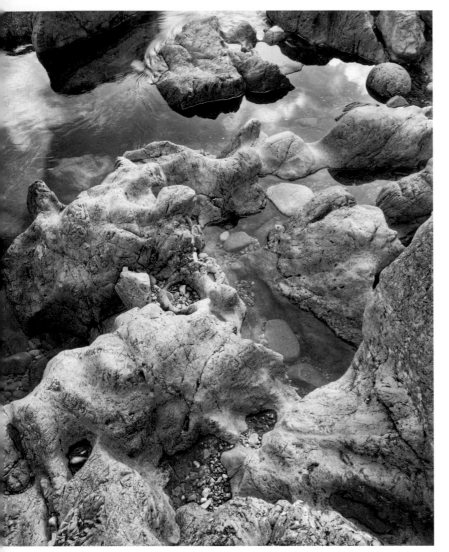

▲ Pools

With this image I asked myself, "If I can't do anything with the whole thing, what can I do with the parts?"

OK—so beauty isn't essential to photographs, even landscape photographs. It's probably true though that if you want to photograph the grand landscape, you are going to have to go somewhere pretty and interesting, then find the beauty in it. If you can move in a bit, then you might not need inherently pretty scenery, but you will probably need persistence or luck. If photographing a portrait, you would at least want an interesting face, if not a beautiful one. When doing figure studies, beauty helps if shooting the whole body, but when concentrating on parts, you might well be able to work with all sorts and sizes of people.

When shooting industrial subjects and still lifes, it is a matter of finding the beauty in ordinary things, or outright creating beauty through careful juxtaposition, use of shadows, and finding interesting shapes and lines within something very ordinary.

Does it actually hurt to have something beautiful to photograph? Perhaps, in one way it does. The more beautiful and dramatic the subject, the harder it is to create something that is better than actually being there. You risk the postcard look which says, "Wish you were here", on the back.

A scene can be so darn pretty that it's difficult to isolate something that will make an interesting composition. On our trip to Vancouver Island, we stopped at a waterfall/boulder complex that was absolutely beautiful, but it was the whole experience that was beautiful, and the whole couldn't be shown in a photograph. I really struggled to find something I thought worthy to capture; yet no matter how interesting the parts were they never did equal the whole experience.

In other types of photography, beauty may seriously get in the way of a good image. In

"makes" the image. Any other viewpoint may have been pretty, but nothing more.

Over the years, some rather ugly buildings have made for some very nice images; as seen in the images from Atget to Walker-Evans to Joel Meyerowitz. I own a wonderful photograph of the doorways in an insane asylum by Shaun O'Boyle. This image is unquestionably beautiful, yet the subject matter is inherently not.

trying to portray facial expressions, would it be better to photograph a top model, or someone who's face shows some character, weathering, a bit of age, and lots of expression? Given the choice of shooting a modern chrome and glass skyscraper vs. an old tenement with graffiti, rust, stains, and streaks, you may prefer the latter building for creative images. Yet, I have seen some wonderful images from modern shopping malls, where lighting, shadows, concrete texture, line, and form are placed perfectly together to make very strong images, possibly even beautiful images.

Conclusion: Beauty may help in a subject, but it can be distracting and it doesn't come close to guaranteeing a meaningful or beautiful photograph. Beauty can exist in the small details that others overlook, and it may hold true that ugliness itself can result in a beautiful photograph.

If you're cruisin' for snaps, it pays to head to interesting subject matter, but the definition of "interesting" can be very wide, and your definition is almost certain to be different from mine. Whether or not you seek beauty will depend on your goals, but remember that it may not, in fact, be in your best interest as a creative photographer.

Elements of a Great Photograph

If I could compile a list of the essential ingredients of a great photograph, you could simply assemble one, as from a kit. If there were a formula for attaining great photographs, you'd think that those who are clever enough to sometimes make them should be able to make all their photographs great. However, the truth is that even of the images they show us,

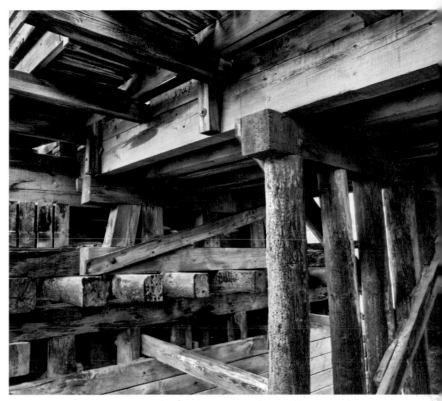

▲ **Bridge Foundation** This is an example of an image in which the edges are probably more important than the center.

some are good, some even admirable, but only a handful are wonderful.

With this limitation in mind, perhaps we can consider those elements that many great photographs do have in common.

Almost without exception, great images are strongly composed. The elements fall into patterns, which work to reinforce the message. Even great news photographs tend to be well composed, because in doing so, the images have a lot more impact, drawing your eyes to the important elements of the image, with the main subject often isolated from surrounding details to make it more powerful. Edward Weston said that, "Composition is the strongest way of seeing." When you think about it, why would you ever not want that to be true?

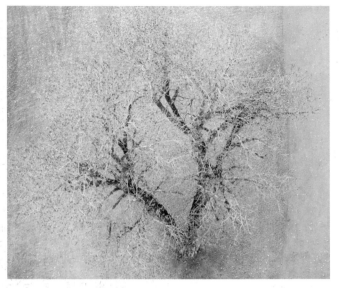

▲ Bare Tree on Golf Course
While ballooning, most people look horizontally, but the most interesting material was to be found looking down.

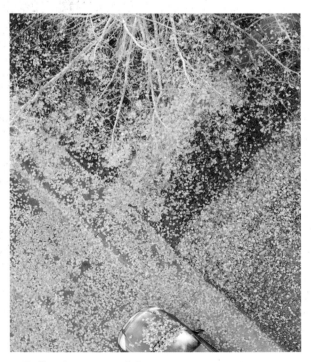

▲ Fallen Leaves and Car
Initially, I cropped out the car, but later decided that the vehicle provided a counterpoint to the rest of the image.

Great photographs almost universally surprise us. It might be showing us beauty in something we would normally consider ugly. It could be revealing something about a person that we didn't expect, such as the dignity of a beggar or the beauty of someone we would normally think old. A great sports picture shows us details of the game we would miss if we were simply viewing from the stands.

Almost without exception, great photographs are quite simple. By and large, complicated and complex compositions tend to be admired only by the photographer and seldom by others, as only the photographer holds the "key" to making sense of such apparently muddled, cluttered, and disorganized images.

Great images often trigger reactions in viewers. It might be nostalgia for small towns of the 1950's, as in David Plowden's images; wonder at the power created by dams; fear of dark streets and menacing, disenfranchised youth; or amazement at the incredible English cathedrals photographed by Bruce Barnbaum.

Many great images tell a story, even if it's nothing more than showing you the effects of millennia on a rocky foreshore.

Great images are often of subjects that happen to photograph well. I don't mean that they are simply pretty, but rather that the objects in the image give off wonderful tones, whether it's the subtle glow of the skin on a beautiful body, or the texture of rust in an old machine.

Great images often show objects or even people in relationships with the scene, which creates interest. Think of the ability of Cartier Bresson to place the people in the scene to absolute perfection through careful watching and perfect timing. Interesting relationships might be the way a log extends into water, the position of a shadow next to an object, or two

objects that would not normally be expected to "go together."

A great photograph stands on its own. That is, it isn't simply a memory marker for a special event, occasion, or location. Good images go beyond simple recording, and give viewers an experience they likely would not have had even if they were in the area at the time.

A good photograph is interesting. That may seem self evident, but I think there is something to be learned here. Can we agree that there are great photographs of mundane (dare I say uninteresting) subjects? Is it possible that the dirty underside of a railway bridge, something you might cycle past daily and not pay attention to, could actually be interesting? What about peppers, dead birds, rocks, weeds, grass, cracked roads, etc.? So somehow it would seem possible to make an interesting picture of an uninteresting subject. How is that done?

Think of portraits. A picture of a beautiful woman or drop-dead gorgeous man merits a quick look, but usually most adults don't give it much time, don't tear it out of a magazine, and don't frame it. Yet, there are portraits that cause us to do all of those things. Migrant Mother by Dorothea Lange is a beautiful portrait and one could say that the woman shows a special kind of beauty; but really it is a picture of a tired, worn out woman who's given up hope, yet has the strength to struggle on. It is such a striking image that the photograph is beautiful even if the person photographed may not be. Karsh's image of Winston Churchill is hardly beautiful, but Karsh captured such a sense of power and determination in the man that you can see how he pulled a nation through a war.

A news photograph might not be considered beautiful at all, but a good one is certainly

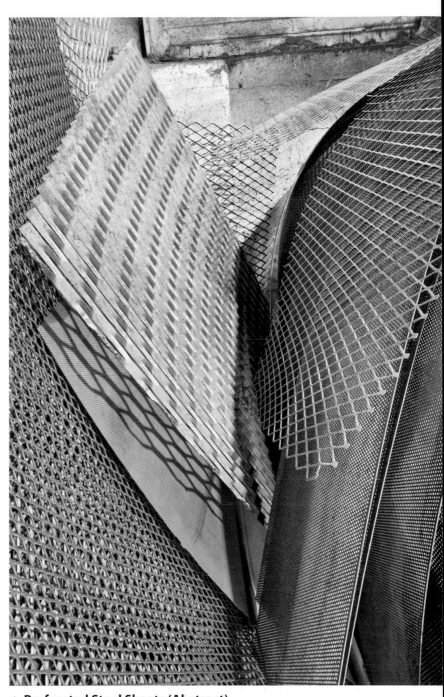

▲ **Perforated Steel Sheets (Abstract)**
On my first visit to this location I hadn't even noticed this wonderful composition. On my second visit, I shot from the side. But, on my third visit, ah...

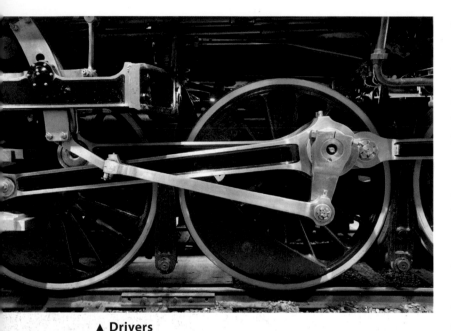

▲ Drivers
This subject is hardly original, yet was rewarding to photograph nevertheless. Old steam locomotives offer many possible compositions, and those polished rods photograph so well!

interesting—interesting because it has a message or is so representative of the issue at hand that it serves as an icon for our feelings about a situation say war, a natural disaster, politics, or whatever.

In the end though, the magic of a great photograph, which probably can't be explained, comes from the genius of the photographer. This may not even be understood by him, and can't be called forth on demand, but rather crops up now and again because the photographer was ready. He was ready due to years spent practicing, looking at images, being alert to the possibilities, and being organized to catch the image the moment it presented itself.

What Photographs Well?

Some objects, materials, and surfaces photograph particularly well. They do so because of their textures and the way they reflect light. You might as well take advantage of this knowledge.

Have you ever thought about whether dark subjects photograph better than light ones, or the other way round? Do gradations have to be smooth or can they be harsh? Do patterned objects photograph OK? How shiny must a surface be to have interesting tonalities; can it be too shiny?

I can spout off about my own theories, but it would be more instructive to analyze the great photographs and see if there are any patterns. I'm going to make some observations from my own experience of looking at good photography.

Below is a list of what photographs well based on my own observations. I strongly encourage you to compose your own list.

1. Light objects are much more important than dark ones. Think of Moonrise over Hernandez: It is the light buildings, the gravestones, and the clouds that make the image. In Pepper #30, the silvery highlights are what make the image, not the dark tones. Far more good images have the light tone as the focus of the image. There are exceptions, but if you were a betting man... Remember that the actual brightness of white photographic paper compared to black is not much different as measured with a light meter. If you want light areas to glow, they need to be surrounded by dark tones, in which case they will appear brighter than plain white paper because of the contrast.

2. Gradual changes in tone photograph better than sudden changes, other than to define a pattern. Think of the way in which water photographs, or driftwood, peppers, skin, or round objects... Of course, this also means photographing rounded objects in soft light to maintain the appearance of roundness.

3. Triangles photograph better than squares, though keep in mind that a square viewed from an angle tapers into the distance and therefore may appear as a triangle. What counts is the apparent shape on the print.

4. Skin is wonderful in photographs— whether it's the special glow in a Weston nude or the lined face of a Chinese octogenarian, it works wonderfully well. One wonders if we would think so if we were feathered birds; would we still shoot human nudes? Regardless of our affinity to human skin (including our own), it does photograph well. Like other wet surfaces, oiled skin takes on particularly powerful tones. It doesn't seem to matter whether it's the pale skin of someone who sees little sun, the freckles of a true redhead, or the various shades of "black" skin, which has great contrasting highlights: They all seem to photograph well.

5. Diagonal lines generally look better than horizontal lines, and they do a better job keeping your eye in the picture. They add energy to an image. Diagonal lines can be parallel, they can radiate out from a single point, or they can be perpendicular to each other. Randomly angled diagonal lines often don't work well. Repetitive diagonal lines of the same angle to the edge of the image can really strengthen an image, pulling it together because of their consistency.

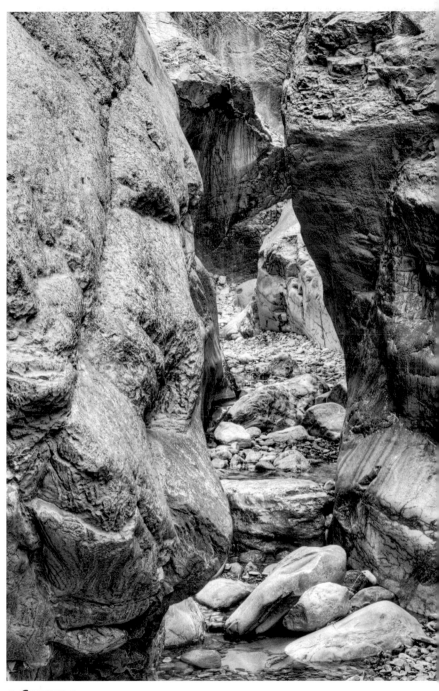

▲ Canyon 1
Soft light allows you to increase contrast and bring out detail. Depth of field was obtained here with multiple images blended in Helicon Focus.

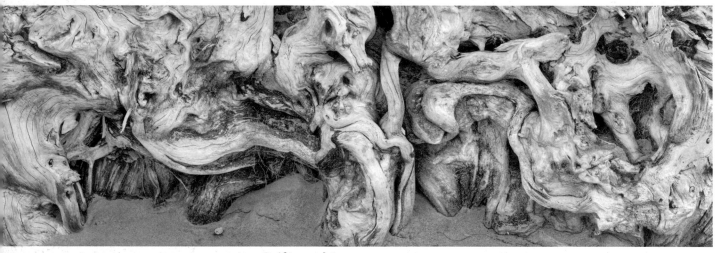

▲ Driftwood Arrow
I intended to photograph rocky shores and crashing waves, but made do with what was found… and started a new portfolio.

▲ My Feet
Even in the bath I am aware of light and shadow, form and composition; so off I went, dripping, to find my camera. Seeing begins with looking.

6. Wet objects photograph better than dry ones. It makes you wonder why we all scurry indoors when it starts to rain. Surfaces such as slate and other dark rocks and roads come alive when wet.

7. Long, soft shadows are generally better than short, sharp, deep ones. The low setting or just rising sun creates both long and luminous shadows. Remember though that you can have long shadows at noon if you are photographing a vertical surface.

8. Partial sun is better than full sun. Those who take snapshots head out in good weather, but the real photographers head out in bad weather.

9. Uneven cloud coverage is better than completely even cloud coverage. A completely overcast sky creates flat lighting, which makes it difficult to achieve much tonal variety unless there are objects that overhang, and thus shadow others.

10. Patchy sunlight (as in a forest at noon) is very hard to photograph.

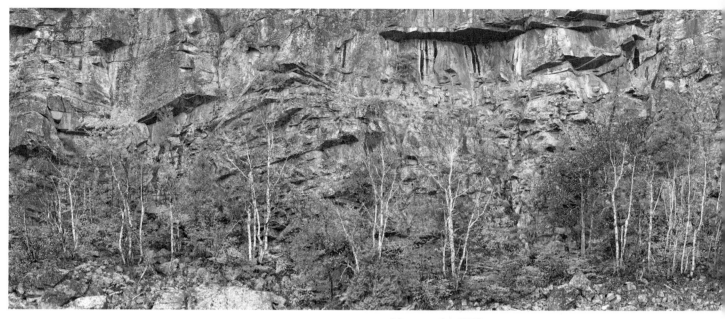

▲ **Algonquin Cliffs**
In the pouring rain, no one else bothered to get out of the car. Their loss!

11. Light colored rocks photograph better than dark ones. On the east coast we had lovely, slick granite; on the west coast we had dull, almost black rock covered in white bits (not all of which was bird poop). Guess which rocks photographed better. The west coast rock simply got darker when wet, but they didn't reflect more light because of their rough surface. The east coast granite was the winner!

12. Age photographs better than new (except in people, and sometimes then too if you aren't trying to please the subject). The patina of old surfaces tends to photograph well, though some new surfaces can also photograph well. I'm thinking of some of John Sexton's power plant images in which brushed aluminum appears to glow in the prints. The shiny, new Guggenheim Bilbao Museum and the Walt Disney Concert Hall photograph wonderfully.

13. Tidy scenes photograph better than clutter, unless there is a pattern to the clutter.

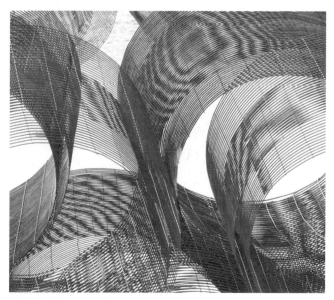

▲ **Wire Forms**
I took advantage of a rise from which I was able to look down into this concrete plant and capture the reinforcing wire. While circular in themselves, the overlapping shapes combine to create an S-bend.

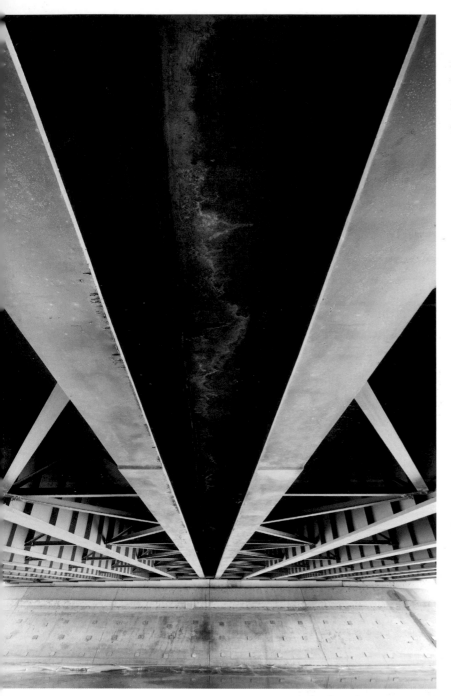

▲ Under Glenmore Trail
A very wide lens and parallel lines
result in bold triangles.

14. Circles photograph well. When viewed off to one side the same circular shapes appear as ovals, which are even better.

15. S-bends are solid gold! Whether this is opposite curves in a road, the patterns in a grain field or the sweep of a stream, it photographs well.

16. Receding parallel lines take on a triangular shape, which looks good. Think of roads, railways, bridge beams, etc.

17. Leaves look better in the spring than the summer, by which time they have a sameness in overall color and brightness which is not as appealing. Wind turns leaves inside out, supplying some variety in tonality.

18. Objects blurred by movement often look good in a photograph, which kind of makes you wonder why we all stand waiting, sometimes for hours, for the wind to die down to capture our images. Though to be fair, slight movement is not as good as a lot of movement, and movement in only a small part of an image doesn't look right when the rest is still.

19. Most objects look better with a plain background. The world's worst background is a forest with patches of bright sky showing through.

20. An image that is just a little out of focus isn't attractive, but very out of focus can be lovely.

This list is at best only a start to describing the surfaces that photograph well. Rather than carrying such a list into the field, you'd benefit more after reading it to simply pay attention to surfaces and how they deal with light so that you can apply this knowledge whether photographing food, sports equipment, machinery, or landscape.

**◄ Driftwood Reaching
(before blurring)**
I forgot to take into consideration
the effect of stopping down while
trying keep all the wood in focus,
which resulted in a very distracting
background.

◄ Driftwood Reaching (after blurring)
It would have been best had I shot this
correctly at the scene, but considerable
work in Photoshop rescued the image.
Think ahead!

Photographing Clichés

Some locations are so famous, so attractive, and so accessible that literally thousands of photographers have attempted to create meaningful images of these locations; so much so that one can't help thinking, "Oh no, not another one."

The same applies to certain clichéd ideas from cute babies to street people.

This then raises the question of whether one should even attempt to photograph these situations any more. Surely, the odds of anyone adding something meaningful to the genre is poor at best.

Well, perhaps YOU don't have a good photograph from one of these places and no one else has one done in YOUR style and through YOUR eyes. Just maybe you can create an image that others will like; but, if you don't create something all that different, does it really matter? Who's to say you can't simply enjoy your image for your own sake? You can even mount it, frame it, and hang it in your office.

The image opposite of Peggy's Cove, Nova Scotia is one such clichéd spot. Everyone who visits Nova Scotia travels to Peggy's Cove. There is a steady stream of tourist-laden busses arriving one-after-another filled with tourists carrying cameras with which to record their own version.

Actually, Peggy's Cove is a wonderful spot to photograph, and I had a lot of fun there. We arrived before dawn and started photographing in the dark, continuing until midday by which time finding a spot without a tourist was the real challenge. I took a number of pictures of the lighthouse, gradually getting more creative. I wouldn't be at all surprised to hear that someone used exactly the same position as me, but you know what? I don't really care.

I found the search for new perspectives to be challenging and am quite pleased with the resulting image. Sure, it's a lighthouse picture, but it's MY lighthouse picture, and I see no reason for you not to go out and get your own.

People have been trying to reproduce Ansel Adams' Winter Storm Clearing for over 50 years from the same viewpoint in Yosemite. Despite the thousands who have tried, I'm not aware of anyone who has succeeded. Somewhere I saw a "straight" print from that negative and you'd never know it was the same image—flat, boring, ordinary—you'd never guess that such a great image could result from this very ordinary negative. Even if you find the tripod holes of those who have gone before you, the image you make is likely to be very different.

Following are several reasons why I think you might want to give photographing a cliché a try:

1. You can challenge yourself to produce a good image, regardless of whether it's been done before. It hasn't been done by you yet!

2. You can challenge yourself to see it in a new way. You could get lucky, and the mental exercise will certainly stimulate you.

3. Working with photogenic material can be a good exercise. You know you should be able to get a good picture rather than doubting that the scene is worth it. Now all you have to do is figure out how. For many of our images we can't tell if we shouldn't have taken out our camera in the first place, or if we just didn't know how to work the scene. That won't be the case here.

4. Cliché scenes tend to be popular with viewers and, frankly, it doesn't do any

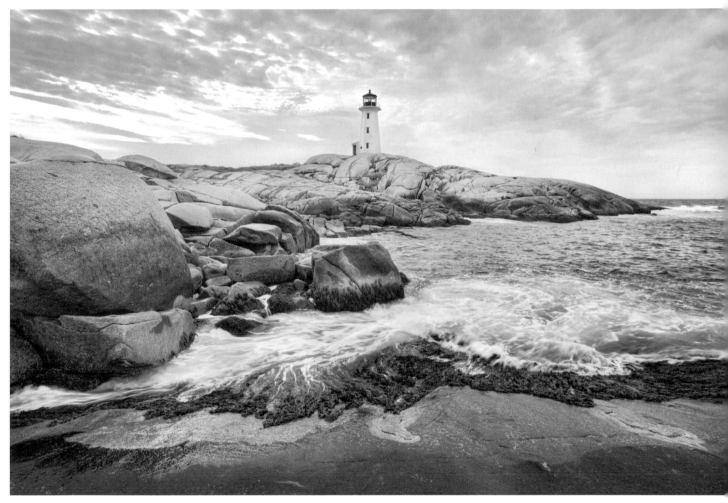

▲ Peggy's Cove
When at a classic location, the most you can do is make the strongest image you know how.

harm to make some money off people who prefer easily understood images of classic scenes. My Peggy's Cove image is my all time moneymaker, and while I may be a bit embarrassed by that, I'm still pleased with how I portrayed the famous scene. So there!

The image was, in fact, challenging to obtain. The lighting varied as clouds came and went, and the waves had to be factored in, but most of all I didn't come across this particular viewpoint until mid-morning, by which time busses were arriving every few minutes. There was an almost steady line of tourists walking to and from the lighthouse, or they were simply standing by the lighthouse staring out to sea, (or trying to figure out what the hell I was waiting for, more likely). Anyway, it took over an hour to finally get enough of a gap in traffic that there were only one or two heads showing behind a rock and none at the lighthouse or on the rocks around it.

Whale ▶
There is nothing
wrong with taking
advantage of what is
offered, in this case
in front of a gift shop.

It's Been Done Before

You take your photography seriously and
you like to think you're creative. But, every
time you come up with an idea you find that
someone has already beat you to it: Either you
realize you have seen the same subject shot
before, or after a great deal of work on your
part some well meaning "friend" tells you
where he's seen similar work. Just how "bent
out of shape" should you be over this revela-
tion? Is it even possible to find a subject that
hasn't been done before? Is it just too bad if
you find out after the fact that others have
been there before you? Do you now hide your
images of the same subject, sneaking them
out when everyone has gone home?

An important issue in serious photography
is whether it is valid to try something that
has been done before, or possibly has even
been "done to death". It's obvious that it is
impractical to eliminate entire categories of
photography on the grounds that "it's been
seen before". By this logic, we would eliminate
all nudes, landscapes, portraits, architectural
shots, flowers, and virtually every other topic,
leaving us to photograph extraterrestrials (as-
suming they visit), and not a hell of a lot else.

OK, what if we were a bit more specific?
What if we were to photograph nudes with
high key lighting? Sorry, already been done.
Does this mean we can never again shoot a
nude with high key lighting? Harry Callahan
did this 50 years ago. Should we then criticize

every photographer since who has used this type of lighting to photograph nudes?

I believe that categorizing images is the problem here. We need to evaluate images based on whether they add something to our understanding of the world or they create a reaction in us, even if we are fairly educated about the history of photography. Should they do so, finding another image by a different photographer with similarities really doesn't matter.

Think of writing instead of photography. Shakespeare used standard plots, situations, and conflicts in writing his plays. He's famous not for his original plots, but rather for his fleshing out characters and his use of language.

Frankly, if the only thing to recommend one's images is that they are new, then I for one don't think that's good enough. In fact, I will predict that they won't last or be remembered, except possibly in a history of photography.

I would rather be known for taking a great photograph of Yosemite, rather than for taking the first photograph.

Rather than spending your time pigeonholing an image, stop, look, and enjoy it. If it happens to be very similar to another image you have previously seen, and is even better, well isn't that wonderful? If it adds nothing to your experience, then don't bother looking at it again. The odds of your images being identical to someone else's are slim at best. Even two photographers with an identical negative make radically different prints (as shown in a monthly series in Black and White Photography magazine).

If a photographer studies only a few of the masters, then it can be challenging to be original. But, if the photographer becomes familiar with the work of many photographers from a variety of styles and schools, then he has so many examples that copying one without being influenced by all the others is nigh impossible. Add to that the photographer's own personality, likes and dislikes, mood and skills, and a different photograph is almost assured.

However, what if you inadvertently do create an image that ends up very similar to one created by someone who is more famous than you, and who did it before you?

Recently, I took some photographs to a museum gift shop to add to the images they sell for me, and there in the collection of another photographer was a very similar shot of one church photographed through the side window of another church. I knew when I set up the image that it was obviously such a good idea that someone else was bound to have done it sometime before. Yet, I liked the idea and the image pleased me considerably once executed. I don't think the gift shop needs two similar images, but I have absolutely no intention of hiding my version even though mine was almost certainly photographed after the other.

Remember that if two scientists come up with the same idea independently and without copying the other, they share in the Nobel Prize. Think of music and how the later composers build on the works of those who have gone before them, such as Rachmaninoff's Rhapsody on a Theme by Paganini.

Consider the case of a painter who creates a magnificent work on commission, but who subsequently creates another painting for someone else that has many similarities to the first. Do we discount the second image as being derivative of self? I don't think so. Both paintings may sell for millions. Monet did

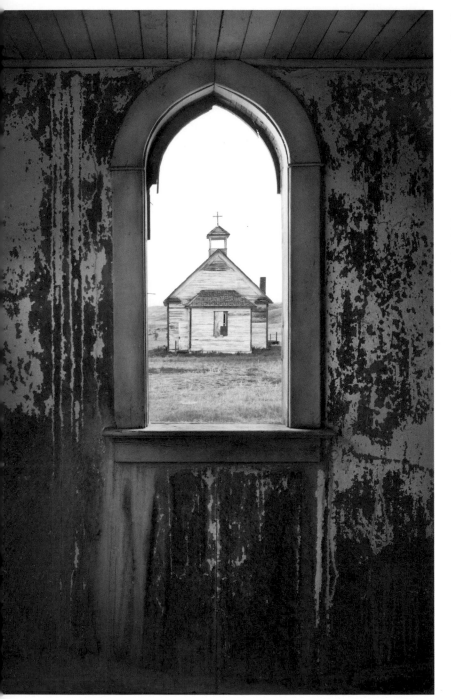

▲ Dorothy Church
Not every image is going to be startlingly
original—not mine, not yours—but we
can do it well and share our best efforts.

many fairly similar paintings of water lilies,
and Rembrandt painted many rich burghers'
wives in a similar style and pose.

No; you should feel free to "stand on the
shoulders of giants" and see further than they
ever did.

Noticing Subject Matter

Much of photography is about noticing; about
paying attention to what is around you. It
helps to be right-brained (creative and non-
linear), but just like Sherlock Holmes you can
learn to observe, and to enjoy the journey
more than the destination, the whole more
than the important parts.

You don't even need a camera. In fact, it
might be better to put your camera aside. Go
for a walk in your own familiar neighborhood
and have a good look around. Check it all out,
from cracks in the sidewalk to the shapes of
shadows, from the manhole to the chimneys.
See how many different things you can dis-
cover within one block that you never noticed
before. Did you notice what kinds of doors
people have? Curtains in windows? Any pets
peering out? This isn't a test. There is no dead-
line, no prize for the most objects noticed, and
no wrong answers. Look in a leisurely fashion,
enjoying the little details.

When you meet people, without staring
too much, notice the features of their faces,
the type of chin they have, the shape of their
eyebrows. What kind of mouth do they have?
Imagine you had drawing skill and had to
make a caricature of them: What features
would you emphasize?

Walk down a back alley and check out the
interesting objects people store behind their
nice, tidy houses. You may discover old cars,

RV's, garbage cans in varying condition, weeds, and decaying fences. See if you can see something unique about each house you pass.

Do you have an odds-and-ends drawer in the kitchen? Have a good look at the contents and instead of simply naming each object, look only at its shape. Look at it from a variety of angles, and note signs of use. Look in the drawer for objects that might photograph well due to their shape, texture, reflective properties, or even their shadows. Look for pairs of objects that might look good together: Not just the obvious functional pair of hammer and nail, but look for other features in common.

Go to your workshop and select some sort of old metal tool and really study it: Take a good 15 minutes to study the one tool. It doesn't matter whether it's a drill, chisel, screwdriver, or hammer. Imagine how you might photograph it. How many different ways can you imagine photographing it? How could you show in a photograph the properties it has when you hold it in your hand? Can your image communicate its weight, sharpness, age, coldness, etc.?

Learn to enjoy the process of looking. Get so that when you see a lovely S-curve, you can enjoy it for itself, without feeling the need to rush home for your camera. At the bus stop note things such as the shape of the collar on the fellow standing in front of you, the people's shoes, and the bags they carry with them. Look around the bus for interesting shapes, tones, lines, and shadows. Pretend you are photographing. How would you frame that fellow across the aisle from you for a half-decent portrait? Instead of seeing a coat, look at the folds in the coat and see how they interact with light.

Come up with your own visual exercises. Read about left-brain/right-brain differences in books or on the Internet. Check out a book on developing your right brain. Become an observer throughout the day, when working or having coffee, when driving to work or taking the bus home.

Become an observer par excellence!

It's not necessary to illegally enter abandoned, fenced off, private, and dangerous industrial sites to get good photographs. I shot this image at Atlas Coal Tipple—the last standing wooden coal tipple in Canada, and now a historic site with signs and guides. Most of the guides have been remarkably understanding, even making suggestions on interesting areas to photograph. Mind you, I'm polite, unaggressive, and very grateful for any help they give. It's important when doing industrial work that you make it clear you don't have a political agenda (unless of course you do). Private sites often fear government environmental or safety inspectors, and it's their natural inclination to say no. You need to make it clear where you stand before they get a chance to say no.

I photographed this part of a conveyer belt mechanism previously, but with better equipment and wanting a wider image I was ready this time to do a stitch of three vertical images. You are looking at the device which can swing horizontally as well as raise and lower the conveyer so it can spread the load of coal in the cars. A hut has been built over the equipment, but it is exposed to the elements from the front, and not surprisingly, has developed a lovely patina over the years.

Camera position was pretty limited, as there was really only one position from which the gears and shell and base all worked together. Mind you, finding that position quickly comes from practice and awareness of the relationship of all the parts.

There was nothing particularly tricky in making the image—some perspective correction since I'd been aiming upwards to start. The cobweb has had considerable work in Photoshop to make it brighter without disturbing the background. There were probably 40 other minor adjustments made to produce this image, all designed to lighten or darken areas or adjust contrast up or down in an effort to reinforce important lines, deemphasize ones which aren't as important or just plain don't work, and to provide an overall balance to the image.

Old machinery is both photogenic and interesting, and questions come to mind such as; What is it? How did it work? What is the scale? How did it get there? That doesn't mean that new can't be interesting—in fact modern often means bold colors, dramatic shapes, clean lines, and smooth textures which can photograph very nicely, thank you.

ADM Mill

I found these grain silos a few years ago in Calgary, at one end of ADM Flour Mill. I was attracted to both the fire escape and the cracks in the concrete. The lighting was flat and the image needed more contrast to look interesting. As I ramped up the contrast , I noted that the old lettering, which in real life is very subtle, started to really come out, and an image which had been rather ordinary before the increase in contrast started to shine.

Interestingly, this has been a very popular image amongst young people—suggesting there is hope both for black and white and for non-traditional subject matter. I had interesting reactions when I took a print to the mill (in the vain hope they'd let me photograph inside). The manager was horrified that I'd made their 1914 building look old. The secretary refused to believe there was lettering on the building and immediately took off to check for herself. In fact, you are looking at the remains of "Spillers Flour" from several decades ago.

Like many of my images, I have cropped tightly, emphasizing patterns, textures, and lines over form and location. Others might prefer including the surround in order to give the image a sense of place, but up close you can certainly get a sense of age. It's like the difference between a head and shoulders portrait vs. an environmental one. To each their own style. Think of it as the difference between telling a story and evoking an emotion, the latter being the tightly framed image with no distractions from the message.

I not only cropped out sky and ground and surrounding buildings, I even cropped out the "penthouse" sitting on top of the building. It fit in fairly well, but in my opinion, the diagonal lines of the roof didn't match the vertical lines of the rest of the silos.

Working the Scene—Part 1

You have scouted out some picture possibilities and have found fertile ground. Now you actually have to position and aim your camera. For example, let's say you found a rusting old truck in a farmyard. The truck is the "center" of the image, though it doesn't have to be positioned that way. Let's say that for this image, you have decided to photograph the truck while showing its environment in the background, rather than coming in close.

You have a choice of photographing the truck surrounded by farm buildings, or with a harvested grain field in the background. The choice you make will determine the character of the image. In this case, you try for the grain field because the farmyard is full of old machinery.

You wander around the truck looking for the best angle from which to photograph and to determine what will show in the background. Unless you want the junkyard look (and you might), you will want to simplify both background and foreground to help keep the main focus on the truck. Modern buildings or objects are not going to work well with the truck. Can you find an angle from which to shoot where the truck works well with the background?

Let's say that, despite your best efforts, the backgrounds are all absolutely terrible. You can't get a clear shot of the field due to telephone wires, there isn't a nice weathered barn against which you can photograph the truck, and the truck isn't surrounded by enough unmown grass to isolate it.

The activity described above is called "working the scene". And yes, it actually is work!

What are your options? You could accept the cluttered look and perhaps deliberately emphasize it to represent many old farmyards that act as mechanical graveyards and unintentional museums.

How about getting really low, belly on the grass, and using the sky as a simple background? That eliminates the junk behind the truck, but results in emphasizing any objects that are in front of it. The sky is awfully bright though; perhaps you can filter it because it's blue.

Perhaps you should abandon your original intention and shoot from inside the truck. Could you photograph the truck as reflected in the side mirrors? (Save those ideas for the next shot.) What if you were to leave the doors propped open? Does that create a better or worse shape?

If the background is cluttered, how about photographing from high up? Could you come back with a stepladder (or borrow one), or find something on which to climb (with permission)? Is there a barn with a hayloft from which you can shoot?

Because you don't have a political agenda, you are looking for perspectives of the truck in which you see interesting patterns or shapes with foreground and background objects. What you find might be the S-bend in a dirt road, something in the background that repeats a shape seen in the truck, or perhaps you can compose the abandoned truck with something so obviously new and shiny that it provides a nice contrast. Perhaps the shadow of the truck can become part of the composition.

Maybe it's a good time to stop and ask yourself exactly what it is about the truck that makes it interesting; after all, that's what you want to show in the picture. Is it the rust, the still intact headlights, the crazed windshield, or maybe the curve of the fenders?

You are not TAKING a picture of a truck: You are MAKING a picture with a truck. An entirely different thing!

Photographing with a wide angle will encompass more background objects in the image, and a longer lens will include fewer objects. Rather than consider lenses at this early stage, I would suggest that you simply walk around the truck in smaller and smaller circles until you see what you want. Of course, you have to be careful where you walk. The grass is tall and your footsteps are going to show, so if you move in, you can't move back out again. That can be a good reason to shoot first from further away before moving in.

You could look for something to frame the truck, but keep in mind that anomalous branches reaching into your frame from out of nowhere don't work in landscape pictures, despite the recommendation in many a book. The same will hold true in this image. Perhaps though, you could use the end of a building or another vehicle at one side of the image. This might create depth of field problems, but if shooting digitally you could shoot two images, one focused on the truck and the other focused on the building, and then later you can blend the images.

Perhaps you always shoot in color or you always shoot in black and white, but having invested this much energy into the picture, give some thought as to which would be better, and be willing to experiment.

You have found the best position, best height, and best distance from the truck. Now stop and give some thought as to how you might print it—OK visualize it. Maybe the subject still isn't going to work, as the tone of the truck blends with the tone of the barn in the background. Perhaps filtering can help, or if shooting digitally you can filter after the

fact. If those things don't help, but you need to do something to separate the tones, now is the time to figure out how.

You line up your camera, aiming at the car. Whoops! Not ready yet. Not if you want a really good image. You still have to refine the framing of the shot for the strongest possible image.

At this point you have selected your spot, your direction, and your height from the ground. The choice of lens will determine how much of the scene you include. If you are using a fixed focal length lens, you must have the space to move forward and back far enough to frame the shot just right. With zoom lenses you don't have to compromise on your ideal spot.

Your last task is to figure out just where to place the four sides of the frame.

Tip: My trusty plastic rectangle with a cutout in the same format as my camera, hanging around my neck on a shoelace, is invaluable for framing my shots.

You already roughly know what you want to include, but the question is exactly where to place the edges of the frame. Start by thinking about the left edge. You can have things meet in the corner, or you can create interesting shapes where the side of the image combines with something in the image or even a dark area in the image (e.g., a shadow). Now do the same for the right edge. This now gives you your focal length, though you still have to decide whether to shoot in vertical or horizontal format. This is determined by the strongest composition with upper and lower sides. If it is necessary to crop significantly, it is a sign that you should consider stitching, which

you might do anyway just to get a higher resolution image.

Now for a final check of focus, ISO setting, RAW or JPEG setting as needed, etc. Is everything OK?

That pretty much does it. You are in the right location, at the right height, and pointing in the right direction with the right lens. Your camera is set up properly. Now, a quick check on wind, anomalous reflections, and making sure that the lighting is still good. A glance at the sky to see a cloud heading for the sun: If you time things right, you might be able to soften the bright sunlight a little without making the image dull. You're primed and ready. You expose to keep detail in all the important areas (or shoot more than one exposure if you can't) and you have done everything you can to ensure a good image.

All you have to do now is to repeat all these steps 99 more times and the odds are fairly good that one of the images will be a keeper.

Working the Scene—Part 2

In Part 1 above, I described a hypothetical shoot. This time I'm going to discuss a real shoot I was on recently, and show you some of the preliminary photographs I took and point out why I thought I didn't have the definitive picture.

I was in the badlands of Alberta, specifically Dinosaur Provincial Park. Much of the park is now restricted access because of the paleontology going on, but, the area between the park entrance at the top of the hill and the campground at the bottom has proved very fertile ground, so to speak. (It isn't really fertile, of course. It's mostly barren, with only a few silvery shrubs and the occasional patch of cactus.)

I was with a friend who hadn't shot there before, so I showed him some of the better spots I was familiar with, but decided that I would explore a different area for myself. I found a gravel road that loops around, on which you can walk or even drive. It's about a mile in total and the area in the middle of the loop is a mesa with small cliffs reaching down to a stream between the cliffs and the road.

I began shooting near the stream with some mudbank shots. I then photographed the cliff from my vantage point below; then from part way up (an easy climb); and then from the other side of the road where I could get a bit higher up to shoot the cliff faces. I wasn't seeing anything very exciting though, and I didn't have much expectation for the images (in this case I was right—but I'm not always). Eventually, I decided to explore the top of the mesa, which I hadn't checked out before. A little climbing and I was on top of the mesa, which itself was not at all flat but consisted of small eroded hills, some gullies, and most interestingly some mudflows.

I knew from previous visits that the light beige mud of the badlands photographs well, and the dried mudflows are even better being a light gray, which in black and white photographs has a very nice glow to it. In the past, I had simply photographed the cracked and dried mud, but this time I wanted a bit more. I found an interesting swirl of mud, not entirely dried out, which showed some darker streaks. There was a small area surrounded by these curve shapes, which would provide balance to the sweep of the mudflow. This small area wasn't overly impressive, yet I hoped that it would record well. As you can see, hope is all it was. The smooth area of mud surrounded by

▲ Flow 1
This is the first effort, original image, before any manipulation.

▶
Flow 1 Edited
Note that the small area of smooth mud isn't big or interesting enough to balance the top of the image.

▲ Flow 2
More interesting, but hardly original, still it is progress and is a normal part of working a scene.

▶
Flow 3
Now this image seems to have potential. Contrast is a bit low but we can work with that.

cracks was neither large enough nor interestingly shaped enough to carry the image. Close but no cigar.

I tried the same image from a variety of angles but the same problems plagued all the images. Time to move on. Fortunately, there were several areas of drying mud and I tried a variety of them, getting stronger compositions, but still not the image I was hoping for. I found a tree-like structure in the dried mud that I thought might work.

This was certainly closer to what I was looking for, but I wouldn't know for sure just how

good it would be until I printed the image. On with the hunt. A short distance away I came across a small mound with sides covered in streaked, smooth mud, and with cracked mud at the base. It made an interesting contrast and I was beginning to think that here I might have a good picture.

This appeared to have potential, so I tried several different framings, positions, and focal lengths before settling on the final image below.

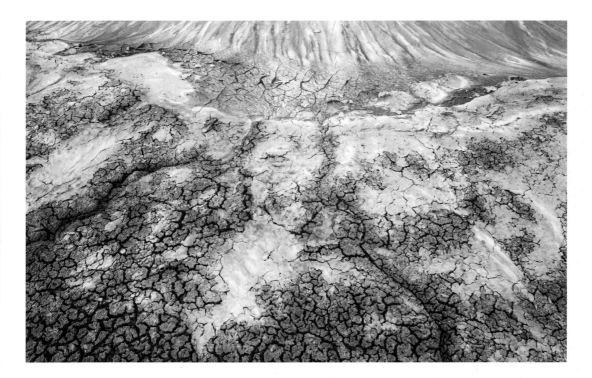

◄ Flow 3 Edited
The striations in the upper mud have been emphasized and the lighter mud has taken on a little bit of a glow. Even older 4 x 5 photographs printed in the wet darkroom show this feature of the badlands.

The Poison of Preconceived Ideas

Whether planning to attend a car race, photograph a pooch, or work in a nearby ravine, we typically select the venue because of its possibilities for photography. In selecting a location or situation, we imagine how it might photograph. We can't help it: It's simply part of the mental process of wondering if it will be a good spot for our purpose.

It might be that we think of previous images in similar situations (either our own or those of others). We might be doing something unfamiliar, yet we still think of the ways in which we might create an image. If we are planning to visit an old steel plant, we expect pictures of pipes and rust, piles of coal, and lots of grime.

These preconceptions can come at a price. We may not be able to see beyond our expectations. For example, while visiting the steel mill, we may be so focused on rust and age and grime, that we miss the ducks on the tailings pond. We can be so fixed in our idea of a curmudgeonly old gentleman, that we miss the wonderful, wistful expression on his face as he speaks of his old dog. I suppose that we may have an agenda—we want to show the world just how cranky this old neighbor is—but in doing so, we might be missing the stronger image.

Realistically, we can't tell ourselves to not have expectations: After all, we need to select equipment and come prepared. However, we do need to learn to turn off those preconceived ideas the moment we arrive at our location, and turn our visit into a voyage of discovery.

Perhaps we are photographing a car race and our preconceived idea is of fast cars and blurred backgrounds, yet we might be missing

▲ Tennis Shorts Hanging
While lying in bed reading, I couldn't help notice the lines and tonalities made by the clothing casually hanging in the corner. No subject is too mundane to at least see if it could make an interesting image.

the more interesting pit scene or photographs of fathers taking sons to their first race. After all, do we really need more pictures of fast cars?

We may be visiting a stream and canyon, and we are so fixed on those two items that we neglect to notice a lovely rock wall detail, those wildflowers clinging to existence half way up the cliff, or the leaves circling that backwater.

A better strategy is to anticipate possible images before we go, but upon arriving, stop and take inventory. What is there besides the obvious and expected? This will likely require exploring the scene, or at the very least having a good look around.

This first inventory is object oriented, but do a second inventory of shapes, tones, patterns, and lines. Consider relationships and repeated themes.

Go ahead and get the preconceived shot out of the way. After all, we would look pretty stupid if, while looking for other things, we missed the opportunity of getting what we originally came for as the sun moved out of range. But, once our planned shot is in the bag, we can go back to our inventory to see what else the scene might have to offer.

Finding Inspiration—Interest Comes First

I think that "trying hard" is probably the worst thing you can do as a photographer. I don't mean you shouldn't be careful, but rather that the harder you look for a good photograph, the less likely it is you will find one.

This of course leaves you with the thought, "So, how the hell do I take good photographs if I'm not supposed to go looking for one?"

What if, instead of hunting for great images, you were to go out looking for things that interest you? I didn't look for an interesting image in my bedroom; I simply observed that the shorts hanging there made an interesting pattern, and THEN wondered if it might make an interesting photograph despite being such an ordinary subject. The point is THE INTEREST COMES FIRST.

When I photographed ADM Flour Mill, the patterns made by the cracks in the concrete caught my interest and then the question was asked, "Could that make a good photograph?"

Imagine your English professor assigning an essay on a particular topic about which you have absolutely no interest. It's possible to do the assignment, but the chances of creating a work of art in the essay has to be considered slim at best. On the other hand, for a subject that you feel very strongly about, you might write an essay whether or not anyone asks you to; whether or not you will receive credit for it; or whether or not you will be paid for it.

Mind you, you could easily argue that unless I am quite odd (which is entirely possible), I wouldn't have an interest in underwear (other than to find a clean pair), therefore the interest cannot have preceded the photograph. However, even with underwear, it was a simple observation that clothes dumped randomly on the floor or casually hung up sometimes create interesting patterns. I looked at those patterns for most of my life before deciding to photograph them.

What I'm trying to say is that the interest usually precedes the finding of the photograph, and that what we should be looking for is not the photographable but the interesting, and I don't think they are the same thing at all.

▲ **Underwear Left Lying**
Now we're really pushing the bottom of the barrel for an image, but I couldn't resist that lovely curve and those shadows on the floor. The image pleases me. I don't have to show it to the world, though I guess I just did!

What if the very thing you are interested in is the process of taking photographs? It's all very well if you are a hiker or a Sierra Club member, but what about the guy or gal who just enjoys mucking about with cameras? Are they to be discounted, doomed never to make a great photograph?

I began by suggesting that you have to be excited about the subject matter; that if you have no emotional response to your subject, how can anyone else have an emotional response to your photograph?

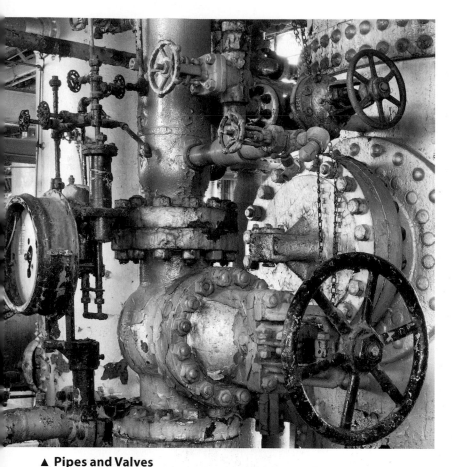

▲ Pipes and Valves
I love the challenge of taking a large, complex subject, such as this sulfur scrubbing plant, and finding parts that form patterns, shapes, lines, and textures which please. This is art, not a technical illustration.

For example, can someone who thinks football is boring still take a great football picture? Can a photographer who is assigned to photograph a boxing match and who is disgusted by the whole thing still manage to make a photograph that shows the excitement of the sport?

Was Edward Weston obsessed with dead pelicans? I highly doubt it. What Edward Weston was excited about was shapes, curves, and tones. He didn't care a whit where he found shapes that excited him—whether a pepper in a funnel or a toilet shot from the floor—it didn't matter as long as it had the "light". Hell, we don't know if Edward Weston even liked to eat peppers!

If we take the same argument to the world of painting, we can ask if Rembrandt was obsessed with rich burghers of Ghent, or was he obsessed with light and composition and conveying facial expressions?

Was Andy Warhol obsessed with Campbell's tomato soup? Probably not.

What about Arnold Newman, the late great portrait photographer? Did he emotionally react to each of his sitters equally? Surely, some subjects didn't interest him and it became an intellectual exercise to make a great portrait of a rather ordinary person.

I like photographing weathered industrial subjects. I'm not an engineer, I don't tinker with old cars, nor is my backyard garden littered with odd bits of machinery. I like old machinery because it photographs well, not because of some obsession I have about the past. I'm happy to photograph modern structures if they have the right tones and textures, e.g., my parking garage series. I do park my car, but I am not obsessed with parking structures.

These examples would suggest that interest in the subject matter is not, in fact, essential for a good photograph. Shouldn't that mean that I can simply point my camera at anything, and as long as it's possible to place it in an interesting composition a great photograph will ensue? If only that were the case!

Some subject matter excites us or challenges us due to its photographic characteristics, which has absolutely nothing to do with who or what is being photographed. When Edward Weston photographed José Clemente Orozco in 1930, what made the photograph interesting and challenging were the coke-bottle-bottom glasses the sitter was wearing, distorting the eyes and providing interesting highlights. One could imagine Weston making

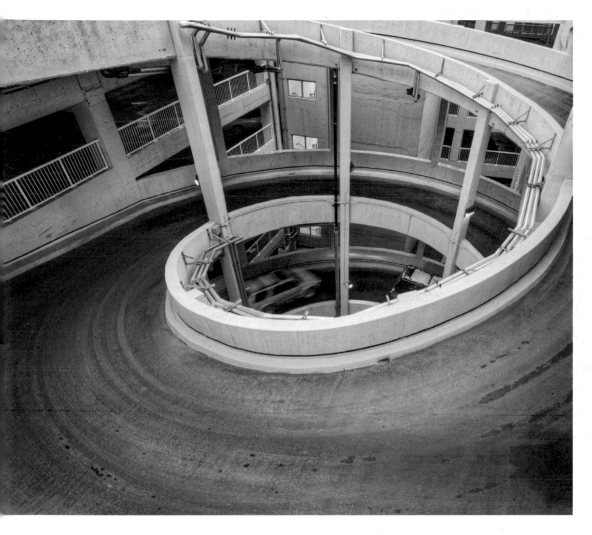

◄ **Parking Spiral**
Even ugly subjects can be made interesting if not actually beautiful. It might be easier to think of words like character, history, noble, enduring. You are showing what other people don't notice—in this case the yellow line and the tire marks in the driveway.

the portrait even if the sitter had been his garage mechanic's unemployed ex-brother-in-law, instead of a famous writer.

But what does this mean to you and your photography? For a start, you can be excused for not having a passionate interest in your subject matter and you can still make great photographs; remember the pepper! It still means you need to be involved with your subject, just not necessarily for the obvious reasons. Your interest may come from the tonalities that will photograph well, the

wonderful shapes, perhaps because of its oddity (think Diane Arbus), or simply because you know it's something most of us would walk by without a second glance, and you would like the opportunity to show us what we missed.

Whether fascinated with the subject directly or only for its photographic possibilities, the interest still comes first. Only then can you start hunting for great images.

Rules for Looking

Below is a list of points to consider when looking for something to photograph:

1. **Look for simplicity.** Look around for areas that are less confusing. I was about to say, "less cluttered", but perhaps clutter is what you are photographing. Yet, even in this you are looking for a representative area of clutter with an element of consistency of clutter.

2. **Look for a viewpoint from which things appear simpler.** This might involve climbing onto something, or finding a hill to climb or a ravine you can shoot down into.

3. **Always consider the background.** Sometimes you find an uncluttered background first, then you search for something in front of it to show off, whether weeds, bushes, people, or rocks.

4. **Look for the part that represents the whole.** You might be photographing the junkyard experience, so how about concentrating on someone's facial expression as they discover the elusive hubcap from a 1952 Rambler they are refurbishing? If the junkyard is about rust, then look around for the best rust. A photograph of a bunch of gnarled old trees is probably going to be less effective than a single, particularly good specimen unless there is a repeating pattern in the trees that can be used.

5. **Look for something that CAN be photographed.** Some things won't work well, such as harsh lighting, inadequate depth of field, or cluttered foregrounds or backgrounds. If you can't see a way around these flaws, then move on.

6. **Don't look for great photographs: Look instead for objects with potential.** Objects have potential because they photograph well (see essay on what photographs well), or because of their location or uniqueness or interest. Use these to assemble a possible photograph.

7. **If you don't see anything interesting to photograph, stop trying and simply enjoy the location.** Wander around looking at things, whether photogenic or not. In a junkyard you might stop to talk with some of the other explorers, try hefting a rear axle, or peer inside a battered car body or under the hood of a very old car (boy they were simple in those days!). Odds are you will become involved, and once involved your chances of finding something worthy to photograph increase substantially.

8. **Say something about your experience.** Instead of trying to say something different (let's face it, you aren't the first photographer to visit a junkyard), try to say something about your experience of the junkyard. Are you intrigued by the shapes, the decay, the people, the pollution, or the amount of waste? Do you, in fact, have any reaction at all to wandering around the place? If you have no emotional reaction to wandering around, the outcome of your shoot is dubious at best. You could treat it as an exercise, but don't build your hopes for great art.

9. **Maintain a positive attitude.** A project, whatever it might be, is unlikely to be successful if it starts from a premise of, "Here is a list of things it can't be." Regardless of whether it's an idea for a science fair, selecting living room furniture, or making photographic art—always proceed from the positive. Ask yourself, "What could this be?" An open mind is bound to see something new and creative.

10. **Explore.** Get down on your knees, look inside the cars, and climb if you can. Limiting yourself to the world as seen from standing eye-level and looking straight ahead is to deny yourself a view of most of the world. What about looking straight down? Can you truly say "I have seen" by the time you leave?

11. **Consider the possibility that what you came to photograph may not be what you should leave with.** You might have come for the rust, but you leave with the people. Be flexible in assigning yourself a project. There is nothing wrong with it turning out to be radically different from what you intended or expected.

12. **Stop!** After wandering around for a while and finding nothing interesting to photograph, pause for a minute and analyze the scene. OK, so you found nothing interesting to photograph, but did you find nothing interesting at all? If the answer truly is "nothing", then perhaps you should go home. If your reaction though is, "This is a cool place!", then ask yourself what's cool about it and resume your wandering now focused on what's cool.

Seeing Fatigue

I'm not talking about eyestrain here. Rather, I mean that our ability to "see" sometimes fails us. It can do so in several ways:

Finding Images—I find that after shooting for a couple of hours in the same location, I begin to get numb. I seem to run out of ideas and there is probably not much point in continuing to shoot.

Fortunately, this problem can be overcome in a couple of ways. This "seeing fatigue" doesn't seem to carry over to some different scenery, so it might simply be a message to move on, even just around the corner. It may be nothing more complicated than taking off your backpack, sitting on a rock, and just relaxing—perhaps grabbing a sandwich or a granola bar, taking a sip of water, and simply enjoying where you are, without actually hunting for images.

Color Vision—Our eyes adapt to strong color casts within a second or two, which means, for example, that we don't see the blueness of objects that are lit only by the sky, or the yellowness of something lit by the reflection off a yellow wall. The camera will record a green tinge to a rock under a tree which the eye, knowing that rocks aren't generally green, completely ignores. These problems can affect photographing in canyons, while doing portraits, and in any number of situations where we have definite ideas of correct colors, yet the scene records otherwise.

Print Darkness and Contrast—It is human nature not to notice small changes. If someone gradually gains weight daily, you are not likely to notice. However, someone else who hasn't seen that person for a while will instantly notice the difference. My patients will report being ill for a month or two, yet when treated, realize they had been ill for many months.

The same phenomenon occurs when processing prints. You gradually make your prints darker, and you increase the contrast in such small stages that you often don't notice that you have gone too far until you have gone "way over the top", and then you actually have

to back up several steps. Just about any print adjustment can be taken in small steps until it has gone way too far before being noticed.

Print Viewing Fatigue—There are those images of which one never tires. And, there are images that are meant to be seen only occasionally--they work better in a book than on a wall. Almost any image, if studied too long and looked at too often, gets a bit boring.

I happen to enjoy watching the same movie more than once, but even for me there comes a time when "familiarity breeds contempt", and it is time I shelved the movie for a long time before bringing it out again. The same is true of photographs. If you spend hours working on an image, it is not unreasonable to develop some doubts about its strength, simply because you have spent so much time with it. If you find this happening, then stop working on it for a few weeks and come back to it refreshed. That will tell you if the image really has legs.

There's Nothing Here to Photograph

I suspect it's universal to sometimes go out photographing, and in a particular location, we find nothing to move us (except to a different location). Nothing photogenic, nothing inspiring, nothing interesting. We pack up our bags and head off somewhere else.

Many times this is exactly the right thing to do. But, what about when you know there should be something to photograph, and you just can't see it? You might know because it looks photogenic or you've had success there before. Perhaps someone else made good images there.

Oh, sure, you might fire off some images with little hope of getting anything (you wouldn't even have bothered unpacking a 4 x 5, but with digital, perhaps a miracle will happen and the pixels will magically align).

So, the question is this: If a location should or could lend itself to good photographs and you can't find them, is there anything that can be done to salvage the situation before you pack up your gear and move on?

The answer to this question could turn into an entire course on photography, but for our purposes, following are some questions to ask yourself and points to consider before you pack away your gear:

1. Have you explored the scene from every angle, including low and high? Recently, I shot a tiny, ice-covered waterfall; which I don't suppose it was even two feet high. From front-on it didn't amount to much, but when I waded through the snow to get above the fall, lovely arcs of ice appeared. My change in position made the difference between failure and success.

2. Did you show up with a wide angle frame of mind and miss the telephoto shot, or the other way around? Preconceived ideas of what will work best for a scene can impair you.

3. If the conditions prevent the scene from being workable at this particular time (i.e., light, wind, or clouds), could you either take advantage of what you thought was a problem, or do you simply work around it? So the sky is boring. Who says the picture has to include the sky? Photographing at noon brings the challenge of harsh shadows. How about actually incorporating the shadows as part of the picture? Noontime shadows on flatland are short, but on ver-

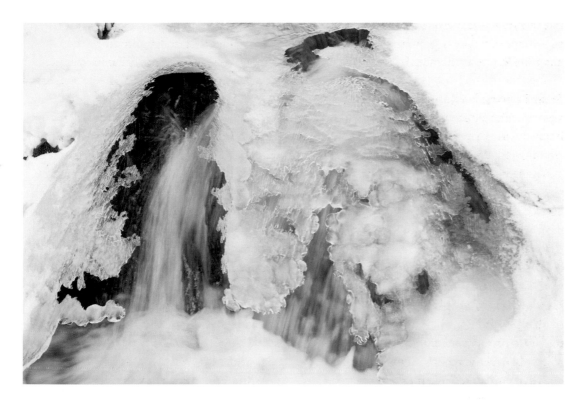

◄ Ice Formation from Below
I would call this pretty, at best, but it is not a good photograph. It's hardly unique and the shapes are not great. It's an image to toss.

◄ Ice Formation from Above
Effort well spent, the same ice formation from above and we have great and sweeping curves. Note the repetition in the lines in both ice and water unifying the image.

tical surfaces they are long and dramatic. I wonder…

4. If there is material there and you just can't see how to put it together, stop searching for a few minutes and ask yourself, "What makes the scene pretty or interesting or moving?" and "How might I go about showing that within the limitations of what is available?" So often we run around without much thought, looking for things to fall into place, whereas, if we give some thought to why we are there, we might make better use of what we find around us.

5. Consider treating the location as an assignment: You HAVE to get the best possible photographs in this "bad" situation. Sometimes just simply starting to photograph will break you out of a slump, and the first pictures, which really are poor, will quickly lead to better pictures.

6. Try to treat the scene in an abstract way. Instead of photographing the rocks and trees, try photographing a mood or emotion—the shapes and lines.

7. Make a picture of the light rather than what is lit.

8. If you are younger than me, try bending over and looking at the scene upside down between your legs (assuming no one is looking). Suddenly things might fall into place.

9. Consider just lying down and staring at the sky for 10 minutes. There is a fair chance you will find something when you get up again.

10. Pretend you are someone else who's style is a bit different from yours, what would they photograph?

11. OK, so a straight photograph isn't going to look good, but if you really changed things in post-processing—radically darkening parts of the image, lightening others, changing contrast, printing high key, or printing low key, might there be something that would work? Think of the scene as only the material for the image you are going to build.

12. Put down your camera and explore the scene without it. While taking a portrait, for example, stop playing with your camera and talk with your subject.

13. Put yourself in the most awkward, uncomfortable, wet, cold, prickly, or otherwise nasty spot in the scene. Want to bet that is where the best position can be found? Ask yourself, "How many other people would make the effort?"

If all the above doesn't do it for you, it probably is time to move on, perhaps coming back on a different day or at a different time. Leave though, remembering that the problem may well lie with the photographer and not with the scene, and that it could be very rewarding on a different day.

Where Should You Point the Camera?

When shooting the "grand landscape" there is often only one place to aim the camera and the issues center around timing and where to plant the tripod more than what to shoot. But a common scenario is to be wandering around looking for photographs in an area of interesting material. This could be an outdoor farmers market, an old abandoned industrial plant, an interesting bridge, a canyon, a field, an abandoned farmyard, a street somewhere in an exotic country, or a junkyard. It could even be a nude.

Where do you point the camera and how much do you include? Are there any rules, guidelines, suggestions or tips to help?

Common to all these possible subjects is the need to make order out of chaos. An attempt to photograph the whole often leads to disappointment, leaving the viewer with none of the excitement you felt while there. A picture of an entire bazaar in Morocco would look more like an illustration for a report on traffic congestion. It wouldn't even make a good travel brochure illustration, as it lends nothing of the experience of actually being there.

To make a good travel brochure picture, you would want to show one or more vendors and their wares, colorful clothing, and exotic backgrounds. You probably wouldn't include the tacky tourist in the awful hat, loud shirt, and bad shorts. As a creative artist though, you might want to make a study of tourists and their garb. If you did want the vendor, it would be because of an interesting face, patterns in the wares displayed, an interesting shadow across the scene, repetitive shapes, appealing color contrasts, etc.

Let's imagine a less exotic scenario. You are wandering around a junkyard. There are heaps of rusting cars, piles of old parts, broken glass, puddles of dubious liquids, and scattered around, people searching for treasures amidst the junk. Your aim is to produce a series of pictures that represent the "junkyard" experience.

Here, I want to address the problem of finding something to photograph rather than fine tuning composition. I think you can imagine without too much difficulty two camera carrying photographers wandering through the junkyard. One is a hobbyist of little experience and no background in art. The other is Cartier Bresson reincarnated. The novice wanders through while randomly taking snapshots of colorful piles of junk, gets bored, and heads home having decided that the problem is the junkyard. Once home none of the images look even vaguely interesting.

The other photographer is kept extremely busy, and in fact is frustrated when, at the end of the day he is asked to leave, the gates are closed, and he goes home tired and happy. On looking at his images, he sees that many show the elements of good photographs. More to the point, he had no trouble finding subject matter.

A common phenomenon is a hobbyist photographer heading to a location previously shot by one or more of the greats. They attempt to recreate some of those images and are sorely disappointed that their prints look nothing like what the master had produced.

A further problem is that people are sometimes wowed by the majestic photographs made by highly skilled photographers, only to visit the locations themselves and find the actual location disappointing; the mountains don't look as high, the river seems smaller, and the scenery appears less spectacular. It's not that the greats somehow stretched the mountains in the darkroom, but rather, that they created order out of chaos. Other elements do not distract from the majesty of their image of the mountain. The photographer knew how to get the best out of what he had available (i.e., Half Dome at noon is not nearly as exciting as it is late in the day).

How then does one find good images? It isn't possible to give specific directions, because clearly it will depend on each individual situation, but there are some guidelines that might be useful.

I didn't "find" this image until today when I was looking for tall images suitable for full page views in this book. It was, in fact, a multi-image stitch and was originally quite horizontal, but I reckoned that a severe crop of both ends would be both effective and suitable for the book. The original image has a strong blue cast, being lit only by blue sky directly above this very narrow slot canyon. This isn't one of those famous Arizona canyons—this is just west of Calgary and is easily accessible to me. It's called Jura Canyon, named incorrectly for the age of the local rock formations—go figure. This location is popular with geologists, but it's wonderful for photographers.

It's quite nice in color—the rock naturally has a bluish gray tint to it anyway, except for those rocks sitting at the bottom of the canyon, which clearly have been washed down from elsewhere—those are beige in color.

However, in color it seemed a bit busy; a problem nicely solved by converting to black and white, in this case without any "filtering".

My friend Robin introduced me to the canyon and it has been a delight. I've been back twice since, in an attempt to get things just right. Adequate depth of field is problematic in the canyon, being only a few feet wide; and I have had success with multi-image blending using Helicon Focus—sharpness is possible from six inches to infinity with wide angle lenses, from six feet to infinity with telephotos. Very handy.

That little reflection of sky and tree is crucial to the success of this image—it's quite common to find that something little like that can "make" the image. Or more to the point, lack of it means the image is rather ordinary. I have several similar images from elsewhere in the canyon, but it's this one that is seeing the light of day.

The message here is that small details in photographs often have power out of proportion to the real estate they occupy on the print and can make the difference between a nice image and a great one.

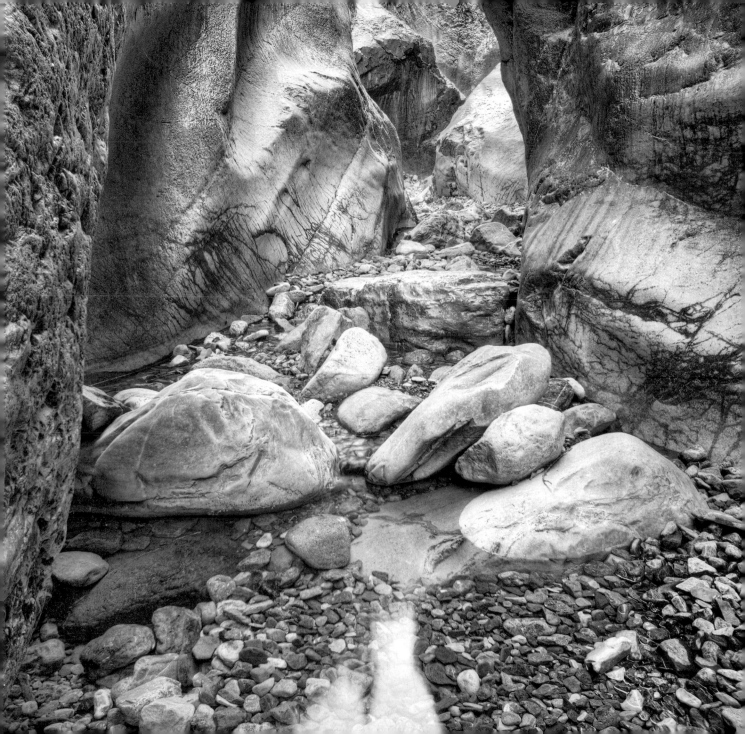

I'd been photographing the landscape, and having used up all the good light, decided to pay a visit to Atlas Coal Tipple once again. It was late in the day and it was actually closed. I could have hopped a very low fence, but I chickened out, not wanting a confrontation and noticing a number of cars parked at nearby houses. Fortunately, lying around in a field in front of the museum grounds were a number of mining machines, all too heavy to be stolen, perhaps waiting for their chance as an exhibit.

I spent a delightful hour wandering around, looking for interesting shapes. Some of the machinery, while fascinating, just didn't make interesting compositions and had to be by-passed. The few photographs I tried of these machines were just as disappointing as I had expected. I was looking for simple arrangements, clean backgrounds, interesting shapes, and something that was inherently photographable (some things aren't by their shape or tones or requisite depth of field needed to record them).

I was drawn to the circular marks on this large metal plate, which was lying on the ground but not quite perfectly flat. Two areas were clearly lower and had retained rain water longer than the rest of the plate, and so had rusted in a different way as the puddles gradually dried up.

I was attracted to the fossil-like markings, because in the last few years my photography has become more abstract and needing fewer visual clues as to subject matter, location, or orientation. I recently made an image I particularly like of the rusted side of my wheelbarrow, though that image only looks good in big prints. Rust is a wonderful substance, taking on a considerable variety of colors, tones, and brightnesses. To me the image has a bit of an astronomical look to it with two suns approaching. Alternatively, you can think of it as a nude (OK, with a lot of imagination). It might even make you think of a couple of cells in an electron microscope. The two circles are just asymetrical enough to provide interest—had they balanced perfectly the image would have been really boring.

3 Composing

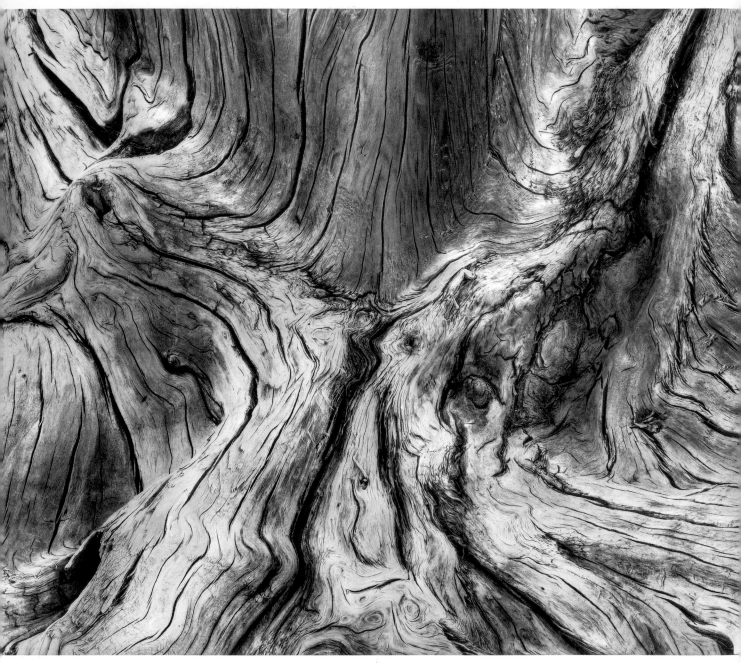

▲ Driftwood II
Symmetry makes for a quiet, stable, and calm image. It could be thought boring, but that really depends on how much there is to the image.

Sketching to Make Photographs

A powerful tool in learning to see, and subsequently in composing your own images, is to make an outline sketch of the image you are studying or the composition you propose to record. To be honest, I don't run around with pencil and pad sketching the outlines before I photograph, but that's because I can imagine the sketch, and there is no reason why you can't do the same with a bit of practice.

If truth be known, my process of making crude outline sketches actually started years ago with the use of hand metering and the zone system in large format photography. I would draw the sketch to record which zones recorded where. After doing that for a few years, it became easy to make the sketch in my head and to then analyze this imaginary sketch for the various aspects of composition.

However, the process starts with real pencil and paper, making crude sketches of great photographs you admire. You could use a book or look up the images on the Internet. Do not, however, trace the images (which is hard on your LCD screen, not to mention the books!). Simply study the picture for a minute and then draw a small rectangle representing the image frame—no more than 3 inches in any dimension, or even half that is OK. Mine are generally around 2 inches. Neatness definitely doesn't count, so whatever you do, don't measure and don't use a ruler. This is only meant to be a sketch. With a small amount of practice, you will be able to do it in 10 seconds, and even 3 seconds is reasonable. I did say "crude" here. No one is going to mistake this for a master sketch.

Now draw the 2-3 main lines in the composition. You are not necessarily looking for real lines in the subject; rather, find the lines that

divide the image by color, tone, or the edge of a shadow. You want an approximation of these divisions. It is more important to approximate the shape of these "lines" than their actual location. Did I say "crude" and "fast"?

Add more lines as needed up to a maximum of about 8 in total (including the initial 2 or 3). You should now have a rough approximation of the image. The actual image may have dozens of lines you could record, but some are more important than others and we want only a hint of what the image looks like. Don't bother with shading. Were you taking a picture of a daisy, for example, the head of the daisy is a circle, the stem a single line.

Some lines are especially important, such as those lines that separate very dark from very light areas. Horizons almost always should be recorded unless the horizon is not tonally separated or is mostly hidden by foreground objects. Significant white areas should almost certainly be circled.

Practice with good images until you can make simple sketches very quickly. Try imagining the sketch by either closing your eyes or looking at a blank wall or an even sky. Remember that the goal is to capture the main elements of the image in the fewest possible

▶

Rugged Rapids Park
Wandering paths introduce questions about where is it going, or who may be just around the corner.

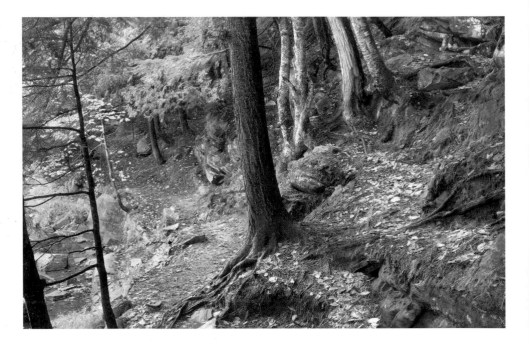

▶

Old Growth Tree
It could be argued that this image strongly favors the left side with the mass of the tree, but even the fine branches and small logs can balance it nicely.

▲ Horseshoe Canyon Before Storm
At first glance there aren't a lot of major shapes in this image, but there are lines to be seen; gullies and pathways, folds and crevices.

strokes. You can continue to practice this sketching technique using great images, while you start applying the technique to your own photographs.

Check these simple outline sketches to see if you can recognize the balance, outlining, and so on, which help make these compositions strong.

When it comes time to sketch your own compositions in the field, a tripod makes life a lot easier, so that is how I suggest you start out. Don't think though that the technique isn't applicable to sports, weddings, portraits, and all manner of subject matter. There's nothing wrong with hanging the camera around your neck while making a quick sketch with two free hands. At first, I even recommend you bring along some of the sketches you made of great images. A small pocket sketchbook is ideal for carrying your already made sketches and for making new ones.

So, into the field you go, and when you find something you want to photograph, line up your camera as best you know how. If on a tripod, you can simply lock it down at this point and refer to the viewfinder to make your sketch. If you are hand holding a compact digital camera you can use the LCD screen; if using a digital SLR without live view, you can simply take one picture and then use the review image on the LCD for extracting your sketch.

Now, look at your sketch. Does it appear as interesting, balanced, etc. as the sketches of great images? On the other hand, does it look like a random collection of lines with no real pattern to them? Now go back to your viewfinder and see if you can relocate and/or re-frame to strengthen, organize, and harmonize these lines. Maybe that strong vertical would be best far off to the right side of the image, with the radiating, almost horizontal lines splayed out to the left. Perhaps it is now obvious to you that the horizon just isn't going to work in that position: should it be eliminated or moved or partially hidden? Perhaps the sketch shows that all the action is in the center and the outsides of the image contribute little, or perhaps it is the bottom half that is not carrying its weight.

Does the pattern of lines in the sketch match your intent for the image? Jagged lines

Your exercise here is not to make a great image, which could be problematic when you are struggling to make sketches the first few times. Your assignment is to use the sketch to make the best possible image. You could start with simple subjects like your house or car, the living room or the backyard, or wander downtown and shoot some architecture.

How long you continue to sketch images is up to you, but I suggest you try it for a month. You may still be doing it years from now, or that may be it. You might become good at making "air sketches" and quickly drop the pencil.

If your compositions are lacking a certain something, this might just be the tool that will help you fix them. It can improve seeing in general and composition in particular.

Complicated doesn't Cut It

If there is one common characteristic of great photographs, it is that the message is not weakened by many extraneous elements. In fact, the majority of great photographs are downright simple. Of course, that leaves us asking ourselves, "If they are that simple, why are they so hard to make?"

Almost invariably great photographs are images that have an obvious design—it doesn't take work to appreciate them—they may have hidden depths, but they hide under a bold, simple arrangement that is easy to recognize. One could argue that since more people are capable of understanding a simple image, it only follows that these would be the most popular images; yet critics, museums, publishers, and photographers themselves seem to consider these same images as the great ones.

▲ Grain Processing
Some images have no particular center of interest, relying instead on the interrelationship of a number of details, as in this case.

are hardly going to be calming, and too many horizontal lines are very static and could be boring. Do the curves work? Are the lines in the top-right complementary or harmonious with those in the bottom-left, and so on? Is that what you wanted?

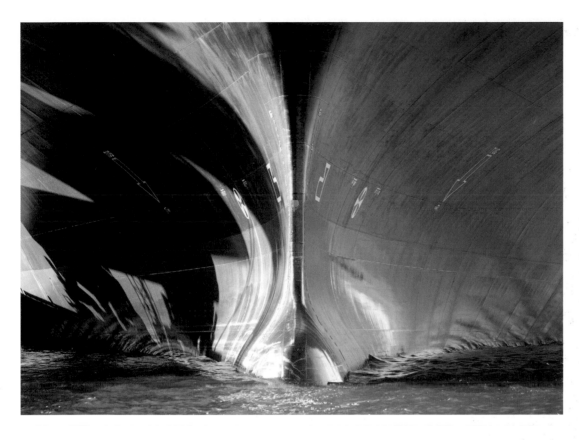

◄ **Ship's Bow**
A simple design combined with bold colors and a limited palette result in a strong image.

Thumb through books of great images or look them up on the Internet. I think you will find that the designs of the images are elegant and simple, and are easy to understand at a glance, while offering more for the person who stays with an image.

Perhaps we can compare good photographs with going fishing. First, a fly designed to get the attention of the fish is needed. Next, the lure has to persuade the fish that he wants to swallow it. Then having had the fish strike, the lure must keep the fish hooked. A lure that can't catch the eye of the fish in the first place is not likely to put food on the table.

This has implications for our own images. We may choose to balance half a dozen different image elements, but for the image to have widespread appeal, the image better have a few main elements (at most) that are easily apparent and which aren't disguised by the other aspects. Those few main elements should take up most of the picture, unless they sit on an uncomplicated background.

Here is an example from my own recent experience. Last fall I was photographing a series of small waterfalls, pools, carved rocks, and reflections. An image that has three main elements (i.e., three small reflecting pools) better have them balanced throughout the picture. If the bottom-right part of the image shows a bunch of jumbled rocks, that will distract from the three pools. If an image contains six features, such as a gorgeous curve on the left, a light stone positioned halfway out of the pool on the right, a fall of water toward the top, a shadow on the bottom, a reflection

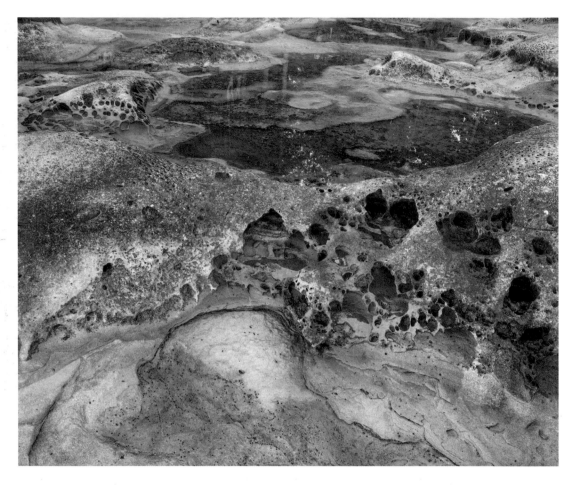

▶
Hornby Beach
There is so much going on in this image that it's hard to tell what it's a picture of. Is it the eroded rocks or the pools with background trees reflected? There are too many shapes, too many different textures, not a successful image. It might be the raw material for a better image though.

in the other pool... Well, you get the idea. With that much clutter, the odds of making something out of it are poor.

Therefore, an image should have a main pattern. It can include more to offer the viewer, but the other "layers" to the image should be subtler so they don't overwhelm the main pattern.

The image above is one I happen to like a lot, yet no one has ever purchased it and it gathers no kudos from viewers. People have actually told me it's just a jumble of objects with no pattern to it. This is a little frustrating because I do see patterns in it, yet even I have to agree

that they are complex and there is no single pattern that drives the image.

Simpler images on the other hand, are much more popular. You even risk confusing art experts with a complex image and would do well to get some feedback on a more complex image before considering it for a portfolio or publication, a contest or a gallery.

I happen to think that upon further inspection, the complicated image above offers more than some of my simpler more popular images, but if the viewer is not lured in by that first impression, it matters naught.

It's very hard to resist the idea of "more is better", and to be fair, when we pare down the

"items" what is left may not be strong enough to stand on its own. When this happens, we need to find a way to compose these several items into a coherent whole. If we can't, we don't have a photograph.

Here is a little exercise. It will cost you a magazine—one that features many outdoor pictures. It could even be a National Geographic.

Go through the magazine and cut out some interesting features that don't look too odd together. Don't worry too much about how tidily you cut them. Try to collect at least a dozen. It might be trees, rocks, water, grass, or clouds.

Now, make yourself a frame out of rulers or sticks or paper, so you have an "image" area of about 15x20 inches (40x50 cm). Randomly toss the cutouts into your frame making sure all are facing right side up, rotating them so that the tops of each are all toward the top of your frame. See if you like the patterns that were made. It is rather unlikely that you will come up with anything interesting the first time out with a random toss.

Next, see if you can rearrange this dozen or so "objects" in any meaningful way, which you will find is not easy.

Now eliminate half of the "objects" and place the remaining ones in ways that make them work off each other. It's getting easier.

You now take a plain large sheet of paper and draw a bold line with felt pen. Your line could be a diagonal, a sweeping curve, or an S-bend. Place a few of the cutouts on the paper and use the line drawn to place the objects in such a way that the line ties your items together. These objects could be at either end of the line, on either side, or cupped by the curves of the line. They could sit on the line itself. Move them around until you see pleasing patterns. This is getting better and better.

▲ Johnsons Canyon Complex
What if I can make sense of the pattern of things in the image but no one else can? Complex images are harder to make sense of, but that doesn't mean I can't challenge the viewer now and then.

Photography is much like this exercise; only we usually can't pick up and move objects either because of weight, anchoring, or simply due to lack of time. Our options are to reframe or to move our viewpoint in such a way that it changes the relationships of the objects within our frame. If we can do so successfully, we have a picture. If we can't, we need to recognize it and move on.

Does an Image Need a Center of Interest?

It is generally assumed that a photograph should have a center of interest (or possibly more than one). In fact, some viewers will automatically reject any image that doesn't have one. That being the case, are we obliged to

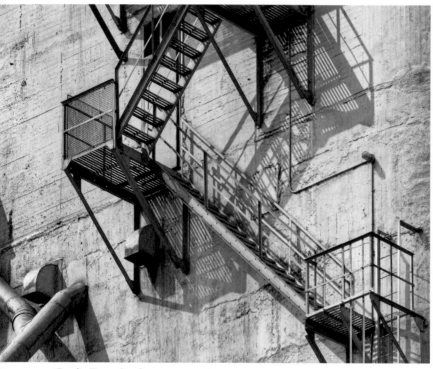

▲ Grain Terminal
The repeating diagonal lines make this image interesting.

other, but the fact that they balance each other means there is an implied connection, and one's eyes are drawn back and forth. If the eye sees an object with certain characteristics, it tends to seek out and recognize other objects with similar features, so again, a line is not needed connecting one to the other.

The most obvious examples of images without a center of interest are those recording a recurring pattern. It can be a series of independent different shapes, which nevertheless share certain characteristics.

Without a center of interest, holding the eye of the viewer is that much more challenging: The pattern has to vary or there must be detail within detail. I saw a Chip Forelli image the other day—ripples of sand on a beach with cloud reflecting. The ripples faded out from bottom-right to top-left and the cloud became stronger. These variations on a pattern offer the viewer more to enjoy, and a reason to linger for a while or simply to come back often.

always have center of interest so that we can please the greatest number of viewers?

While I have written that images should not be too complicated, by the same token, I don't think we need to "dumb down" images in order to please absolutely everyone. The necessity of a center of interest is, I believe, one of those areas which, if handled well, you do not, in fact, have to follow the masses.

How do you go about keeping your viewer's interest if there isn't a center of interest? First and foremost, there must be a connection between various items in the image, usually involving lines, e.g., edges of objects or shadows leading from one part of the image to the next so that our eye can follow this imaginary path throughout the image.

Simply balancing two centers of interest on either side of a line can be one way to connect them. There is no line running from one to the

How Close to Perfect is Needed?

Let me state outright that perfection and greatness have very little to do with each other. Dorothea Lange's Migrant Mother image is poorly focused (the shirt is sharp but the face isn't), but that isn't noticeable from normal viewing distances and small prints, and is completely irrelevant to everything the image means anyway.

Perhaps this means that the greater the image, the more likely we are to forgive lack of perfection in the image. Maybe that explains why boring photographs need to be shot with a 4x5; if they aren't very interesting, they darn well better be real close to perfect.

◄ **Construction Underway**
In this image the shapes aren't as important as the colors, providing strong contrast with orange and cyan (blue/green).

Could it be that we spend too much time working on perfection, and perhaps not enough on greatness?

Images may have imperfections that are minor and in no way spoil the experience of looking at the photograph. Oddly, the size and obviousness of the imperfection can have little to do with how disturbing it can be. A noticeable imperfection that was simply part of the scene and unavoidable is just a fact of life

and may well be acceptable. A tiny flaw that only the photographer notices can really spoil the image for themselves.

There are flaws, damn flaws, and fatal flaws.

Let's describe a theoretical picture. This picture is of a rock formation that is rounded, smooth, and sensual. The image makes you want to reach out and hug the rock, to stroke it and caress it. You are proud of the image and

▶
Rebar Stacked
My first reaction on seeing this was "too new", then "those labels spoil the image", then "those labels make the image". There were enough of them to form a pattern and so add to the image. Were there only a few…

▶
Windshield in Rain
First I saw the pattern of the rain on the windshield. Only on getting my camera did I notice that the subtle details of the car interior added to the image.

excited to be working on making a good print which will show off this image to its best.

In working on the image in Photoshop at 100%, you notice that the top of the rock is out of focus. When you print, if you look carefully, you can see that you didn't quite get the depth of field right. In every other way, the image is gorgeous. When shown to non-photographers, they think it's great. When you point out the lack of sharpness at the top of the rock, they have no idea what you're even talking about.

When you show the image to other photographers they like it. They can see the lack of

sharpness if you point it out, and they may commiserate with you. The problem is, YOU know the rock is out of focus slightly and it bugs you. You think of it every time you look at the image. So, do you reject this image from any submissions, portfolios, or shows? Or do you tell yourself to get over it and enjoy the image?

It seems to me there are some minor flaws that don't weaken an image, and while they might be less than ideal, the flaws don't detract from the enjoyment of the image, nor do they magnify your irritation the longer you spend with the image.

Other flaws may be small but they niggle at you, and the irritation only gets worse the longer you try to persuade yourself that the image is OK. It may be that a flaw that drives me batty doesn't bother you at all, and the other way around, as well.

Perfection and greatness are not one and the same. Perfection is relative and is pointless without greatness, but the opposite is not true. You can have greatness without perfection. Hmm...

The types of flaws most likely to bother you are those which could have been easily avoided at the time of capture. However, for a number of reasons you didn't avoid them, and inevitably, they will grow in magnitude and haunt you forever. Flaws in composition caused by simple mistakes, e.g., a situation where moving just a few inches to the left would have avoided a problem, are good examples.

Limitations of equipment (and even physics) can perhaps be disappointing. If you can't make a 30x40 inch print look great, yet the image looks absolutely stunning in a 5x7, so what? You did the best with the equipment you had, and if the background is a little soft because you didn't have a tilting lens and

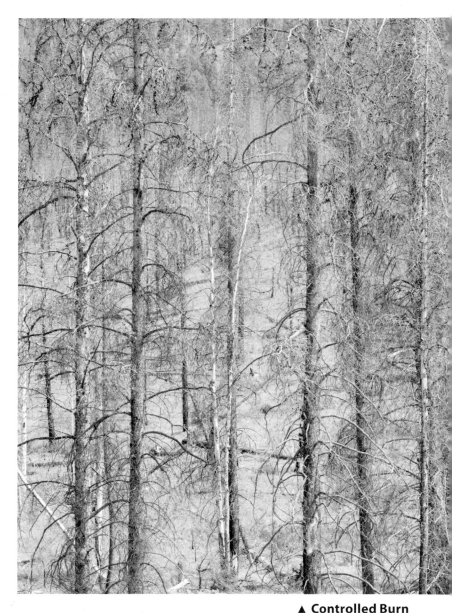

▲ **Controlled Burn** The pattern of dead trees left behind in a national park after a prescribed burn made for a simple, yet elegant texture.

stopping down wasn't enough, that is OK. Enjoy the image anyway.

In composing images, we try to make as many elements in the image work off each other as we can. It might only be one pair of objects, but would two pairs be better? Sure it would. However, since we could go for three, then two isn't perfect either. The truth

▲ Oriental Poppy
By moving in close and eliminating the edges of the flower, it has a more abstract and exotic look and a view that many don't bother to take.

is, there is no such thing as perfection. With that said, it is possible to create a great image in which absolutely everything works, and adding better shadows or highlights, greater depth of field, or slightly better lighting would not improve the experience of the image. The image would be better in theory, but the image works as it is.

It's necessary to learn when enough is enough; when it's time to say, "That will do", and hang the image. Although you may change your mind days, weeks, or months later, for now the image is the way you want it and you are happy with it. Let the world enjoy it!

Artists must learn when to stop messing with their work—when it may not be perfect, but they are willing to call it done, put their name to it, and show it to the unwashed masses.

How can you tell when enough is enough? I think you start by having your past work set your standard. Any new image is going to be compared to that level of quality, and any new

image that is significantly inferior to your former work is not going to please you. This means looking harder at a scene and walking away more often, refusing to even try for an image because you know before you shoot that it will not work. If you struggle to effectively arrange two objects in an image, then just about any pretty image will please you. If on the other hand, you routinely have half a dozen carefully placed objects in the image which are working off each other, then you are hardly going to be pleased if only two of the elements work and others just sit there.

For me, the standard for new images is this: With appropriate editing it is possible that this image could go in a portfolio with some of my other favorite images. Although it may be unrealistic, I hope that each image will be better than the ones before it.

It is human nature that one's skill level will tend to peak occasionally, and then will return to its normal level. Gradually, the peaks become more frequent (with some still higher than others), and eventually the "normal" level becomes consistently higher. Thus, with any new image, it seems acceptable just to achieve one's normal level of accomplishment, and more than likely you won't be able to tell whether or not it is a new peak; not until you edit the image and produce some prints.

Decisions and Compromises

It is rare for a scene to perfectly unfold before you with obvious boundaries for framing the image and a clear indication of the strongest shooting position. In my experience, what happens in the real world is that if I move left, that rock shows nicely but then I have a problem with the bush. If I move right, the bush

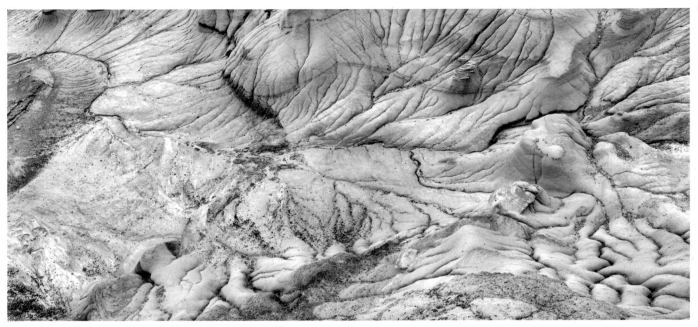

▲ **Dinosaur Provincial Park** I haven't become bored yet returning to this fascinating landscape. It's common for a photographer to have a favorite place to visit and in which to create.

is hidden but I lose the curve of the rock, and on it goes—one compromise after another. Sometimes the compromises are such that you have to walk away, or at least that image doesn't get used. Other times there is a solution that results in a strong image. The image that requires no such decisions is unusual.

This discussion raises the following questions:

- Do great images only come from images that required no compromises?
- Would a different photographer have more or less trouble making the right decisions? Would they find an uncompromised solution?
- Is there something we can do to help the process of making decisions?

It is not normal for us to be aware of any compromises made in great images. After all, we are not made aware of what good stuff was left out to eliminate something bad, since neither shows in the image. Since we are discussing great images here, presumably whatever was left in was of sufficient merit to rate this approval.

If on the other hand, something bad was left in so something good could be included, and we still think it a great image, then either it wasn't much of a compromise in the first place, or the photographer was able to minimize the impact of the problem; maybe through filtering, printing, or possibly even cloning.

You learn through experience which types of compromises you can live with and those you can't. Some won't be obvious until you have lived with the image for weeks; other times you know before you press the shutter that this compromise "won't fly".

It is almost a given that not all photographers are created equal in regard to making decisions and settling on compromises. Some are bold in personality and are used to making snap decisions: If they happen to be

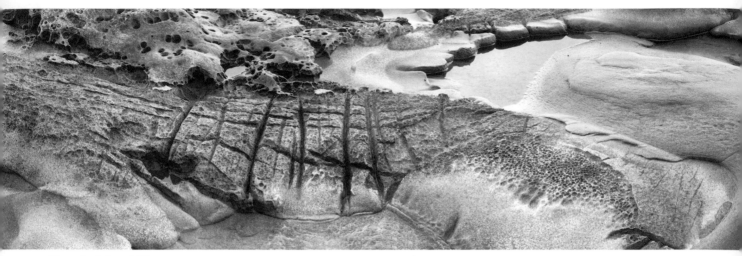

▲ **Hornby Island Shore**
This is the original multi image stitch which subsequently provided the one image crop which is more powerful. There is a lot going for this image, but almost too many elements, and they don't quite work together. Various croppings have been tried before the portfolio version was made (see page 94).

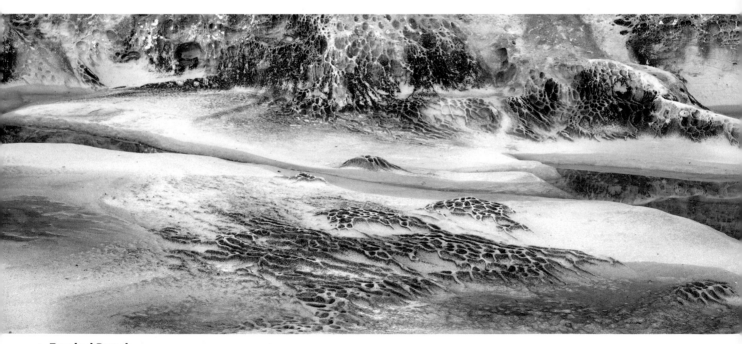

▲ **Eroded Beach**
Simple design and elements of an S-bend in the curves can make a good image.

wrong they are quick to forgive themselves and move on. Others are insecure, second guessing themselves, and worrying whether they got it right long after the shot was taken. We know for ourselves that on some days we make those decisions quickly and confidently, and on other days in similar situations we are indecisive. Therefore, it would seem reasonable that there must be differences between photographers. It may be easy for a beginner to make the image since he is not even aware of the subtle elements about which the more experienced photographer is agonizing. It's more than possible that the photographer who couldn't decide and gave himself two negatives from which to choose will be the one returning with the great image, so it isn't a given that boldness is best. I would argue that more images are spoiled by the addition of a distracting element than by the elimination of something nice, so all things being equal, it's better to go with the "less is better" image.

Sometimes you don't have a choice of positions through geography or timing, and you have to make the best of the situation. In this case by eliminating as many of the distractions as you can with appropriate framing, and hope that the other distractions can be minimized in the editing and printing.

To be fair though, we need to remember that elements may be distracting because they stand out from the picture in a 3D world. Perhaps with one eye closed, the element is not at all distracting. Maybe the element is distracting due to its color or brightness, which can sometimes be corrected in image processing and printing.

Your Options

Suppose you have an image that has a lovely S-bend in a path, but to include the full sweep of the curve you are also stuck with a skinny tree in your frame. You can move forward, but you lose some of the S-bend, so that won't work. You move back and the tree is included. Perhaps, if you move really far back and shoot with a long lens you can eliminate the tree. Could you climb high, still see the S-bend, but minimize the effect of the tree? Are you certain that shooting from the other end of the S-bend won't work? Perhaps you should check it out and photograph from the opposite direction. Is there a way you can live with the tree showing, perhaps by balancing it with something on the other side of the path?

Depending on your position, it doesn't have to be another tree; it could be a clump of grass if you are low enough. If the tree is mostly green, can you blend it with the background so it isn't as obvious, perhaps with some careful image editing. Just maybe this S-bend isn't going to photograph well, at least for now. Do you have the strength to walk away when you recognize that any image taken will be fatally flawed? Walking away can be difficult, especially if it's a great S-bend, if you spent considerable time on it, or if it is the only thing you found worth photographing in a couple of hours and you are getting desperate.

Many other compromises occur. If you duck down low you eliminate that ugly item in the background, but now the foreground becomes problematic, not the least of it being a lack of enough depth of field. If shooting action, exposure can be a compromise: Do you favor the shadows or the highlights? (Generally in digital imaging, clipped highlights are more problematic than showing detail in shadows).

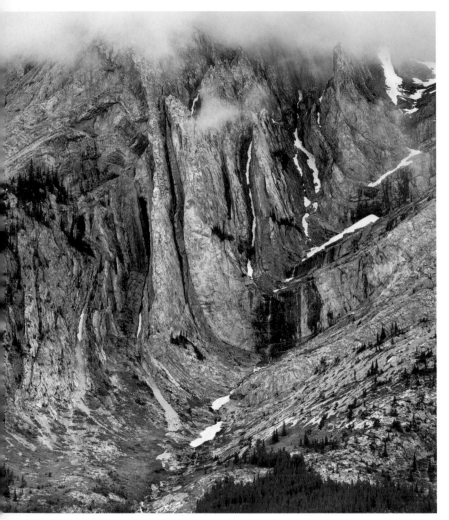

▲ Mount Kidd
I loved that lush green on the bottom, but in the end it doesn't really work as well as the simpler composition shown next.

Sometimes even timing can be a compromise. Do you wait in the hope that a particular cloud moves into the right position or do you accept the image as is? The wind isn't too bad, but perhaps if you wait longer it will die down. Waiting is reasonable, but so is moving onto greener pastures.

There are no right or wrong answers to these compromise questions. You make your choice and hope for the best. Where practical, you can give yourself a choice of images from which to work, some with and some without

the areas in question, shooting from two possible positions, and so on.

Beginners aren't aware of the compromises, novices don't know what to do with them, intermediates struggle to decide which is best, and advanced photographers know when to walk away.

Where Should You Point the Camera?

When shooting the "grand landscape" there is often only one place to aim the camera and the issues center around timing and where to plant the tripod more than what to shoot. But a common scenario is to be wandering around looking for photographs in an area of interesting material. This could be an outdoor farmers market, an old abandoned industrial plant, an interesting bridge, a canyon, a field, an abandoned farmyard, a street somewhere in an exotic country, or a junkyard. It could even be a nude.

Where do you point the camera and how much do you include? Are there any rules, guidelines, suggestions, or tips to help?

Common to all these possible subjects is the need to make order out of chaos. An attempt to photograph the whole often leads to disappointment, leaving the viewer with none of the excitement you felt while there. A picture of an entire bazaar in Morocco would look more like an illustration for a report on traffic congestion. It wouldn't even make a good travel brochure illustration, as it lends nothing of the experience of actually being there.

To make a good travel brochure picture, you would want to show one or more vendors and their wares, colorful clothing, and exotic backgrounds. You probably wouldn't include the tacky tourist in the awful hat, loud shirt, and

bad shorts. As a creative artist though, you might want to make a study of tourists and their garb. If you did want the vendor, it would be because of an interesting face, patterns in the wares displayed, an interesting shadow across the scene, repetitive shapes, appealing color contrasts, etc.

Let's imagine a less exotic scenario. You are wandering around a junkyard. There are heaps of rusting cars, piles of old parts, broken glass, puddles of dubious liquids, and scattered around, people searching for treasures amidst the junk. Your aim is to produce a series of pictures that represent the "junkyard" experience.

Here, I want to address the problem of finding something to photograph rather than fine tuning composition. I think you can imagine without too much difficulty two camera carrying photographers wandering through the junkyard. One is a hobbyist of little experience and no background in art. The other is Cartier Bresson reincarnated. The novice wanders through while randomly taking snapshots of colorful piles of junk, gets bored, and heads home, having decided that the problem is the junkyard. Once home none of the images look even vaguely interesting.

The other photographer is kept extremely busy, and in fact is frustrated when, at the end of the day he is asked to leave, the gates are closed, and he goes home tired and happy. On looking at his images, he sees that many show the elements of good photographs. More to the point, he had no trouble finding subject matter.

A common phenomenon is a hobbyist photographer heading to a location previously shot by one or more of the greats. They attempt to recreate some of those images and

▲ **Kananaskis Clouds**
This simpler image includes only the essentials and is all the stronger for it. It may not be as pretty, but it's more powerful.

are sorely disappointed that their prints look nothing like what the master had produced.

A further problem is that sometimes people are wowed by the majestic photographs made by highly skilled photographers, only to visit the locations themselves and find the actual location disappointing; the mountains don't look as high, the river seems smaller, and the scenery appears less spectacular. It's not that the greats somehow stretched the mountains in the darkroom. It's that they created order out of chaos, and other elements do not distract from the majesty of the mountain. The photographer knew how to get the best out of what he had available. Half Dome at noon is not nearly as exciting as it is late in the day.

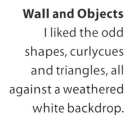

► **Seaweed**
I'm quite proud of this image. I planned it out, predicted the effect, and then achieved it. Shutter speed and polarization were critical to the success of the image. You can't see the blurred movement in the viewfinder, so experience is necessary.

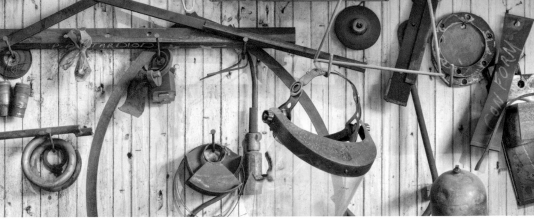

► **Wall and Objects**
I liked the odd shapes, curlycues and triangles, all against a weathered white backdrop.

How then does one find good images? It isn't possible to give specific directions, since clearly it will depend on each individual situation, but there are some guidelines that might be useful.

Framing Your Images

Edges and corners are extremely important real estate. Edges can act as the overture to the image, but they also set off the center of interest, return your eyes back to the important parts of the image, and in good photographs, are interesting in themselves. It would

◄ Athabasca Falls
In this case stitching made for a square image, rather than having to crop – the preferred technique when practical.

not be unreasonable to spend as much time setting up the edges as the rest of the image. If you photograph an interesting subject and handle the edges well, you are already most of the way to a really good photograph.

To properly discuss the art of framing a center of interest, we have to deal with the issue of cropping. After all, without cropping we are doomed to copy the format of our current camera. Therefore, before moving on to discuss how you might handle edges and corners, I will present some of my thoughts on the issue of whether or not to crop.

The Art and Religion of Cropping

The following discussion is very much a matter of my opinion and beliefs, and such works well for me. If it doesn't work for you, that's OK. But perhaps you haven't really thought the issue through, and therefore, I offer the following for your consideration.

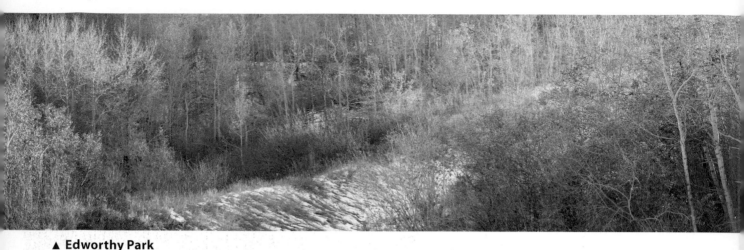

▲ Edworthy Park
Not even a 6 x 17 camera is going to fit this image perfectly. I woudn't want more on top or bottom, nor to lose any at either end, yet that is what the "no-croppers" would have me do – or not take the image in the first place – which would be a pity.

To Crop or Not to Crop, That is the Question

Some people are dead set against cropping, claiming to get framing absolutely perfect every time, and believing that all images should match the format of their camera. Nonsense! Well, mostly nonsense.

The following are four points I think most of us can agree on and will provide a starting point for this discussion:

1. Throwing away pixels (or film) from both the height and the width of a single image simply means you can't print as large, and is to be avoided whenever possible. Some of you would disagree with that "whenever possible", and would instead say that cropping in both directions must be avoided "at all times". You might argue that it is only sloppy technique that results in having to crop in both directions, but I disagree and will address this further on.

2. Throwing away pixels from only one dimension of an image changes the aspect ratio of the image, which some believe is taboo. This thinking is rather like religion—you either believe or you don't—and common sense and logic have little to do with it.

3. Cropping ever smaller in the hope that somewhere in there is a great image, is the mark of a beginner and is to be discouraged. Besides, it almost never works and so we all give it up sooner or later.

4. Cropping less than 10% of an image to improve composition could be considered fine-tuning and should be perfectly acceptable to most people (especially if you don't tell!).

Let's tackle the issues of image aspect ratio. Some photographers feel that making good images is difficult enough without thinking about an infinite variety of aspect ratios; from long, skinny panoramas, to square, and then onto vertical. They prefer to work within the rigid boundaries of their viewfinder or ground glass, which provides an edge against which to compose.

They may admit that there are square images they can't take, because they are shooting with 2:3 ratio cameras. Yet, they like the discipline of working within the constraints of their "pet ratio" enough to ignore any disadvanages. This is akin to a black and white photographer

saying, "Sure, color can be nice, but I'm concentrating on the wonders of monochrome, so please don't distract me with talk of color". They are often loath to throw away any part of the framed image, in either direction.

Formats and Aspect Ratios

Traditionally, 35mm film shooters cropped fairly often, but 8 x 10 inch shooters almost never cropped, wanting to take advantage of every millimeter of film surface at all times. There are even shooters who prefer square images and have a bar built into their camera to force the 8 x 10 inch back to record only 8 x 8 inch format. I believe David Fokos is such a photographer and it certainly works for him with some lovely images.

Oddly, many "full formatters" commonly change cameras, and with each camera comes a different aspect ratio. Thus, they can't even make the argument that only 5 x 7 is right (or 6 x 7 or 6 x 6 or 6 x 9 or whatever ratio they happen to be using at the time), and that this day's ratio is the only true religion, and worshiping all other formats is blasphemy. On that basis they would blaspheme every time they made a switch. They conveniently worship the aspect ratio of the day, based strictly on whichever camera happens to suit the subject or their mood. They may shoot the 8 x 10

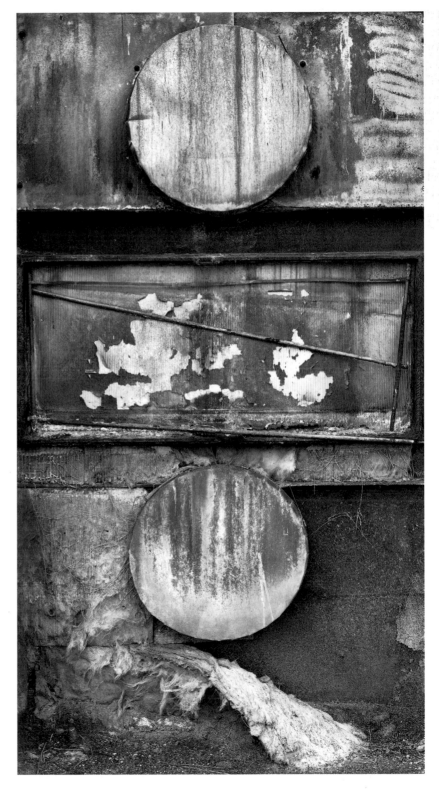

▶

Two Circular Doors
Old industrial sites can offer fascinating material, in this case a three image stitch to avoid cropping. I confess I do crop a bit more often since I have a higher resolution camera, but still do a lot of stitching.

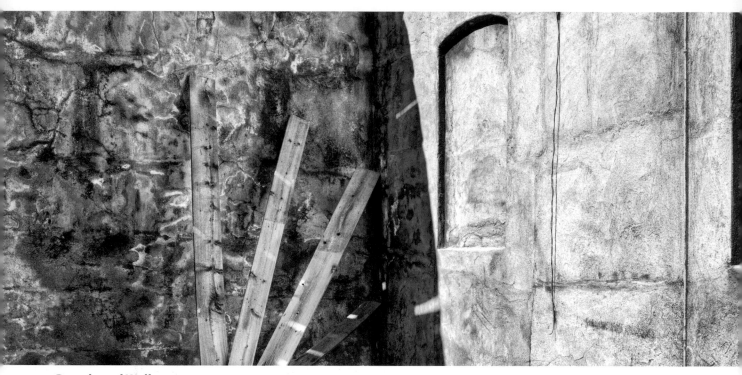

▲ Boards and Wall

In theory, when stitching, you can leave defining the left and right ends until later so long as you include a bit more than you need. But you risk finding that there are NO really good places to crop to, so planning ahead remains essential.

around home; but due to its light weight, they take the 5 x 7 on hikes; for multi-day trips the 6 cm x 17 cm is appealing; and when traveling internationally they opt for a 645; each time bowing to the viewfinder and camera designer to determine the shape of each and every one of their photographs. In my opinion this is just plain silly, and I will tell you why.

It may be easier for some to compose using the hard edges of a viewfinder, but it is not something that must be set in stone. Just two simple pieces of L-shaped cardboard can provide an infinite variety of aspect ratios.

Furthermore, when stitching, we are not tied to the aspect ratio of the viewfinder, because we can stitch together two, three, or even a dozen images, resulting in an endless variety of aspect ratios.

There is nothing more frustrating than cropping carefully in the viewfinder, only to later

find that you cropped just a hair too tight and the lines you thought met in the corner didn't quite make it into your image, or a circular shape that was supposed to just kiss the edge has been just a bit cut off.

While some cameras have very accurate framing, many others don't, and the miniscule 2-inch LCDs, and even smaller viewfinders, are hardly ideal for critical alignment. Thus, it is advisable to give yourself just a little extra room to guarantee that you won't lose an important part of the image. Having done so, you can later crop as little as 1-2 percent to achieve perfect framing. In fact, many SLR viewfinders only show 90% of the image that is actually captured on the sensor in case the photographer is a little careless (at least that's one way to think of it).

It may be easier to learn to see in a particular aspect ratio, but frankly, I find it hard

enough to find good photographs of any aspect ratio without feeling that I have to walk away from nine tenths of them just because they don't happen to match the aspect ratio of my camera. Worse yet is forcing an image into the aspect ratio of your camera even though it would have been better and stronger at a different ratio. (Want to bet that never happens? Yeah, right!)

What About Cropping Both Ways?

I will admit here that I sometimes do crop both ways. My goal is to create the best possible image, not the largest possible image. If I see a better way to frame an image after the fact, then I think it is silly not to do so. If I were to trim a fair amount off (say more than 10%), and do it very often, then I would be rightly accused of sloppy work. But, cropping small amounts now and then to strengthen an image is perfectly reasonable.

Sometimes I don't have a choice. I find this happens more often than I ever would have predicted. For example, I may be standing at the top of a ridge, which means I can't move back and I can't move forward without risking life and limb. If I have a zoom lens that exactly matches the framing I need, that is all well and good; but perhaps I want my Canon TS-E 90 mm lens for a tilt, my 50 mm macro lens because it's sharp, or my 300 mm lens (when what I really need is a 320 mm lens, but I don't have one).

Occasionally, I will throw away half of an image if I think the remainder is really worth it. I sometimes later find that the image I saw is not the best possible image, so why shouldn't I take advantage of the available tools to improve it? Darn it, I don't have to admit that I

▲ **Stream Edge**

An unusual way to frame an image, but it generates a lot of positive feedback, so apparently many are comfortable with this way of presenting a scene. I certainly had the sense I was breaking sombody's rule as I shot it.

▲ Front End Loader

In this case I didn't frame as well as I might have at the shoot, so had to crop after the fact. But with the surround, it's just a piece of equipment, framed tightly like this it becomes a modern sculpture, almost abstract in form.

cropped an image. No one will ever know unless I fess up. I would much rather have a really great image that I can't print bigger than 9 x 9, than a mediocre one that nicely fills 13 x 19 paper, thank you very much.

Some subjects beg for panoramic treatment, but a 3:1 ratio is pretty long and narrow, and if an image is better at 2:1, I see no reason not to go with that. Even Tillman Crane, who lugs a 12 x 20 camera around to get the biggest pos-

sible negative, is known to occasionally crop to make a better image.

All of the above aside, I do happen to think there is something special about square images. There is only one aspect that is square, and there is something special about images that work perfectly in this format. Does this contradict all that I have said above? Sure it does! Do I care? Not much. I reserve the right to be rigid about my flexibility. So there!

While I have a particular fondness for square images, I personally don't make a conscious effort to trim images to be exactly square. If my images happen to frame better with a half inch more width than height, so be it.

Despite believing all of the above, there are significant advantages to using a fixed format. For example:

- If all images are the same shape, it can make mounting, matting, and framing easier.
- When hung, the consistency in format means images have a greater chance of looking good together.
- Consistency in ratio makes designing web pages easier.

And that's about it for advantages! Frankly, I don't see anything on this list to convince me that adhering to a fixed format is the right way to go.

Back To Framing

With that behind us, how do you go about setting up the edges of an image? In the following section I offer some suggestions for help with framing, an outline of the purposes of framing, then some specific strategies for using the edges and corners of your images.

Framing Assistants

Since cropping and framing are so important, it's certainly worth looking at some possibilities for defining the edges of the image. Of course, the viewfinder is your first and most obvious framing device, but it is less effective when stitching, since you can only see one part of the image at a time. Therefore, something else is helpful. And, if you do plan to crop part of the image, then defining the edge while shooting may be important.

My normal routine is to carry a viewing rectangle hung from a cord around my neck. While looking through it I can instantly zoom from wide to far, flip horizontal to vertical, and with my other hand or with another piece of plastic, I can crop to change ratio. I constructed mine out of 1/8 inch thick styrene (available from hobby stores) after bashing several cardboard ones, but wood, cardboard, linoleum, polyethylene, or just about any material you can cut would be suitable.

A card measuring about 4 x 5 inches with a good-sized opening works for me. I have tried using an 8 x 10 sheet of cardboard, but while the edges are better seen, the card is rather large and cumbersome, and for telephoto shots you need an assistant to hold it several feet in front of you.

If I weren't so lazy, I would paint one side of my viewing rectangle white and the other black, because the surround can affect the appearance of the image. A black surround (like a DSLR viewfinder) tends to make the image look more impressive, whereas a white surround deemphasizes the image and makes the image work for its glory. My framing rectangle is white.

These days, I recommend using a compact digital camera with zoom, black and white

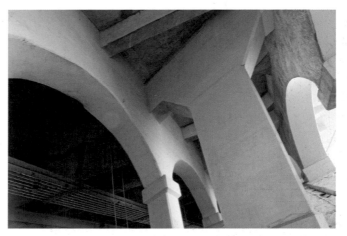

▲ **Center Street Bridge, Uncropped**
My chance to stitch in a very tight location, removing a significant part of the image is essential to a strong photograph.

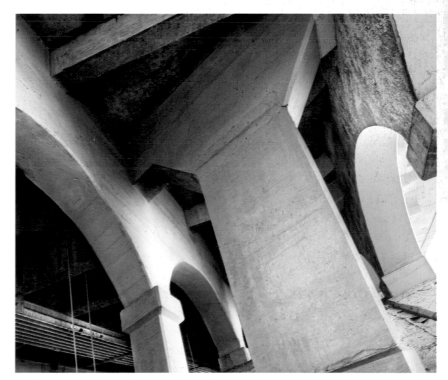

▲ **Center Street Bridge, Cropped**
The image is just right along the bottom, but I do wish I had a little more head room to complete that triangle formed by the top of the pillar and the beam reaching out to it.

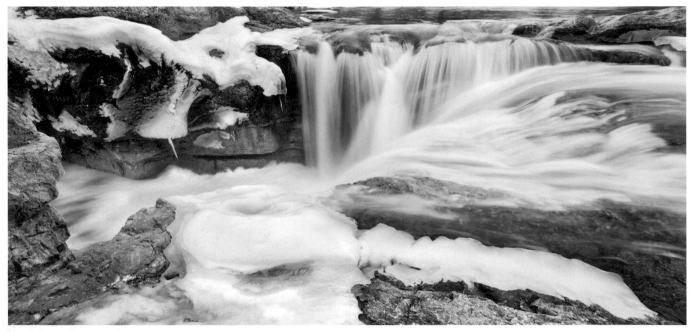

▲ **Elbow Falls**
There is about a 10% crop here to fine tune the framing— a matter of deciding later that trimming from the right and bottom made for a stronger image.

mode, and a large LCD screen (say 3 inches). This is especially helpful to someone using a view camera and black and white film, but can also be helpful to a DSLR user.

A reader of my blog thoughtfully pointed out that if you shoot RAW (and why wouldn't you?), even if you set the camera to black and white mode, the images are digitally stored as color, preserving the ability to "filter" your images in Photoshop. This way you get the LCD showing black and white, but have the best of both worlds.

There is something different about looking at an image on an LCD screen, as opposed to looking through a viewfinder. One gets a better feel for the strength of the image. You could, in fact, flip the digital camera upside down to emulate the upside down image of the view camera.

Of course, you can (and I sometimes do) use your thumb and index finger of each hand to

make a rectangle. The price is right, it's hard to forget at home, and storage isn't an issue.

What Edges Can Do For Your Images

1. The primary function of dark objects forming a frame is to set up the main part of the image or to keep your eyes from wandering right out of the image. I have never been really sure that just because something is dark it prevents the eye from going on. I suspect the effect has more to do with making the center of interest stand out so you want to go back to it. Edges can be light colored, but remember that paper is white, and unless you plan on using a dark matboard with no paper showing (for the signature, for example), very light edges don't look all that great against the white of the paper, and if there

▲ **Scaffolding Stairs**
There really isn't a center of interest to this image. The edges and the corners are in fact the whole image, with their lines reaching all the way to the center.

is pure white in the edges of the image, then it just looks like a hole in the image.

2. It is better for the edges to reflect shapes in the center of the image in order to re-inforce the message. Thus, angles of lines can be repeated in the shapes at the edges, or they can be opposite and complemen-tary.

3. The edges can literally point to the center of interest. This is especially the forte of corners, which often have lines leading from there to the hot parts of the image.

4. Edges can provide an area of calm sur-rounding a busy center, or they can even occasionally go the other direction and provide lots of detail to complement a very simple center of interest.

5. In really good photographs, there is often as much going on at the edges as there is in the center, and there is much to explore in the image. Therefore, getting bored with the image isn't going to happen any time soon. This can be tricky though. If the things going on don't strongly relate to the center of interest, "busy" is the feel-ing they are going to leave, rather than "interesting".

Working on Edges

With these thoughts in mind, I offer the fol-lowing strategies for first working the edges, then the corners of the image.

▲ Driftwood Eagle
The tree trunks
provide ideal
framing for the
"driftwood" center
of interest. Imagine
how much less
effective they would
have been had
they been perfectly
straight and vertical.

a relationship photographically, not just logically – that is, it should tie in with the main subject in tonality and/or shape, as well as what it happens to be made of. In fact I'll go further and suggest that shape and tone are more important than actual content.

A park scene might look better with a tree providing the framing, but it must appear as if it belongs with the rest of the scene. A single branch sticking out into the sky on one side with no trunk to support it can look very odd. The idea of using the entire tree to frame one side of the image at least looks OK, but the concept has been done to death in many "Improve Your Snapshots" type books, and thus, it would be a brave soul who would try such an image in front of an editor or curator.

Just last night, as I was photographing a road bridge, and I had the option of placing one of the concrete pillars at the edge, or near the edge, of the composition. If I chose to place the pillar near the edge, then the dark recesses of the bridge were what would end up next to the edge rather than the foreground concrete. There was not much detail within this dark area, however, it formed a strong shape being so dark and could be just as much a compositional element as the brighter foreground pillar. Which was better? Only later, during the printing process, after I had printed this area down sufficiently, did I decide that I preferred the pillar at the edge. Because this dark shape was too skinny. It looked like an afterthought.

Your options for working with the edges are fairly simple: You can work with straight or curved lines. If straight, you can have the lines near the edges run perfectly parallel, just slightly off parallel, at an obvious angle, or perpendicular to the edge. My own opinion is that lines that are just slightly off parallel are

Firstly, the edges of the image should somehow relate to the rest of the image in terms of subject matter. It might be convenient to use a tree to frame a subject, but if that subject is, say, a car, unless the car ran in to the tree, there's no relationship. These relationships may be because of subject matter (perhaps using the door of the next car to frame the image of this one, but there should probably be

generally ugly. When I correct the perspective in an image, I am amazed that as little as 0.2 degrees of rotation can be quite noticeable, though I would defy anyone to consistently line things up that perfectly in the viewfinder of the typical DSLR.

A modest angle to the edges of the image can be quite attractive—something in the order of 7-15 degrees—forming a long, slim triangular shape. It seems to be just enough off kilter not to be considered poorly aligned, and just dynamic enough to provide a little interest while not jumping out at you.

Angles that are at 30-60 degrees to the edges can be very dynamic (see page 89, figure 4), providing the image with energy, but this type of composition might not be optimal for a peaceful snow scene.

Curved lines near edges can create some very interesting shapes. Keep in mind that these lines can even be the edge of a shadow. Being the edge of a solid object is not required. A complex, wavy curve that approaches the edge more than once may be a bit much: S-bends do better within an image rather than just along the edges. Instead, look for a nicely sweeping curve.

In the case of the windshield image at right, two curved lines form the roof of the truck, creating a very interesting shape, which is balanced by the marker light and the shape below the window, forming the bottom edge of the image. I could have cropped the bottom of the image so that the shadow of the marker light and the point of that shape under the window both touch the bottom edge, but in this case I felt it better to give them substantial breathing room. Not everything has to meet at the edges or corners. Over doing it can look just a bit too clever and contrived. Hey, I didn't promise this would be easy! Making images is

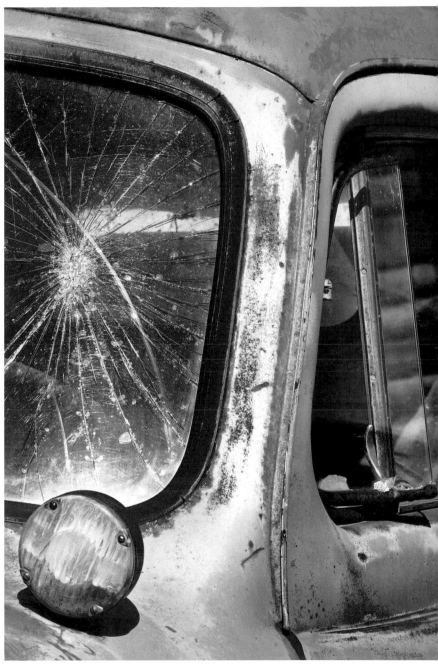

▲ **Cracked Windshield**
See how many shapes you can define around the edges and decide for yourself if this is helpful to the image. (See page 155 for a color version of this image).

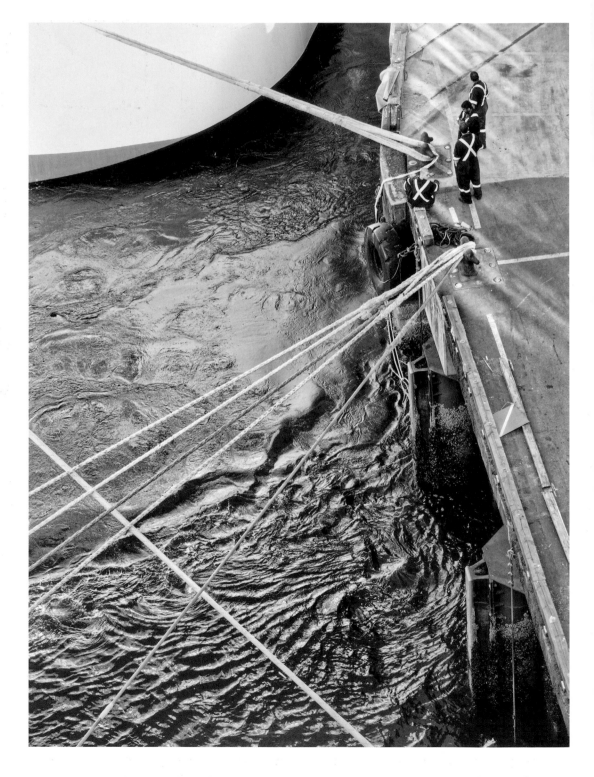

▶
Dock and Workers
Note the angle of
the dock to the
side of the image,
the other diagonal
lines, and the
tones in the water.

hard work with decisions left, right, and center; many of which are compromises.

A curve that runs right around a corner acts as a very effective barrier or framing device, and is just crying for the main subject to be cupped by it. Curves that come close to the edge in the middle and curve away from the edge at the ends seem more stable than a curve that is far from the edge in the middle with ends that are closer to the edge (figures 8, 7). Both of these curves provide a completely different effect. The former keeps your eye in the image (acting like a cup); the latter is more like trying to balance a marble on the top of a dome.

Corners and What To Do With Them

Unless you are using a full fisheye lens or a view camera with a wide angle lens designed for a smaller format so the entire circle of the image is contained within the format, you are going to have four corners to deal with. You can try ignoring them, but it makes more sense to use them to your benefit. In that case, just what can you do with corners?

Compositional lines can lead into the corners; they may point directly at or near the corner, or if there is more than one line, they can straddle the corner. Lines leading to all four corners might a bit distracting, but there could be times when it is both possible and reasonable to implement such a composition.

Lines can run across corners—either straight or curved—such as when showing only a quarter of a rounded boulder sitting in one corner, or a straight line could angle out from a side edge near a corner and run toward the top edge (creating a triangular shape). This can create a particularly effective composition if, in the opposite corner, there is a line leading directly into the corner (figure 2).

Figure 1 Figure 2 Figure 3

Figure 4 Figure 5 Figure 6

Figure 7 Figure 8 Figure 9

Figure 10 Figure 11 Figure 12

You can have lines that come near to both the right and left corners of the top edge, the bottom edge, or both (figures 5, 6). You can have lines offset from the corner in the same direction (clockwise or counter-clockwise) in all four corners (figure 9). You could have a line going from the top edge near the left top corner leading to the right side near the right upper corner, and the same on the bottom. It

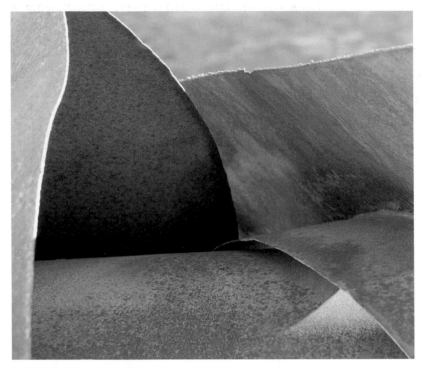

▲ Fallen Smokestack
Pay attention here to how the lines lead into the corner.

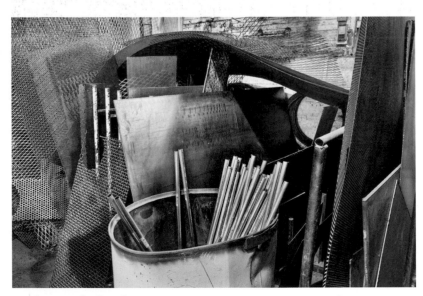

▲ Abstract in Steel
Lines either go to the corner or bracket it. Note the angles of lines and what that does for the energy of the image.

creates a wedge, but other parts of the image could balance it (figure 11). How about having lines going toward the top two corners and actually touching the top edge near the corners, but the lines going to the bottom corners are touching the sides?

Corners can be dark to act as a frame for the central subject, or light to act as balance to some other part of the image. There is something tidy about things meeting in the corner (see image below).

The strategy you pick will affect the overall mood of the image and, to some degree, will control where the eye wanders when looking at a print. The old idea of providing a barrier to keep the eye from wandering out of the print is iffy, but having a line pointing toward something important (i.e., from corner to main subject) creates a very powerful composition and is hard to ignore.

Wide angle lenses lend themselves to working with corners, because natural perspective tends to create lines radiating from the center of the image to the four corners. Objects with parallel lines approaching the photographer automatically do this (i.e., a railroad track).

Look at the example images here and on the next page and note how the corners were treated. Decide for yourself whether it works for you as the viewer, and consider other ways you might have composed the corners, predicting what effect the alternative corner treatment might have produced.

Not every image is going to have important corners, especially portraits and landscapes, but some do. Corners are very important in industrial and architectural images. Go through some of your favorite photography books paying special attention to the edges and corners.

Note that these days, it's pretty easy to modify an image after the fact and to force

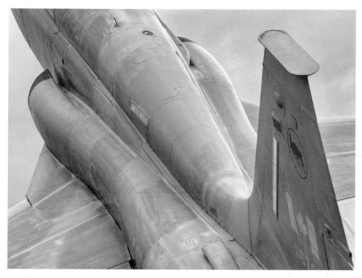

▲ CF5 Jet

Cropping to have something meet two corners works well, but having all four corners aligning with image lines may be a bit much. If those corners that do align are diagonally opposite to each other as here, so much the better.

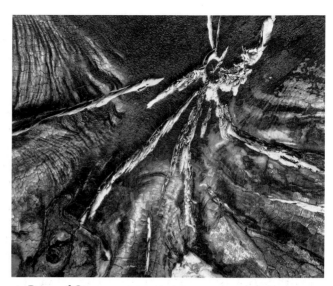

▲ Burned Stump

Almost full frame from a 4 x 5 negative of 25 years ago, a large ground glass can make for more accurate framing, and easier aligning of edges and corners.

lines to meet in the corner, so you really do have to make a decision as to which is best. The worst thing you could do would be to simply ignore the corners all together or let lines fall where they may on the assumption that it doesn't matter.

Example Images—Composing Corners and Edges

Image 1 at right shows varied corner treatments. In the upper left, the spokes point right toward the corner and are balanced in the lower right corner by both a line cutting across the corner (the rod) and the ties coming out from the corner (albeit not radiating). In the lower left corner is the dark space between the spokes, bracketing the corner; and in the upper right there is a shape reaching into the corner, which is wide enough that its two edges bracket the corner. Note too the overall

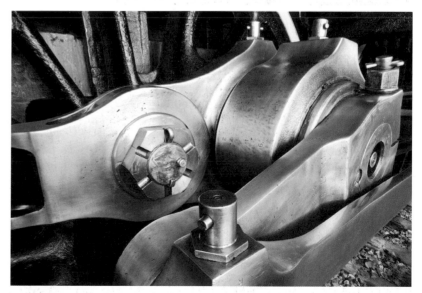

▲ Image 1: Bearing

The driver reaches bottom left to upper right, but the spokes and ties run the opposite direction in the other two corners.

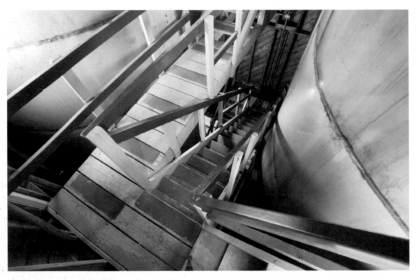

▲ Image 2: Distillery Stairs
This image really makes use of the corners, though in two different ways, top vs. bottom.

▲ Image 3: Bedroom
Only one of the four corners has a line touching it, yet the lines do come close and are, I think, very important to the image.

diagonal design created by the drivers (lower left to upper right), which are balanced in the upper left and lower right by lines going perpendicular to the bright metal shafts.·

In image 2 at left, we have the two lower corners with lines running exactly into the corners, while the curved lines of the seams on the whiskey tanks bracket the upper corners.

In image 3, only a single line in the upper left goes toward a corner. The other three corners are bracketed with repeating trapezoid shapes anchored in each corner: The cupboard anchored in the bottom left corner, the doorway at the bottom right corner, and the ceiling at the upper right corner. While there are only three of these repeating shapes in a four-cornered image, they seem to work well together.

In the bottom of image 4 the lines come right into the corner, but on the top they bracket the corners. I could have framed it in such as way that all four corners had lines pointing into them, but I prefer it this way.

Cropping For Good

The pair of images on page 94 provides a good example of cropping to improve on the edges. First, note that the cropped version lost only about 50 pixels in width (in an image that is over 3000 pixels wide), which is less than 2% of the image. On a 2 inch LCD, this amounts to .04 inch or 1 mm. In other words, not very much and hard to adjust for when framing. Most camera manufacturers would be pleased to offer framing that is accurate to within 2%.

Despite the small amount of cropping, I think there is a huge difference between the two images. In the full size image, the peaked rock at the top right of the image comes to its end and there is a fairly bright border to it. The

top of the rock does reach the top edge of the print. In addition, there is a fairly bright band across the top left of the print, which looks OK against a dark background, but which I suspect is going to look a bit odd against the white of the paper or matboard.

Note that in the cropped version, the peak of the rock in the upper right comes close to the edge, but doesn't touch it. I felt (rightly or wrongly) that this was important: The rock should be associated with the edge, just not sitting on it.

But what if it had been the other way around? What if I had not given myself that 2% breathing space, and in the end I realized that I would rather have had just a tad more room. The same image shows that on the left edge, a third of the way down from the top, those small rocks lining the pool are clipped just a little tighter than I think is ideal. It's looks OK, and perhaps I might have cropped it there anyway, but since I didn't give myself any breathing room on the left, I will never know.

Cropping 2% of an image is inconsequential when it comes to making prints. It is equivalent to losing half an inch off of a 25-inch wide print, which is not much of an issue quality wise. On a 16-megapixel chip, we are throwing away 0.3 megapixels: probably a pretty good bargain to give us the flexibility and breathing room to get the image just right.

Summary

Here are some brief points about framing images.

1. Whatever you use to frame your subject should look like it belongs in the image.

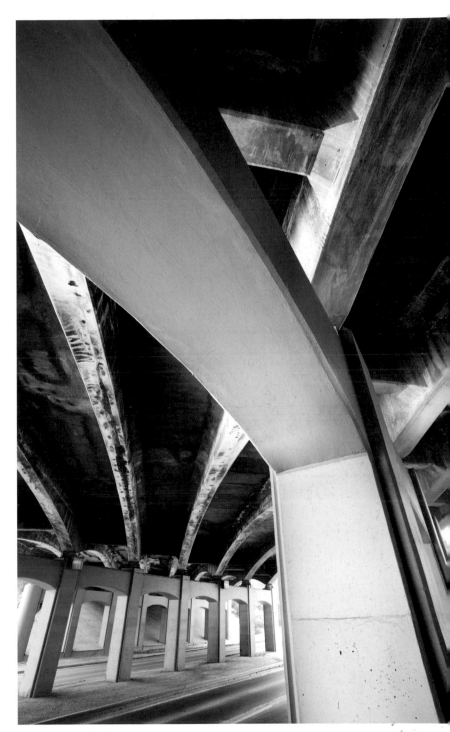

▲ **Image 4: Underpass**
Wide angle lenses lend themselves to strong diagonal lines and use of image corners.

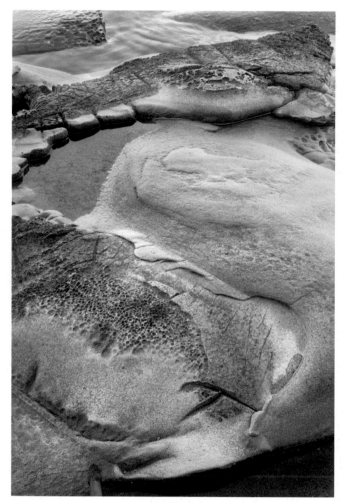

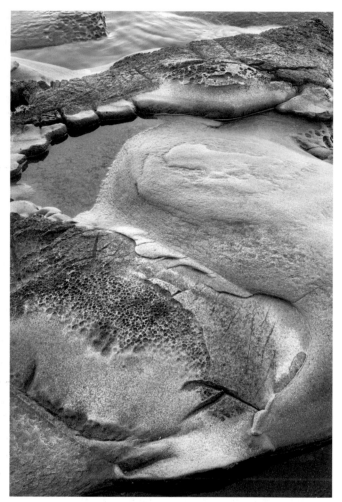

▲ Rocks and Pool, Uncropped
Oops, I didn't notice that tripod leg when I shot it.

▲ Rocks and Pool, Cropped
Subtle differences, but important in my opinion. Note the cloning out of the tripod leg.

2. Framing on all four sides can create a feeling of claustrophobia.

3. Framing as an L, that is, using two adjacent sides, works quite nicely with something less substantial at the opposite sides.

4. What you frame with doesn't have to be an object. It can even be the dark space next to an object.

5. Framing should complement the center of the image, rather than compete with it.

6. Consider how the image is going to be presented when you think of ways to handle edges. White edges next to white paper won't look anything like white edges surrounded by a dark viewfinder.

7. It's one thing for the viewer to wonder what's around the corner: It's another

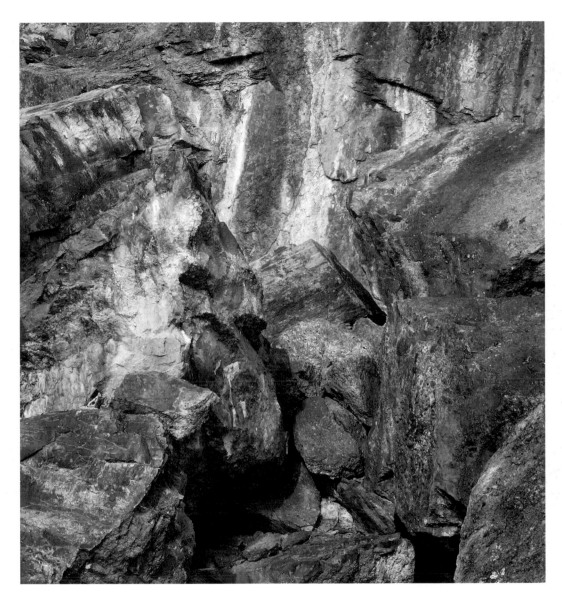

◄ **Rockfall 2003**
Shot with a 6MP camera and cropped in both width and height (I was using my longest focal length lens and shooting across a river), I reshot this in 2005 (see page xix), though with different light and significantly different results.

thing for the viewer to feel that the image is incomplete.

8. Edges don't have to be in focus, but if they are out of focus, they need to be out of focus enough for it not to look like an accident.

9. Corners act as image anchors, but that does not mean you should print them so dark they shout, "Fake"!

In the end, edges and corners are the supporting cast. Sometimes they can play a minor role. At other times they so perfectly support the lead players, that the star couldn't do his performance without them, and it can be tough to know whom to nominate for a Best Actor Award, they so perfectly set up the lead players.

Center Street

I have a "thing" about bridges—I like them for their weight and size, their sweeping curves, their engineering, and for the interesting shapes they make when photographed. This elderly bridge takes traffic from downtown Calgary over the Bow river. I was walking along, looking at the bridge, and wasn't seeing any good images, when I noted a retaining wall above the path and right next to the bridge.

The wall was very conveniently made of concrete sections, stepping slightly back at each level and making for a good foothold. I was able to climb inside the bridge and make two pleasing images. Initially, it was the other image that I liked the most, but there was something about this one which showed promise. I'd made this version color, the other black and white, but once I switched this one into monochrome and did a little work on local adjustments (using Photoshop masked adjustment curves layers), it grew on me.

Without extensive local adjustments this image would have failed. The pillars were very evenly lit and a combination of dodging and burning type adjustments were needed to give the image some character. I cropped off some excess on the bottom and actually had to clone in the top quarter inch of the image as I didn't quite include the meeting of the pillar and the diagonal white line. Does it matter? I liked it enough without adding the top and I could in fact have cropped to the point of the shaded triangle below and not needed to cheat. But, I am not above doing whatever is necessary to make a good image. I don't feel a strong loyalty to the original scene. In my time I have removed fuel signs, garbage, cracks, branches, and people—no animals were hurt in the making of these images—though I'm sure some will disagree with my manipulation of images.

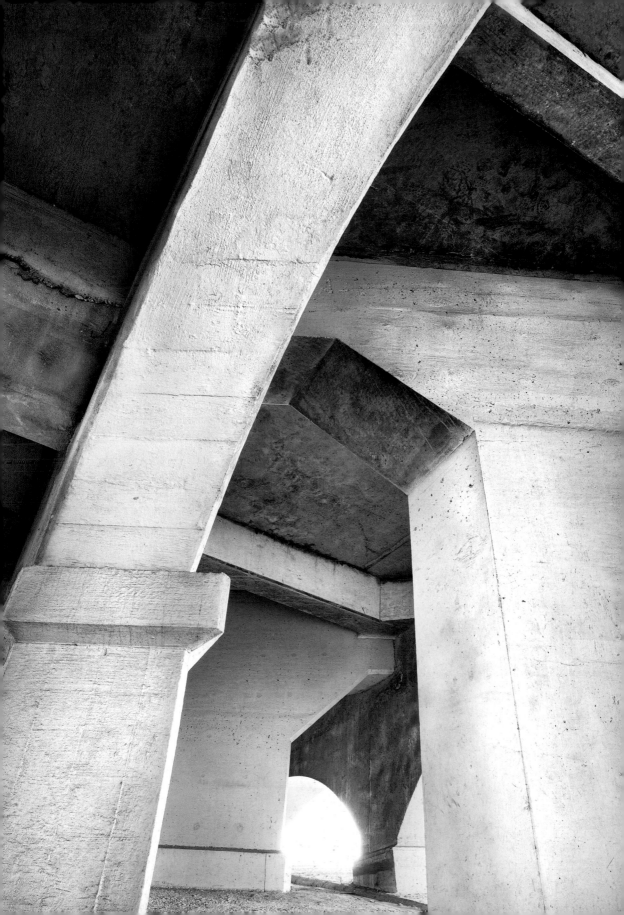

A friend asked my advice about a new digital camera. I made a recommendation and then after a suitable delay, I asked if I could try out his new camera. I wandered near downtown and came across this railway bridge support. The base itself was rather ordinary, but that line of sun sneaking under the bridge, then reflecting onto the concrete, then back to the camera—well, it was just too good to be ignored. I took one shot straight on to the concrete, but with the diagonal lines being more important, the second image on the angle, so to speak, works the best. This has been an extremely tricky image to edit, due in part to the range of brightness that needed taming, while bringing out detail in the rusted concrete without looking over the top.

The version you see here is about the fifth, and I didn't achieve it for two years, trying again and again, often from the original—oh the others were OK, but this is clearly the definitive version... for now. In the early days of digital, people decried it as being fixed—one could simply crank out prints over many years without making any effort or adding any creative input. For me at least, this has turned out be far from what actually happens. Usually, when I come to reprint, I see something I want to change. It may be minor, it may take hundreds of steps, or it might drive me back to the beginning to do the whole thing over. I would estimate that I have spent more than 30 hours working on this image in one version or another.

A commercial photographer has to deliver the image to the customer promptly, but when creating fine art photography there are no deadlines, and the only rule is that I need to be satisfied with the result. Frankly, I'm hard to please (at least that's what my wife says). This trait may not be good in marriage, but it sure is important for creating the best possible images.

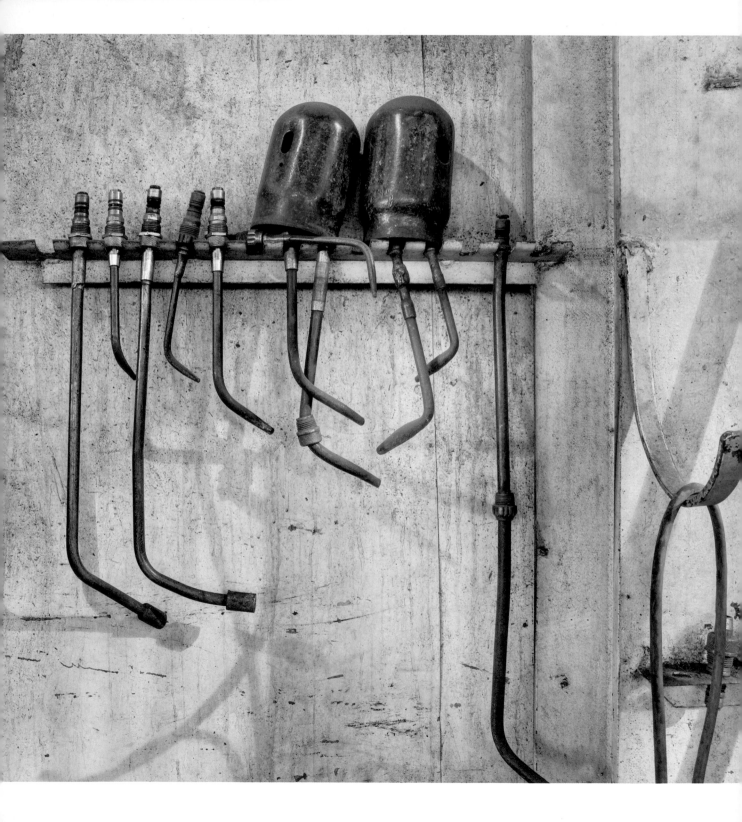

Initial Disappointment

It is not uncommon to come home from a shoot, download your images (or hit the darkroom), and then find yourself very disappointed with your results. If this happens often enough, you may start to question your skills and whether it is even worth persisting. This can lead to periods of weeks, months, or even years without photographing.

Disappointment can come from a number of sources, some of which are listed below:

1. You may have missed that one great image you had hoped for.

2. The image may require a lot of editing for the good qualities to even be apparent. Thus, unless you particularly remember the image (and in a big shoot you very well may not), you may have to make some preliminary adjustments before you appreciate its worth. This is very apparent when you "expose to the right" with digital cameras (as you should), and thus, in using the maximum exposure that won't clip highlights while supplying good shadow detail with low noise, you end up with an image that is very light and washed out—enough so for you to not recognize the image's strengths.

3. After the shoot, your memory of certain images might overestimate their value, while discounting others. The truth is that you often can't tell during a shoot which shot will end up being excellent.

4. Images of simple design may look OK in thumbnail size, but many images do not, and all your images deserve to be seen at full size on your monitor before you consider ignoring them.

5. Perhaps the images would be better in black and white.

6. Cropping may be necessary (at least in one dimension) for an image to show its potential.

7. Some images take time to grow on you.

Therefore, following are some suggestions for reviewing images after a shoot.

- Create a slideshow that allows you to view the images in full screen and uncluttered. Use a rating scale (available in many cataloging programs) to eliminate technically unsalvageable images, and do not discard any other images. Review the remaining images very carefully and assign a rating to images with potential. Consider the possibilities for monochrome conversion, cropping, and other editing adjustments and how they might impact each image.

- Do not discard any aesthetic duds for the first year, though you might feel brave enough to discard duplicates (ensuring that you keep the best one). Frankly, with the cost of storage coming down, you may feel it is never wise to throw out an image, because it may prove useful later on.

In the fall of 2006, I was on holiday on Vancouver Island and returned home with hundreds of images. My initial review of my images left me very disappointed with the results. However, over several months time, I found some nice, if not exactly earth-shattering images, and my opinion of the trip

◄ **Welding Equipment**
The subject matter isn't exactly exciting, but I like the shadows and the shapes.

▲ Flour Mill Wall
Overlooked until the editor asked me for more images, and I thought, maybe if I correct perspective, and it was one of those published.

changed significantly. Since that time, I have refined a few of the images and they are now among my best. Had I not rechecked those files again and again, I would be missing some portfolio-quality images. This experience represents a very important lesson.

I realize, though, that I have to be careful. Sometimes, in an attempt to find something new, I will scan old files and try to convince myself that an image, which I previously rejected, is worth printing. There is nothing wrong with that, providing that at some point in the process I recognize when it isn't working and know when to abandon the image. I

find I can usually tell part of the way through the editing process when I am simply trying too hard to save a mediocre image. In the case of finding "late bloomers" the feeling was quite different—each just got better and better as I worked on the image, until I recognized it as a major find.

At the time of capturing the images, I had no awareness that any of them would turn out to be one of the best images of the trip. My feeling about these was the same as it was for hundreds of other images, which was, "Has potential—hope for the best."

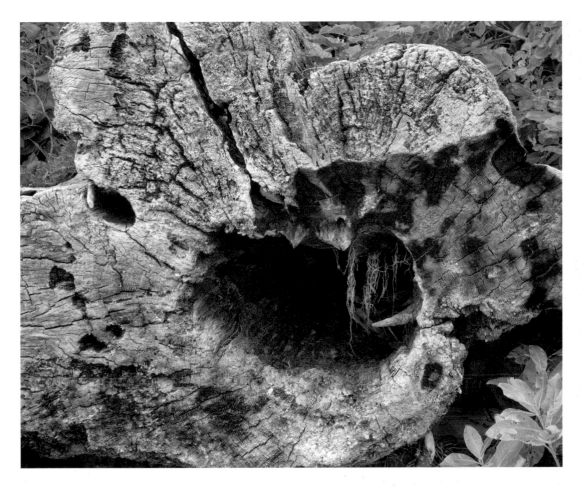

◄ Hollow Stump
Both driftwood and burned stump in one. The massiveness of the stump compared to the delicacy of those roots hanging down, and the age of the wood compared to the freshness of the leaves is what the image is about.

Selecting Images for Presentation

When selecting images for your own entertainment, a "greatest hits" theme works just fine. If, on the other hand, you want to impress someone who knows art, then this strategy is less likely to impress. This holds true whether you are seeking the approval of a magazine editor, a gallery owner, or a museum curator. It is also true of many photo contests.

From the point of view of the keeper of the gates (e.g., the editor or gallery owner), their reputation hangs (sometimes literally) on the work you give them. A gallery owner hopes for a good review in the local newspaper, an editor

wants more advertisers and readers, and a book publisher's living depends on the success of the book. They have the right, the need, and even the responsibility to choose very carefully.

A cohesive collection says a number of things about a photographer, some of which are described below:

1. It implies a certain degree of commitment to the work—usually involving multiple shoots, sometimes spanning a period of years.
2. Being able to come up with different images on the same topic says a lot about the skill of the photographer.

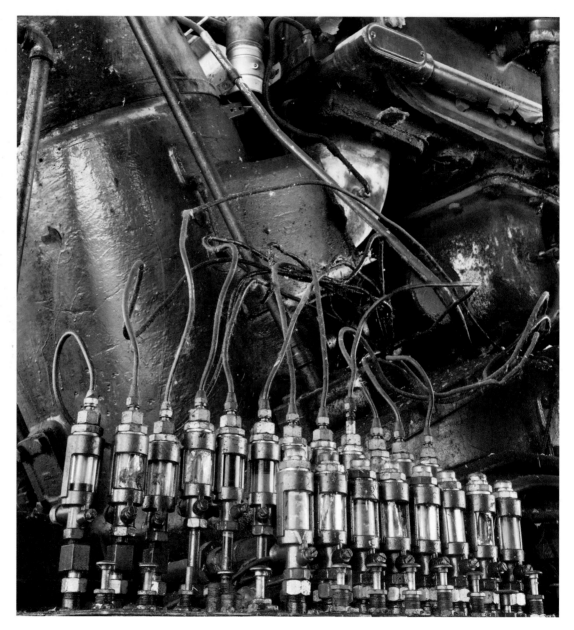

► **Lubricators**
Glass and polished
metal reflect light
wonderfully—here
we have both.

3. A unified theme to the work implies some emotional involvement, as well as determination, which suggests there is more to the images than just being technically great and well-composed.

4. A consistent body of work means that luck is unlikely to have anything to do with the images. A photographer who is out there a lot might get lucky in the mountains, at the seashore, in the derelict building, and with a picture of the girlfriend, yet they are very unlikely to get lucky ten times in a row with a single theme.

5. A single subject implies at least the pos-
sibility that the photographer has some-
thing to say.

Sometimes magazines hosting a contest will
specifically state that the work should be of
a single theme, or that preference is given to
such. Sometimes they don't tell you that until
after the contest, or until the deadline for sub-
missions has passed. You should assume this
is implied unless specifically mentioned other-
wise, and even then, you should still wonder,
knowing judges are only human and perhaps
not even aware of their biases.

In the case of B&W Magazine, every other
year they publish the top portfolios received
(on alternate years they publish best single
images). This is the only way to get one's im-
ages in the magazine, other than by specific
invitation. No other submissions are allowed.
They clearly specify that they prefer a unified
theme. They look for 8-12 images, and ran-
dom, top-ten type collections are not typically
selected for publication.

Some editors, owners, and publishers are
specifically looking for something new and dif-
ferent to present; the more "artsy" it looks the
better, but it damn well better be different.
For example, Camera Arts Magazine goes out
of its way to push the boundaries and feature
the new, different, or some might say, just
plain odd. Sending this magazine a portfolio
of classic landscape images is unlikely to get
very far.

On the other hand, while Lenswork Maga-
zine does like to show things not seen before,
the classic and traditional values of quality
still hold forth here, and a traditional port-
folio is more likely to be welcomed. Do keep
in mind though that magazines of this ilk
receive hundreds, if not thousands, of such
portfolios, so your work does need a certain
something to make it stand out.

Following is a list of questions you might be
asking at this point:

- So, how DO you select images to present?
- Is it true that you are defined by your weak-
 est image?
- Can you submit two images of the same
 subject from different viewpoints and
 compositions—perhaps one near, one far?
 How similar can they be while still being ac-
 ceptable?
- How tough do you have to be in selecting
 images?
- Should you even be doing your own select-
 ing, because we often hear that we are not
 the best judges of our own work?
- What if you have barely enough images
 that you think are good enough to meet the
 minimum requirement?

▲ **Machine Shop
Odds and Ends**
Sometimes you
know right from the
beginning that this
will make a good
image. I did have
the added challenge
though of moving
the objects in the
box to the best
position.

▲ Fjord Horse Conversation

The alignment of the heads and the question of just how many horses are there makes for an interesting image.

Remember that it is human nature to want to control one's work. That applies to us photographers, but keep in mind that it also applies to the editor, and after all, it's their magazine you are hoping to get your work into. This means that giving the editor who plans to publish six images, several more than they asked for so they can choose what they think is best, is only common sense.

I will walk you through the method I use when I am selecting images for submission to a contest or magazine.

I start by selecting every image that could reasonably fit the theme I am presenting. I collect them together, and because mine are digital, I run a slideshow on the computer and rank the images as I go.

The first time through, I eliminate any images with technical flaws. Keep in mind that even if you sneak a digital copy past the selectors, sooner or later you are going to be asked to make a print of the image. Therefore, all the images must hold up in print. If you haven't printed every image by the time your collection has been determined, then print those you haven't to confirm quality and check for any printing difficulties.

Look for flaws such as:
- Over-sharpening
- Lack of resolution
- Less than subtle image manipulation

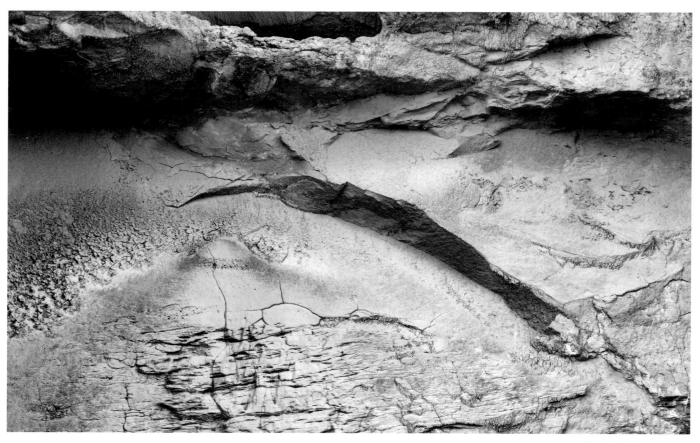

▲ **Mudwall**
I have been returning to the badlands to photograph for 22 years and it's still exciting for me.

- Bleached-out highlights and blocked shadows
- Focus that is spot on

If I feel any hesitation about the quality of an image, I eliminate it from the collection.

Next, I run through the slideshow again and pick the obvious winners–the images by which I define my photography. They don't have to be crowd pleasers; I may only be trying to impress a single person whose taste I am not privileged to know beforehand. I then place the definite "keepers" into a separate pile or folder so I don't have to repeatedly go through all of them.

At this point, it's not necessary to have a detailed ranking system–we don't care if an image is a 3, 4, or 5. All we need at this point is a good, bad, maybe system. Fine-tuning may be helpful near the end of this process when trying to separate the good from the great, and making final choices for the portfolio or submission.

By now, I am probably down to 50% of the original group of images, having passed through the top 25% and rejected the bottom 25%. My selection process now becomes more difficult.

The middle-of-the-pack images that are remaining are there for several possible reasons:
- An idea that almost came off and I hate to give up

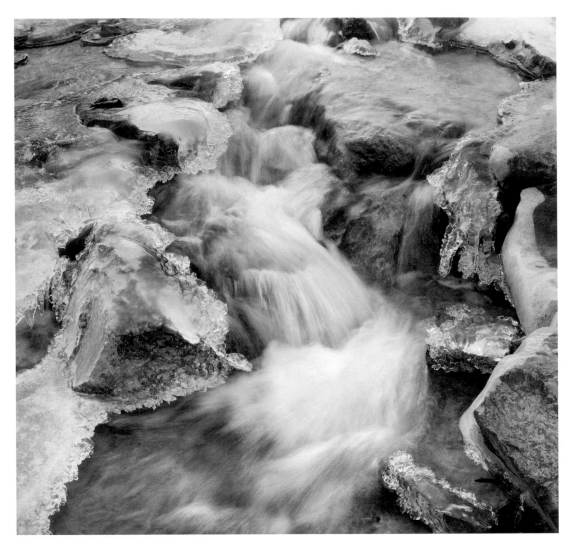

▶

Ice and Stream
Translucent ice
is always worth
exploring and
flowing water
doesn't hurt either.

- A sort of nice image, an image that others like but I don't
- An image that is terrific in every way except that one little flaw that keeps bugging me
- And certainly there are many other types

Hopefully, none of the images fit into every one of these categories! Many images may be flawless, yet not so obviously exciting. That's OK. Not every image has to be a barnburner. Because they will be presented together, some images may be needed to fill gaps, provide explanations, or expand the story.

The images that I like except for that "one flaw" are probably best bounced off of someone else. I had an image I showed my wife (who is a non-photographer) and she said she liked it. I then asked her about the out-of-focus areas (which, if truth be known, weren't out-of-focus enough), and she said that they were distracting—so, out with that image! Other times, though, the one thing that

bothers me in an otherwise wonderful image may not be distracting to others.

If you look through the published images of the greats, there are lots of minor imperfections, which, had the photographer obsessed about it, we would not have had the opportunity to view the work. We expect perfection from ourselves, but are more forgiving of someone with a proven reputation. The subtle imperfections we notice this year may turn out, with a couple more years experience behind us, to be glaring errors. I have found myself in this very situation, looking at prints I made a few years ago and thinking, "My God, I've come a long way!" At least that's what I think on a good day. On a bad day I think, "God, I was awful. How did I ever have the nerve to show that in public?"

Regarding images that are good but not great, when I submitted my work to Lenswork for issue 57, I sent them about 25 images. After accepting me, they then asked for everything I could send to them that was along the same theme (black and white industrial). I sent them everything I had that I thought was reasonable, and I even processed a few more images that hadn't excited me enough previously to even work on. To my surprise they didn't consistently publish the images I would have selected as my strongest, and they published several images from the extra images I sent. This was interesting, because they printed 17 images, and I originally sent them 25. They chose not to publish about 11 from the first batch of images I sent, and used four of the extras. Of course, I'd already been accepted, there was nothing to lose in sending the extra images. We should all consider the possibility that we are not necessarily the best judges of our own work. Some of our "goods" are "greats" to other people.

At this point, I usually want to show my entire selection to someone else to get his or her feedback. This is especially helpful if the person is pretty honest about their reactions. I am blessed with a wife who, while not making derogatory comments about a picture, will let me know how interested she is in it, and if it doesn't work she is not afraid to say so. This is a great asset, and though my wife doesn't have a visual arts background, I find that if she isn't excited by an image, I'd better have a pretty darn good reason to overrule her. You too might want to find someone who could play a similar role. I believe it might be better if it isn't a photographer. Usually, people who aren't photographers themselves, but are skilled lookers, will judge our work.

And so, back to my selection process:

Well, I needed 8-12 images and am now down to 15. I now do a double check for consistency of theme. I realize that although all the images are from the Badlands, 11 are close and middle ground images with no skies, one has a dramatic thunderstorm over the Badlands, and the last is an old truck dumped into a gully in the Badlands. It would make sense to eliminate the last two images no matter how strong they are because they are jarringly different from all the other images (or, alternatively, add more images in that style so the two don't look like they are crashers at the party).

Here's another check I do. I ask myself if any of the images are too much like each other—enough so that it is repetitive. I do think you can submit more than one image of the same object, person, or whatever—provided there are enough differences to justify both being included. Simply including a second image that is, for all intents and purposes, a crop of the first image is a definite no. You would have to use your feet to explore the subject from a

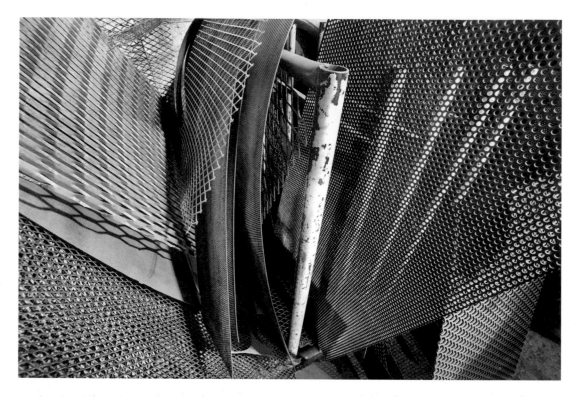

► **Sheet Steel in Rack**
I like that there is
a bit more in this
image, particularly
the top corner of the
middle sheet.

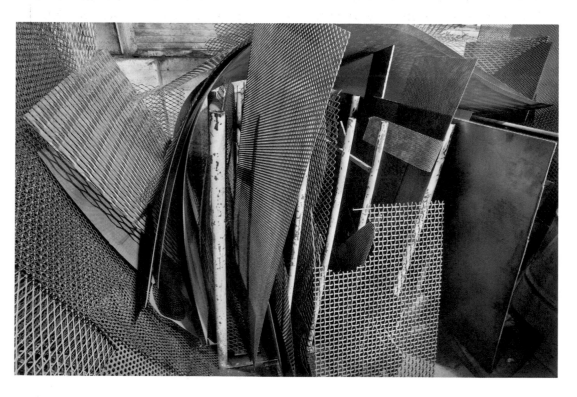

► **More of Steel Rack**
Here the
composition is
simpler, cleaner, but
is it better?

different point of view, and then can include another image that shows a different aspect of the same subject.

Even if the subject matter is different, if it is similar in shape and tonality, and especially if it doesn't really add anything further to the portfolio, this is grounds to exclude it from a portfolio. Though this is not necessarily the case when publishing, because the editor will decide which of the two he prefers and if he happens to use both, well, obviously he felt there was enough difference.

Now for the last check. Let's say I am down to 13 images of the 8-12 I need. It's time to stop thinking about the images and to just react to them. Although by now I have looked at them dozens of times, I flip through them again and rank them according to my emotional response. If I haven't had a chance to sleep on my selections, I need to come back the next day and see if I still feel the same way.

I have to ask myself whether it is better to provide eight really strong images, or to show my depth by providing the full 12. The answer to this depends a bit on the situation. In the case of B&W Magazine, we are told they will only print four images, therefore having eight to select from is pretty good, and if they are strong images, there is nothing to apologize for if you don't submit 12.

This would be a much bigger issue if you had simply included your all time greatest hits, in which case, running out at eight has some pretty significant implications, but you can tell a lot about a single subject in eight photographs, so my inclination would be to see if I can determine where the breakpoint is in quality (the point at which there is a noticeable falloff in quality) and if it falls between the 8th and 12th image, that would become my cutoff, no matter what.

Of course, after doing all these steps, you may come to the point where you decide your work is not good enough for publication, and you lose your nerve and never submit it. Because it is very unlikely that you will magically, within a few months time, produce dramatically better work, why not go ahead and stand behind your work and say, "This is the best I can do." The worst that could happen is that you may receive some derogatory comments from a gallery owner referring to bird-cage liners, but even here there may be something in the feedback that you can take and work with. The only time you can guarantee no rejections is to never submit. And, what a pity that would be!

I think there is some truth to the saying, "You are defined by your weakest image." If you include images that are glaringly weaker, they may tend to drag down the better images. I would never submit an image of lesser technical quality. Aesthetically though, who's to say? The image you worried over may be their choice for a cover.

Good luck in selecting a portfolio of your own work. Show the world the best you can do, and then move on.

More on Picking Our Best Work

Someone mentioned that we are not the best judges of our own work. This raises a number of questions.

1. Is this true?
2. If it is true, then what does this imply?
3. And, what do we do about it?

I have heard this expressed before, though of course, something being stated multiple times does not necessarily make it so.

Let's assume you and I are reasonably talented photographers with something to offer

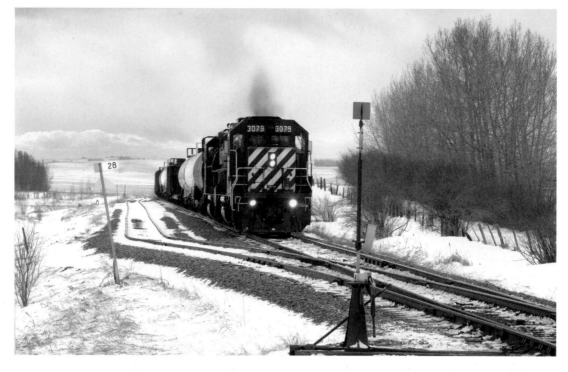

▶ CP Train at Olds
It can be tempting to always aim for the dramatic, the most exciting. But images which evoke typical local scenery or events may well have more power than photographing the Grand Canyon or Mont Blanc.

the world. Some of our images have been admired. We normally present only our best work to the public, burying our mistakes.

First, allow me to make some bold statements.

A dog is a dog is a dog. If we think an image is bad, chances are pretty good that everybody else in the know will agree. That is not to say that these images might not get positive feedback; regardless of how bad they are, they may be liked for any number of reasons, not related to their strength as images. Perhaps the person looking at them doesn't have an educated eye and simply doesn't notice the compositional or technical flaws, which are so glaring to us. Still, a skilled viewer is likely to see the same fatal flaws we do. Flaws don't fade with time, but instead become amplified.

Secondly, when it comes to sorting our good from our best work, we are not necessarily

good judges. There is a reason that in the movies there are directors and there are editors, and for the most part they are not the same person.

Here's another story. For a recent show, I sent a number of images, some strong enough I would stake my reputation on them; others good enough to sell, but definitely not amongst my best. Of course, it is one of those weaker images they chose for the catalogue, website, and advertising. My first reaction was to be upset that my "name" was going to be made (or not) on the basis of this image. I thought of asking them to change it, but I'm not the one to tell a curator they are wrong when they have offered me a show, so I kept quiet.

It is now six months later, and looking at the advertising material from the show (even with my name spelled wrong!) I now see this image

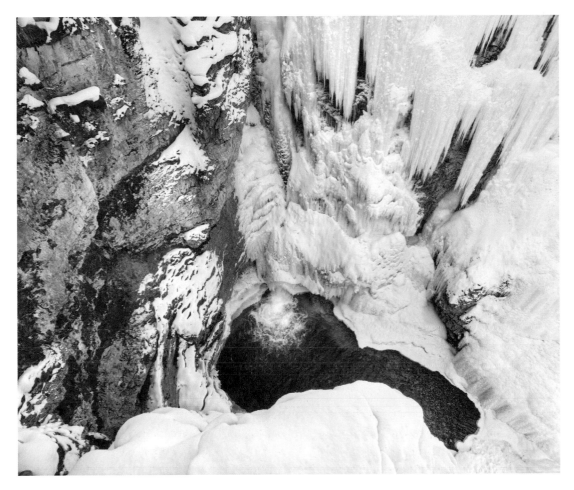

◄ **Frozen Waterfall**
The gallery picked
this image to use
in brochures, yet
it's not an image I
especially like.

in a different light. I see it more as an abstract in forms rather than a picture of a frozen waterfall. Maybe I had undervalued the image, and had either accidentally or intentionally put more into the image than I recognized. In hindsight, I can see why they picked the image. I still wouldn't choose it to represent my work, but I can now see why someone else might. And, I find this a bit disturbing. It clearly means I can be wrong about image choices, so yes, I would have to say that it's true: We aren't always the best judges of our own work, and yes, we do need help from editors and curators, even ignoring the fact that

these shows and publications represent their best efforts and their reputations stand on what they show.

I have read several times of photographers needing and seeking outside help to select and sequence images for a book.

Here's a fictional story. A photographer strongly dislikes an image. He junks it as a failure, but a friend notices it in the garbage and rescues it, exclaiming over it's worth. Our photographer is persuaded by said friend to include it in his catalog. This image turns out to be tremendously popular, our photographer is asked to reprint it many times, and it

becomes the image by which he is known. Yet, he still hates the image and cringes every time he's forced to print it.

I think it means that we need to divide our images into the following categories:

- Bad – I don't want anyone to see this.
- OK – I would be willing to include it in my sales catalogue and actually sell it, but I would not want it in any shows or publications.
- Good – I think it is a decent image. I would prefer it wasn't the image by which I am known, but I'm OK with showing it to the powers that be and I'll take my chances.
- Great – These are the images by which I stake my reputation and by which I want to be known.

So, when picking our best work, it's fair game to pick from the great and the good, but not to use any of the others, no matter how enthusiastically someone else might recommend an image.

We run the risk of missing an image that others will get excited over, but we can always change our minds. There are a number of images which I have much later decided are good after all, or more commonly, I can now make good prints of these when I couldn't before (I now see how to work them).

In the end, I think it's better to hold back an image that you are less than happy with.

In terms of sorting out the good from the great, it looks like we may need some help here. Two problems immediately arise.

1. We may love an image for reasons that are not apparent to others, and so they never pick our favorites.
2. We may dislike an image to some degree (i.e., we like an image less than other images), but we like it enough that we are willing to share it. Perhaps it's an image

that we will appreciate in full later on. There may be something about the image that prevents us from seeing it to its full advantage. We might be obsessed with a minor flaw in the image and can't get past it, while others pay no attention to the flaw at all, and even when the flaw is pointed out, they can't understand why we fuss so much.

Just as we can ascribe wonders to an image, which aren't actually there (they are remembered), we can also remember things, which spoil the image, and yet which don't actually exist in the image. Rather, they can come from other memories and associations.

Here is the bottom line: If you hate an image, don't show it to anyone. Maybe, in time, you'll change your mind, but ultimately they are our images and they make a statement about us. If one or two images don't get shown which could have been, well that's just too bad.

If your reputation hangs on a couple of images, then you have more work to do.

Image Deficiencies

I look at a lot of photographs. Some are by near-beginners, others by people who have been practicing the hobby for 30 years. Quality ranges widely and some are fantastic, yet a fair number of the images are quite weak (even some by the same photographer as the great images), more often they are lacking aesthetically rather than technically. The weak images have no message and are often just a hodgepodge of pretty things thrown together. I've written about the finer points of creating images, but these shots are failing at a fairly fundamental level, and at the risk of offending, I think it is important to deal with this issue.

▲ **Horseshoe Canyon in Sun**
Shooting into the sun is usually problematic, but if there is a little haze, you can control the contrast…

These images fail, not because someone did or did not use the rule of thirds for composing. Rather, they fail because the photograph is a disorganized jumble; such as a bright sky here, a deep shade there, and branches sticking out everywhere. I somehow have the impression that what the photographer saw is not what ended up in the print. Giving advice on improving the image is difficult. Telling someone I wouldn't have taken the picture at all isn't terribly helpful, yet it can be true—the image doesn't need improving, it needs replacing. Unfortunately, some photographers are often unaware of their faults, or even if they see something lacking, they are convinced that it could be fixed by a better camera, more pixels, or some technical fix the experts have and aren't willing to share.

The following are a list of the more common reasons for images to fail. Because many of my old images, and not a few of my current ones fail for exactly the same reasons, I hope you will forgive me for raising the subject and for suggesting some image faults to avoid.

Top Ten Reasons Why Images Fail

1. The image is confused because when you saw the scene you did so in three dimensions with two eyes, the viewfinder not withstanding. There are various ways to fix this, but oddly, looking through an SLR viewfinder is not one of them. Better options are to use a viewing rectangle (a simple hole in cardboard or plastic), or possibly the large LCD (liquid crystal display) screen of a pocket sized, digital camera. For all the hassles of using a view camera—a large ground glass is an excellent tool for composing. Even your fingers can make a crude rectangle for composition purposes.

 The SLR viewfinder with its dark surround and optics that make the image appear distant, and the relatively small size of the image all contribute to making the image appear better than it really is. It can actually be worth recording the image with your digital SLR, use the LCD screen to evaluate the worth of the image, erasing it

▲ Machine Shop
Framing is a matter of including enough to give a sense of the place, without including much of the surrounding clutter.

if necessary, and then reframe and reposition as needed to improve the image.

2. You are photographing less than what you experienced. An image can't give us the sound of flowing water or the sigh of wind in the trees, the smell of new buds or the warmth of the sun on our skin. Nor can it record the emotions the photographer experienced in a particular location. You are going to have to work to include any of these sensual elements into the image, and the image has to be strong enough

to survive the removal of all those things Given that you can't, in general, represent these other senses in your images, your images must be that much stronger visually to compensate for the loss of the other senses. This means an image that is cleaner, with fewer distractions, a really strong design, and captured at the ideal moment. Your goal is to find the parts of the scene that can be arranged to represent the whole. You may find a very photogenic person sitting across from you on a subway. They may appear so photogenic that

you get up the nerve to ask if you can take their picture. A snapshot of them sitting on the bench surrounded by ads and garbage and people standing, holding shopping bags and looking tired and grumpy will not show any of what you felt when viewing the entire scene. You may feel that it's the whole human being that is what you are reacting to, but that is unlikely. Far more often there are, at best, just a few things that attract you to a subject, such as their eyes, their smile, or their hair. After all, you haven't seen their backside (they're sitting on it, remember. And, they may have huge, ugly, bunioned feet). Your assignment is to take a photograph that will capture what you saw and what it was that attracted you: You need to THINK! Perhaps it was that faraway look, the smile as the person turned towards you, the curve of the neck, sweep of hair, or glint in the eyes. What was it and how do you go about emphasizing that part of the subject so that others get at least a hint of what you saw? You need to eliminate what distracts and emphasize that which "makes" the image.

3. Something may capture your interest, but you can't find (or don't look for) a way to isolate it, and a cluttered foreground or background completely spoils the image. It can be hard work to find a simple background, and you frequently have to walk away without your shot. Yes, perhaps the rock was interesting, but in its current location it just doesn't make a pleasing picture.

4. Cramming in as many possible shapes, textures, and other things into an image does NOT create a good photograph. Even if adding a particular element could potentially add to an image, if it comes with excess baggage, it can do more harm than good. For example, adding that sand dune to the left is good, but taking the bush that comes with it is bad: Short of removing things in Photoshop, adding the sand dune may hurt more than it helps. Even if a "goody" comes without excess baggage, you should ask yourself whether it really adds value to the image. The rock on the left may have a lovely hue, but unless it somehow ties in with the other rocks (by pattern, texture, or shape), simply adding it because it's pretty may actually weaken the image.

5. Not enough effort has been expended to remove extraneous elements. Simplify, simplify, simplify. Clean up the image by moving to the absolutely best vantage point, and remember that knees bend— get low, wet, and dirty if need be to get a good shot. You can remove extraneous elements by framing your shot so they are excluded, they are hidden behind something, or your position minimizes their prominence. You can reduce their effect by placing them in shadow, or by making them significantly out-of-focus. Objects that intrude because of their color can be toned down. Keep in mind that some "stuff" acts as a frame of reference for your subject, either by literally framing or by simply providing information about the subject, such as its location, or circumstances.

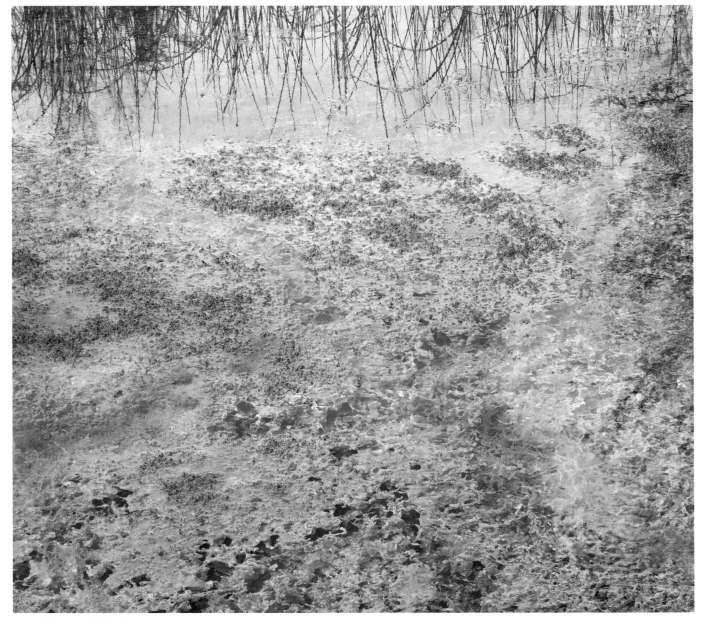

▲ **Cave and Basin Hot Pool**

The reeds are reflections— it doesn't hurt to make your viewer think.

6. People often include skies even when the sky doesn't add to the image. With skies being bright and horizons often horizontal (who'd have thought?), they really are a strong part of the image, for better or worse. I think you need to ask yourself permission to include the sky rather than the reverse. A travel brochure needs the horizon in the image; fine art photography does not. If you feel the sky is important and must be included, you should do just about anything to break up the line of the

horizon. When photographed, lakes have far shores, and unless they are perpendicular to the direction the camera aims, the shoreline will not appear to be horizontal. This can often be very disturbing in an image, even though it is literally correct. The same phenomenon occasionally occurs with a horizon that isn't, in fact, a true projection of the 15 miles away real edge of the sky. Thus, an object that is relatively near can give the impression of being the horizon, but at the same time may not be horizontal. Quite disturbing!

7. Novice photographers often take pictures in which several objects have equal importance; there are no predominant objects, no links between the objects, and no overall pattern to the objects. Such images are often doomed to failure. Firstly, these objects have to have a connection—not necessarily a physical connection, but one created through similar characteristics. For example, an image in which a log, a rock, a tree, and a stream have equal importance (whether through positioning, size, brightness, etc.) is very unlikely to result in a successful image. But, you might be able to link them through positioning. Your perspective and framing can show the water in front of the rock, the log on the left, and the tree on the right. You have now created a logical connection amongst them, and you have arranged them in a way that changes the relative importance: The water and rock being centered in the image take precedence. To achieve this would require a relatively low viewpoint. Standing tall or even looking down at the scene in a valley would equalize the elements and spoil the image.

8. More images are spoiled by failing to fill the frame than just about any other error. "Move closer," should be your mantra. Occasionally we'll regret cropping just a bit too tight, but often the adjustment needed is only six inches, what I'm talking about here is moving twice as close to your subject (half the distance away). Sometimes this can be best handled by using a longer lens, but more often it is simply a matter of shoe leather.

9. Sometimes it's clear that a particular part of an image is most important, but the photographer may not have given it much real estate. Emphasize the most important part of the image! This can be done by moving in as I mentioned, but another way is to use a wide-angle lens so that you can get really close to the object while giving the appearance that everything else is much further away, and therefore, a whole lot smaller. It may also be emphasized through being much darker or lighter than what surrounds it or through having lines in the print point to it or through other parts of the image framing it.

10. Color must be there for a reason. There must be a theme to the color scheme. Unless photographing rainbows, there is usually not much reason to include a wide variety of colors. If you study great art, you will note that many works of art have a limited array of predominant colors in any single painting. You should strive for a similar, reduced palette.

Burned Stump

I was on my way home from my intended photographic destination when I caught, out of the corner of my eye, a meadow in which stood a single dead tree, clearly burned and black. I could see that the surface was uneven, and previous experience with burned stumps meant I knew this was likely to have some great tonalities in black and white. After a quick and relatively safe (but probably illegal) U turn and carefully pulling off the side of the road, I ran across the field with anticipation and wasn't in any way disappointed. It wasn't a particularly large tree—perhaps ten inches across. The roundness of the tree meant that depth of field would be an issue at the edges of the trunk. It was pretty clear it was going to be a vertical image.

There were patterns in the burned bark where branches came off, and some great light areas as well as some deep cracks which exposed the unburned wood underneath. Although it would result in a very tall narrow image (an unusual and unconventional and therefore, probably unpopular shape), I felt this would work best for this image. It took some considerable time to find the best position and focal length to record the image.

Burned wood tends to form small rounded squares of charcoal and some areas, perhaps more dense, actually become quite reflective and work very well in both black and white and color. In this image the only color in the entire image was in the deep cracks exposing the beige wood underneath; not enough to keep it in color and I'm very happy with the black and white result.

In selling photographs, it's not uncommon for people to buy for specific locations, and so it is not unreasonable that they have very specific shape and size requirements. Therefore, even an image of this shape may be perfect for a wall somewhere.

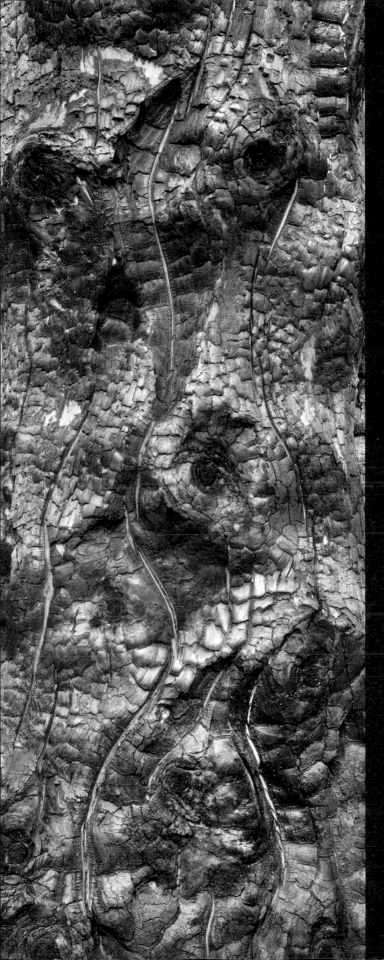

Tree Reflection

This was photographed only a few blocks from downtown Calgary, population one million. The bus barns were behind me and a railway bridge just to the left of the image.

I'd been out photographing on a warm February afternoon. The river was starting to thaw (in fact I went through the ice thigh high at one point trying for an image). I'd hoped to find interesting swirls in the ice, but had in fact been quite disappointed with the patterns. I found nothing that would make a strong composition. Then I came across this scene. With the intensely blue sky, except for a few clouds, two of which are reflected in the pool in the center of the river on top of the ice, and another hiding the sun, there was a little bit of a bay at river's edge giving the lovely sweep of the bottom of the image. A large tree on the opposite bank is reflected in the pool, while the ice at the edges has melted and refrozen so many times it has formed large crystals that are fairly easily photographed.

The blue comes from the skylight, its intensity increased, because of increasing the contrast in the image quite dramatically—so much so that I had to desaturate the image a couple of times to get a reasonable balance. Of course, I know the color isn't real, but remember that I'm a photographer with more concern for creating an image than recording one. Not everyone agrees. My wife still prefers the muted tones of the original image.

This raises the whole issue of fidelity to the original scene. Just how far from "natural" is it fair to go? Some would argue that no deviation is reasonable, though these are often the people who happily darken skies with a polarizer or choose Velvia slide film for it's propensity to saturated colors. Others simply want the image to look natural, whether it's real or not. For myself, I have no qualms about deviating significantly from the original, feeling that I am creating art (with a lowercase "A"). Perhaps this is a left over of my purely black and white days in which manipulating an image was the norm and fidelity to the original was hardly an issue since the color was gone anyway.

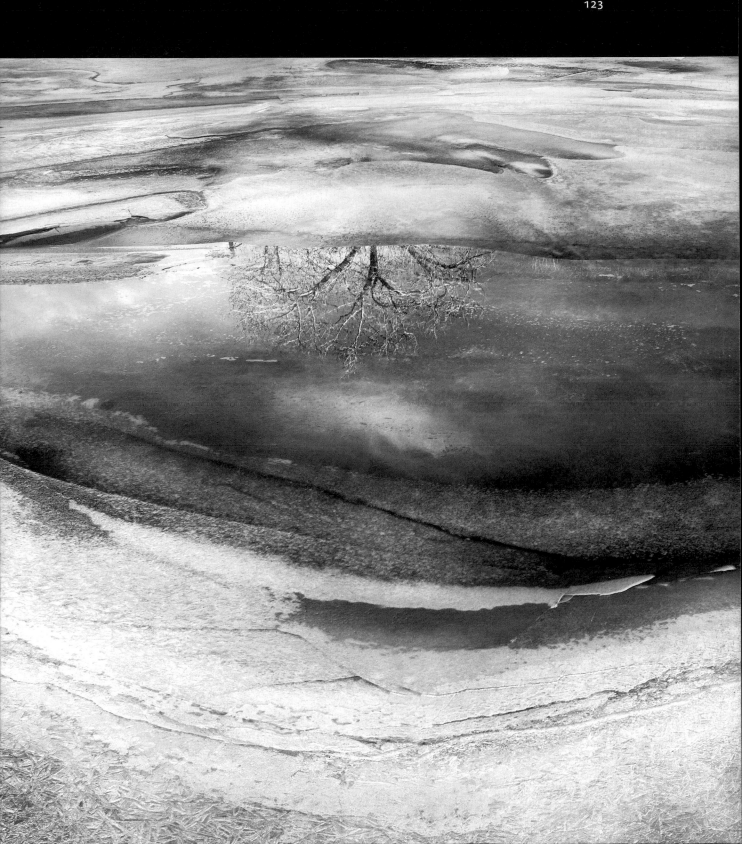

▲ **Water Triptych**
While nice, none of these four images really stood on their own and I got the idea to hang all four on the wall together and so I present them as a set.

Stuck in a Rut

Have you been thinking that many of your pictures are too similar to one another? Perhaps it's time to break out of the mold and try something new. If you have been photographing football games, you could switch to ballet, but of course, that isn't quite what I mean. Presumably, you like shooting football and don't want to give it up, but you would like your images to show some fresh ideas.

It might be time to analyze your current style and see how you might change it.

First, a list of possible characteristics of a photograph:

- Contrast
- Brightness
- Depth Of Field
- Shooting Perspective
- Focal Length
- Subject Position/Pose
- Tightness of Framing
- Lighting Conditions

Take a good look at the prints you now have that you think are too similar. Perhaps it is because they are all football pictures, but maybe it has more to do with the way the game was photographed. If you are used to using a long lens, throwing the background out of focus and filling the frame with a single player, how about widening the angle of view a bit and include more players interacting? If you always photograph from standing height, perhaps it's time to get your knees dirty. Maybe, for a change, you might switch to a short lens and concentrate on the plays on your sideline.

If you usually avoid harsh lighting, noonday sun, or shooting straight into the sun,

◀ **Rock Stack**
Never very popular with the public, I still find the balance and composition very nice. I have no hesitation in showing it. If we only showed work which was universally liked, we'd be catering to the lowest common denominator. Which isn't to say that if you don't like a particular image, say this one, that you are by definition the lowest. There are lots of images I don't like for a variety of reasons.

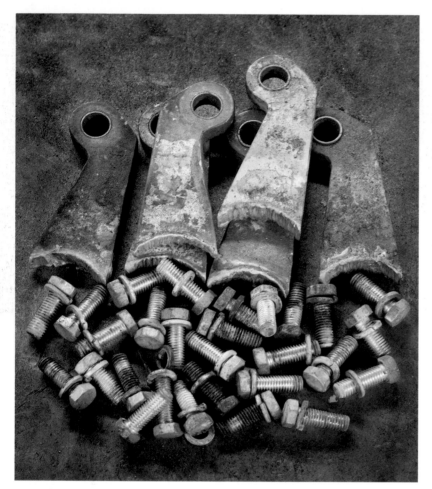

▲ Bolts and Widgets
I found these lying on a counter. I did move the bolts around a bit to polish the composition and rounded up the strays.

how about deliberately doing these very things you have been avoiding, and see if you can make them work for you? Or, perhaps, you should start shooting after the sun is down.

You could experiment with a white reflector to fill shadows when photographing small areas, or experiment with fill flash in situations you would not normally think of doing so.

There are quite a few photographers who occasionally bring out their Holga cameras just to break out of the mold. These cameras record vignetting, fuzzy edges, flare, and a softness of tones that is hard to achieve with any other camera. How about breaking out your old,

neglected Polaroid SX 70 camera, with or without print manipulation?

How you deal with the images you do get can also be changed. You could, of course, switch from color to black and white, or vise-versa. Perhaps you pride yourself on a nicely balanced print with good spread of light and dark tones, so how about deliberately printing really dark, or really light, which doesn't mean simply lightening or darkening the print? You don't want a muddy dark print, you want a richly dark print—not at all the same thing—with the latter requiring careful handling of the highlights and the right contrast for the darker areas.

Sometimes, even just a change in aspect ratio can be the change you need. How about switching to square or panoramic format to discover new possibilities? It is not written in stone that we must make all images in the format chosen by Oskar Barnak, creator of the Leica and the fellow who dictated the 2:3 ratio on what was essentially movie film. If 99% of your images are in horizontal format, how about trying nothing but vertical compositions the next time you go out?

If you don't like cropping, consider stitching? Or, just simply switching from your 35mm to a 6 x 6 camera can instill a breath of fresh air.

If your normal printing style is fairly bold and contrasty, how about deliberately trying to create the softest, subtlest images you can without making them look muddy? Or go the other way and see how contrasty you can make an image and still have it hang together.

If you normally print a certain size, how about trying a portfolio of small prints, say 5 x 7 on 8.5 x 11 inch paper?

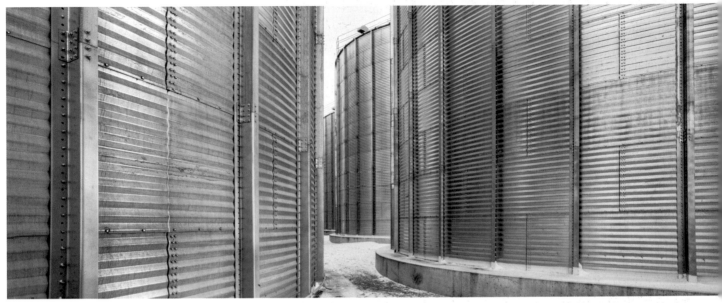

▲ Grain Silos
Knowing the properties of material means we can predict that circular corrugated metal in late day sun has a good chance of working.

Dealing with Slumps

Have you ever had a period when you couldn't seem to create a good photograph for love or money? When everything you shoot turns out to be disappointing, and after a while you lose your enthusiasm? I sure have.

My life in photography has been a series of ups and downs, sometimes fairly dramatic (I gave it up for 15 years!). That said, I haven't had a serious slump for the last five years, and perhaps my experience can be of help to a few other "slumpers".

Twelve Ways to Challenge Yourself

1. You may be a dedicated LANDSCAPE (substitute your own main interest here) photographer, but if you want to avoid slumps, you need some other areas of possible interest. That is how I got started with bridges and industrial images, and also how I transitioned to more abstract images. The industrial images had a number of advantages to me over landscape photography: The locations were closer to me, they were less dependent on weather, and were inherently less common in shows and publications. How do you find your "backup" enthusiasm? You have to try a variety of subjects and styles of photography, which have provided other photographers with lots of subject matter.

2. Change from color to black and white or vise-versa. Perhaps try infrared—even Minor White played with the effect.

3. Perhaps this is the time to play with infrared. A used Sony 707 would be a great start before investing in a modified digital SLR (the normal infrared filter removed from in front of the sensor).

4. Travel. Sometimes the problem is a dearth of fresh scenery. Go photograph somewhere new—which doesn't necessarily have to be that far away—just sufficiently

▲ Fall Color
Paths, trails and roads in an image make you wonder where they go. If they form interesting curves and lead to other parts of the image, so much the better.

different from your usual haunts. Somewhere others have found success so your chances will be good too. A friend introduced me to Jura Canyon. While small (only about 30 feet deep), it's narrow (as little as 2 feet) and full of twists and turns and lovely carved rock with a definite blue tinge to them.

5. Take a workshop. You may not learn a lot (or perhaps more accurately, what you learn may not be what you expected). But workshops are great for getting the interest back up. Seeing the work of others is a huge stimulus for you to get out there. If it's a photographing workshop, even better, as you typically are taken to locations that are likely to be productive. A few years ago I attended a workshop in Canmore with Craig Richards and Keith Logan. With a day trip to Lake O'Hara, not only did I get to photograph in some spectacular locations, I found that my images were well received, I made some good connections, and even found out about a local photography gallery I had been unaware of. It turned out to be a pretty darn good investment for a long weekend, and a whole lot of fun besides. It wasn't even expensive!

6. Do you normally shoot everything from a tripod? Then get rid of it and run around snapping things handheld. Or, if you don't

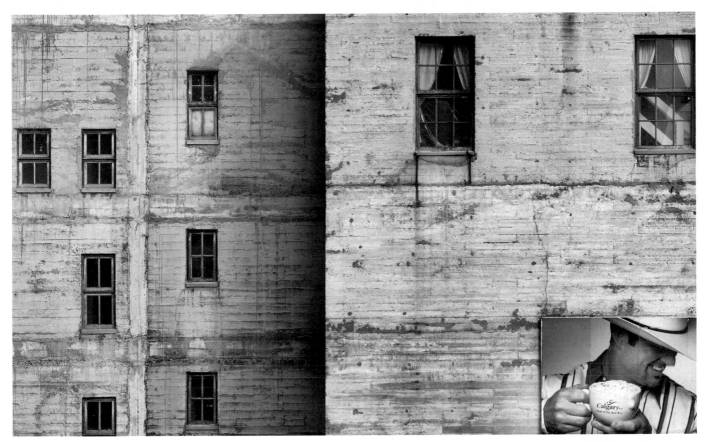

▲ Billboard
Some images are about a juxtaposition—in this case the old building and the sign advertising the "New West".

know one end of a tripod from the other then buy, rent, or borrow one and see if slowing down a little actually helps.

7. In addition to trying to find other subjects to be interested in, how about giving assignments to yourself? For example, how about giving yourself one day to create and print the best possible image of the contents of a drawer; of anything in the back lane behind your house; or the best possible portrait of your dog. (Or borrow a dog if need be!) There are a million possible self-assignments. Think of Bill Brandt with his warped mirror images, or Josef Sudek photographing from his window. Your goal isn't to create a great photograph. Rather, the object is to create the best possible image within the parameters of the assignment. None of the images need to be keepers, but trust me, practicing is better than not shooting; and making a richly toned image of a junk drawer is still going to help boost your photography overall.

8. If, like a lot of hobby photographers, you aren't a people photographer, how about giving it a serious go, from street photography to formal portraits to environmental portraits to figure studies? Joel Myerowitz did an entire book on redheads, but I'm sure there is more that could be said about the freckled ones. You will almost certainly

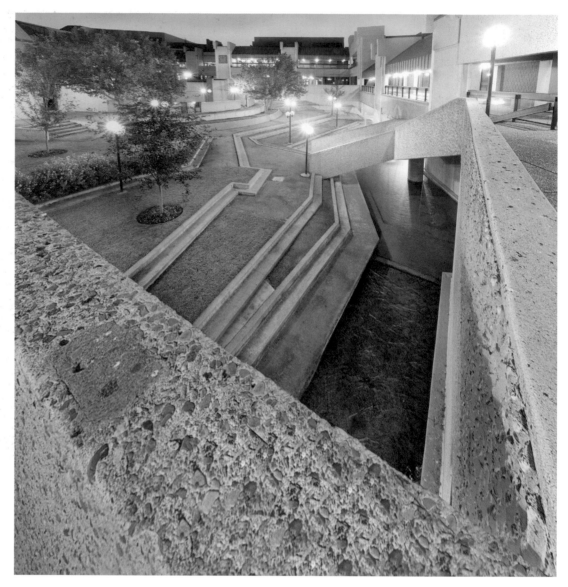

▶
Courtyard
Architecture can be a challenging "self assignment". You can show either what the architect wanted people to see, or you can see if you can find a view that perhaps they didn't anticipate. Light and shadow, reflections and surround can help there.

be pushing your comfort zone, but who ever said that's bad for you.

9. You might choose to stop photographing for a period—until you can't stand not photographing—but use that time to good purpose; printing portfolios of your best work, seeing if you can get published, creating an attractive website, or simply studying great photography by using the money you normally spend on photography to acquire a really good collection of books of photography. You could make a point of visiting as many shows of photography as possible, perhaps even a trip to New York, London, or other major photographic arts centers.

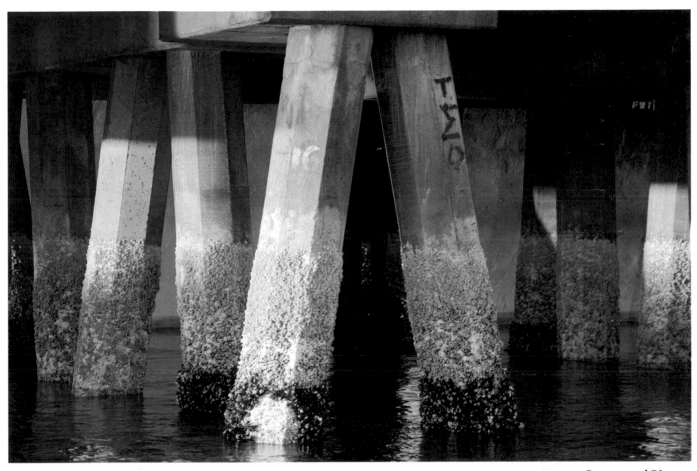

▲ Octagonal Piers
The late afternoon light "made" this image of what would otherwise have been dark and ordinary.

Career, Family, and Photography

I suspect I am in a situation familiar to any number of you. I treat my photography seriously, I'd like others to treat my photography seriously, yet at the same time, I have a career and a family and I have to make compromises.

Some choose to risk abandoning security and becoming full time, professional photographers. A small minority are successful, while many are forced to give up, with their finances ruined and lives stressed beyond reason. Those who make the transition successfully are by and large anything but fine art photographers. Those who say they are full time fine art photographers, in fact, spend 90 percent of their time doing sales, paperwork, accounting, advertising, and just about anything but photography. Even people like Bruce Barnbaum teach workshops, take private students, and write articles to support themselves.

Should you be interested in becoming a professional, i.e., earning the majority of your living from photography, I strongly recommend the book *On Being A Photographer* by David Hurn and Bill Jay (available through lenswork.com).

For those who don't plan on a career in photography, finding the time to get serious

can be a challenge, but here are a few ideas to consider.

Your goals may be impractical for now, but it is possible to set some short-term goals which will help those long-term ones. For example, you may not be in a position to have a one man show of 50 images, but you could certainly be working on some long-term projects so that 10 years from now, when you have the time, money, and reputation, you will have enough images with a theme to put together a cohesive show.

Perhaps you can practice by having a dozen small images displayed at a local coffee shop. Will you get rich, pay off expensive camera equipment, become famous? The answer is "No" to all three questions. On the other hand, seeing your work on the wall and getting feedback will help you in the long run, won't break the bank in the short run, and is quite frankly, is good for the ego.

While it would be nice to have an entire article to yourself, how about starting small with some images in the reader's section of your favorite magazine. You would probably love to be a published photographer with a monograph of your own, but how about for now, putting together a collection of images and having a one-off book made, or even getting a series of images hand-bound into a book? Such a book has a far greater chance of being around a hundred years after you leave this mortal soil than any framed images or boxes of prints.

An exhibit of your work in the MOMA (Museum of Modern Art in New York City) may be out of reach for now, but a local bookstore might want to display your images. Due to your other responsibilities, you might only be able to get out on a serious shoot a handful of times per year at best, but you can keep working on your skills with small local projects, still lifes, urban scenes, street photography, etc.

Having a job other than photography seems to get in the way of being taken seriously. When you want to be visiting galleries to promote your work to curators, you must be at work instead. When you should be out shooting and creating more images, you are taking the kids to hockey, or making those prints for the restaurant. It seems like you are taken less seriously than you would be if you were a full time photographer.

But, you know what? Those full time photographers have kids too! They have mortgages and deadlines, and difficult to please customers; people who leave everything to the last minute, then expect instant service. Those full time photographers also have leaky roofs and bad plumbing, their living rooms need repainting and their families need attention; and what they don't have is a regular paycheck to fall back on. So perhaps, we shouldn't be whining and we should accept our situation with a bit more grace and a positive attitude.

The only consolation I can offer you is that you are in good company. There are many of us struggling with the same issues. Progress toward goals can be made, perhaps not as fast as if you had all your time to devote to photography, but progress nevertheless.

It may be your goal to photograph Yosemite or Mont Blanc, but in the mean time you can probably find some interesting subject matter a heck of a lot closer to home; close enough that you can visit more than once; close enough to make it a project, something that would make a cohesive portfolio. This could be the people at a local racetrack, a small ravine in town, or an abandoned industrial building on the outskirts of town.

▲ Works Office
Probably not much changed in the last 50 years, it's still being used, welders still punch in.

After all, should you find yourself at one of those famous locations, you want to have your skills honed as sharply as possible before hand. There is no point in traveling thousands of miles to find you can't capture the images you want. Remember that you are more likely to become famous for your local work on machinists than for your images of the Grand Canyon.

Keep in mind that it's your regular job that has allowed you to purchase your nice camera equipment!

Dealing With Disappointment

Photography, like life, has to have a little rain in it for us to appreciate the sunny days. Unfortunately, dealing with disappointment in photography is a very personal thing—hitting us at our core worth as artists and leaving us weakened and discouraged.

Recently, I found out I wasn't one of the selected photographers to attend Review Santa Fe. The day after receiving this news, I went down to the Glenbow Museum (which has sold some of my images in their gift shop) to see what needed replacing, and they did not want any more images at the time. I drove around that afternoon looking for something interesting to photograph (i.e., railway yards, industrial side of town, etc.) and didn't find anything to inspire me.

Rejection is a reality. The odds of being successful in each and every endeavor is extremely unlikely, and besides, if you only did things which were guaranteed to be successful, then you must not be pushing yourself very hard.

My options to deal with this insult to my ego include:

1. Sulking—I'm quite good at this.
2. Getting depressed—I tell myself that I'm a lousy photographer with an overinflated self worth and it is time reality sinks in—my photography sucks, and I should give up pretending to be any good. I'm quite good at this one too!
3. Getting mad—I tell myself that those damn so-and-so's wouldn't recognize a good photograph if it slapped them in the face (which may be satisfying in the short run, but perhaps a bit dysfunctional in the long run).
4. Getting even—I threaten to write those so-and-so's and give them a piece of my mind (not that I can afford to give any away!).
5. Worrying—I start wondering what will happen if all my attempts fail. How will I cope? What if I've run out of original ideas, etc.?
6. Giving up—I've done this in the past, one time giving up photography for 15 years, which was a dumb idea!
7. Crying on someone's shoulder—This is actually not so bad, and I can recommend this one. My wife is quite good at sympathizing while still helping me put things in perspective.
8. Pretending it didn't happen—This is a tough one. I'm not very good at pretending.
9. Putting it behind me, and moving on—Making plans to submit elsewhere (though it would be a pity not to learn from this experience).
10. Learning from it—Using the opportunity to realistically assess what happened and why, so I can learn from the experience and do better next time. From my work in psychiatry, and using cognitive therapy to help my patients, I have come to appreciate how helpful this kind of therapy can be and how it can specifically apply to this situation. I'll explain more.

Cognitive Therapy

One part of cognitive therapy is teaching patients to analyze their thoughts for cognitive or thinking errors, which may take a number of forms. While this isn't meant to be a course in cognitive therapy, some of the errors in thinking apply to how photographers can deal with rejection. It teaches you to analyze what was actually said, not what you assumed was said.

The following story is an example I use with patients.

A secretary is sitting at her desk when the boss suddenly comes out, throws down some papers on her desk, swears, demands to know why she can't spell better than a preschooler, goes back to his office, and slams the door. This is devastating to the secretary who fears for her job, thinks her boss doesn't like her as a person, is afraid everyone in the office will think she is an idiot. In general, she first panics.

But, focusing on cognitive errors, the secretary evaluates what was actually said, and considers the circumstances. Perhaps the problem has nothing to do with her—the boss has been grumpy with everyone lately, not only her. Perhaps things aren't going well for the boss at his home. Her appraisal last month was top-notch, and in fact, she got a raise, so realistically, it is unlikely she will be fired. Perhaps the boss knew that spelling was her weakness when he hired her and he told her that wasn't why he needed her. Maybe she actually isn't a good speller and it is a problem—she should come up with a plan to work on it. On the other hand, he said nothing about her value as a human being, nothing in fact about her many other skills and strengths. She could choose to collapse and to "melt into the floor" if possible, or she could decide that the problem needs to be dealt with. Rather than feeling embarrassed in front of the other staff members and being afraid to say anything, she could ask for help from her associate who, instead of making her feel foolish as she feared, is in fact very supportive and points out that the boss did the same thing to her last week. Perhaps she could go to the boss, apologize, and ask if there is anything she can do to help. She might even confront him and point out

his rudeness, though she would have to do it with flair for that not to backfire.

Photography and photographers have similar issues. Rejection by a magazine simply means they didn't need this particular picture at this time. Perhaps they ran a similar image two months ago, therefore regardless of how strong your image is, the timing is wrong. The rejection may reflect on the strength of this particular image, but says absolutely nothing about your talent as a photographer. Of course, if you get rejected a dozen times, you have to think you have some work to do, but even then the message is, "You aren't ready yet?", as opposed to, "You will never be ready."

So, having got past my initial disappointment, I reread the email from Review Santa Fe, and in fact, it included a fair amount of detail explaining why the majority of the 592 photographers' submissions were rejected—they said that either their portfolio was not a single project or done with a single technique, or the style of photography was derivative.

After calming down, I remembered that while all the images I submitted were industrial, some were close ups, others much further back, some were new and shiny objects, others were rusted and old. My images varied from container ships to old mine equipment.

It may be true that the images weren't good, but aside from that, my portfolio was not well-defined and could easily have been rejected for that reason alone. I have no basis on which to assume that the work had no merit.

The email from Review Santa Fe said some photographers' work was derivative. Well, frankly, I think all photographs are derivative as it's nigh on impossible to create new, interesting work without a working knowledge of what has gone before. Of course, they may have meant that they were looking for odd,

funky, or really different images, which mine certainly weren't. I refuse to apologize for that. It is the kind of work I do and I wouldn't change that. It is rather like dating—being rejected by some people can be a darn good thing!

People often compare my work to that of Edward Burtynsky, another much more successful, well-known, and talented photographer who is also from Canada and also photographs industrial subjects. I don't happen to think his images look anything like mine. His images emphasize destruction of landscape by industry and have more political overtones (I would be more popular with galleries if I followed suit, but that isn't what I want to do). While my photography is about finding beauty in mundane objects, Burtynsky makes political messages with his images of excesses and waste, of pollution and destruction. His images generally step back and include the surroundings, whereas mine move in and are more abstract, and I think more creative (or at least created) images.

When rejected, it is important to put the rejection into perspective. Is there evidence that your photography is, in fact, worthwhile? Who has made nice comments about your work? Who asked for a print? Which publications accepted your work, etc.?

Before ever getting published, this can be a tough one, but perhaps your work was admired or even given prizes at the local camera club. Maybe you were able to persuade a local bistro to hang some of your work. Hey, at least your mother says she likes your photographs! It may be that success is when you show your snaps at the office and one person says to another, "Hey, come over here and look at these."

In the end, you have to ask yourself, "Did I set out on this adventure called photography so I could become famous, so I could express myself, or so I could make money?"

If money is your goal, then photographs of babies, pets, and fashion are probably the paths to take in order to make the big bucks. If your goal is to become famous, then you have chosen a hard way to do it—bank robbery might be an easier alternative (see getting rich quick). If you photograph to express yourself (and it's OK to enjoy hearing people say nice things about your work), then does it really matter in the long run that one person or group just didn't need the photographs that you submitted, at this time?

Hell, I just want to go photographing.

Photographic Flops

Unless you aren't human, you will have done at times what I have managed on many occasions—head out all bright-eyed and enthusiastic, have a good time at the scene, yet once seeing the proofs, you groan with disappointment. It just didn't work out like we had hoped. This could be for technical reasons, but if so, those are generally easy to identify and fixes are relatively straight forward.

What if instead of technical failures, we have an entire proof sheet or folder of poorly composed, boring images, which have none of the feeling we had at the scene? Much of this book is dedicated to strategies for avoiding this situation, but the "photographic flop" is bound to happen—it will happen often, and it will happen again—to you and to me.

Apart from becoming a better photographer, is there anything we can learn from such a disappointing experience? I think there is. My own observation is that disappointments

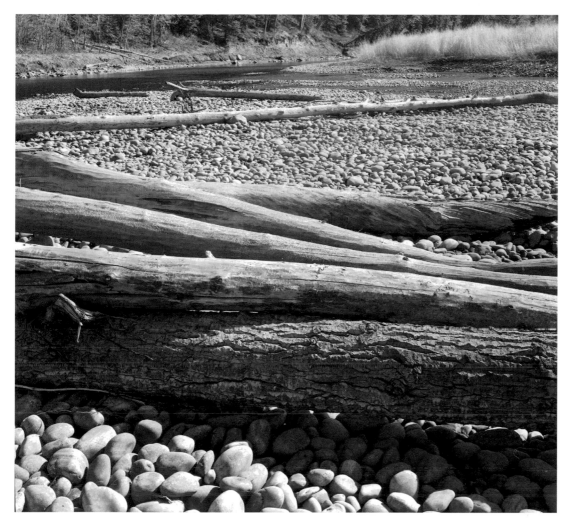

◄ **Logs and Stones**
Medium format film is still an economical way to produce very high quality images in black and white.

like this happen to me less often the more frequently I photograph. So there is hope!

The following are some reasons for flopping and some strategies for doing so less often.

1. When you photograph every weekend, the occasional flop doesn't hurt too much. This week's shoot may be a flop but last weekend was good, next weekend might be great. But, if you only get out half a dozen times a year, even one flop is a disaster and two or three flops are catastrophic.

2. If you don't photograph very often, you can reasonably predict that you might be slow, clumsy, make mistakes, overlook things, and generally not be very good—so flops are much more likely.

3. A flop is an opportunity to learn. You can use the techniques of this book to analyze your own images to see why they didn't work. Surgeons may bury their mistakes, but pathologists dig them up and find out why the mistake was made. Be your own

pathologist, or get help from someone else.

4. Where did you get the idea that your first visit to any location or situation should or would be successful? Most photographers have to visit a location several times. The first visit is for getting a feel for the place, and great photography isn't likely or expected. It's not that you can't produce good work on a first trip. You can, but it is just that it's a lot harder.

5. Sometimes the excitement of a new place actually interferes with effectively working the scene. It is all so darn interesting that figuring out where to aim the camera is problematic. This definitely calls for repeat visits.

6. Be honest with yourself. Were you in top shape to photograph, or were you still bummed out from the argument with the boss or your spouse? Did you even get enough sleep the night before?

7. Sometimes you force it. You are so desperate for a good photograph that you can't see what is offered. You want to take photographs instead of making them.

8. Sometimes you need a break from a certain kind of photography. Not that you need to give it up, but rather that you need to do some other kinds of photography for a while, before coming back refreshed.

Perhaps after all, you can't come up with a single excuse for the poor images, and you simply didn't see very well that day for no apparent reason. Put it behind you. As with falling off a horse, the sooner you get back on… Get out that camera and start seeing!

Equipment Envy

If we spent as much time seriously photographing as we do checking out new, improved equipment; if we spent as much time looking at good photographs as we do experimenting with different formats and changing RAW processors; well, we would be much better photographers for it. If you are like me, you like equipment, and you especially like new equipment (new to us at any rate).

I have been through the 35mm, to medium format, to 4 x 5, and back to medium several times through. I spent a couple of years swapping formats and equipment on eBay, and frankly, I had a lot of fun and don't regret it. But, I wasn't taking any good photographs, so arguably it was wasted time. I decided I had been less than successful because of the slowness and weight of my 4 x 5 so tried out a 6 x 9 with a Mamiya Press, and once I collected a system, it weighed substantially more than my 4 x 5 (and I didn't like the inaccuracy of rangefinder type viewfinders). I tried out Bronica SQ and really liked it, but felt guilty about the money (I still had all my 4 x 5 stuff) so Isold the Bonica SQ, with significant regrets since it was a lovely camera. I did eventually sell the 4 x 5 and tried Hasselblad, but found myself constantly running out of depth of field. I went back to a 4 x 5 and tried a good half dozen cameras, some more than once, before settling on an inexpensive, rock solid and quite odd looking Linhof Kardan Color, and it was with this camera that I actually got back to serious photography after a lapse of many years. I even went so far as to purchase a 19-inch Red Dot Artar lens, mounting it on a Technika board that was wired and glued to an applesauce can, which in turn was attached to another Technika board. This happens to

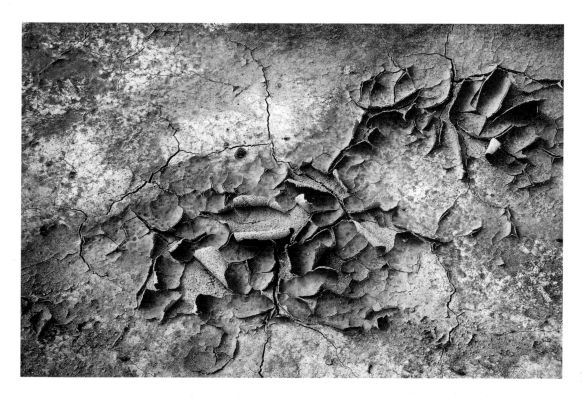

◄ Dried Mud
A single image photographed with my Sony 707. OK, so I can't make 16 x 20 inch prints, but you can make a lovely portfolio of images on 8.5 x 11 paper. It's the quality of the image that matters, not how big a print you can make.

be one of the few cameras solid enough to make this combination possible, and darn that 480 mm lens was sharp!

It was about this time that I started playing with digital cameras just for fun, but one thing led to another, and here I am today working totally digitally.

When I had a digital Sony 707, I was able to use it for serious photography by stitching, shooting a minimum of four and usually 9-12 images for a stitch.

But, I wanted better. I purchased a Canon 10D shortly after it came out to glowing reviews, but even with that I largely used stitching in order to get the highest quality, usually stitching only single row, which made life a lot easier.

After some time I was getting serious about selling my work and people were asking for larger and larger prints. The purchase of a 24-inch printer and a Canon 1Ds2 ensued.

You might think that I am in no position to comment on equipment envy because I already have a multi-thousand dollar camera and a 24-inch printer (and several others too). The point is that I continue to suffer the same equipment envy: I drool when I read of Michael Reichmann and friends using their medium format backs, even though I know that if I were to use one I would have to give up the zooms and long lenses which I like so much. Sure, a 24-inch printer is nice, but for a recent show I had to make 36-inch prints on 44-inch paper. I admit that I was trying to find a way to justify the cost of a really big printer, but fortunately, sanity reigned and I held off.

The fact is that the feelings of, "if only I had better equipment", are exactly the same no matter how good the equipment currently is.

▲ Bluffs and Saddle
This called for six images stitched and work in Photoshop to emphasize the bluffs in very flat light.

We get rid of a Technika because it is awkward to use with full coverage of a 90 mm Nikkor lens, even though that is my least used lens and rarely do I need the shift anyway. I justify cameras that are faster, even though the things I photograph aren't going anywhere.

Before you spend any more time ogling better cameras, here are some things to think about.

The questions to ask yourself are:

- How much equipment do I need, and how good does the equipment have to be to do what I really need to do? Can you actually see the difference in your normal print size between a $200 lens and one costing $2000. Remember that expensive lenses are often that way because they have a wider f-stop and are sharp wide open—necessary for some kinds of photography, but perhaps not yours. I happen to use f16 more than any other f-stop since I need the maximum depth of field more often than not. It really doesn't matter to me if the lens is fast—in fact just the opposite because fast lenses are heavy lenses.

- What would new equipment let me do that I can't do now—and just how important is that?
- Just how big do I really need to print?
- So, how much equipment do I need?

And, remember that there is a price attached, and I don't mean financial.

- Anything you buy, you have to carry. Your backpack is getting bigger and heavier.
- More equipment means more decisions to make over which lens is best to use for each shot.
- More time will be spent changing lenses.
- There is more risk that you have the wrong lens on when you get that fleeting moment of the right expression or the perfect light.

I sometimes wonder about having a 400 mm lens. As it is, I carry a 300 mm lens and use it only occasionally, usually in predictable circumstances, and the number of images in which it was essential AND ended up creating one of my portfolio images is minimal; perhaps four images in two years, which is a lot of weight and bulk for such little return. Perhaps for those few occasions, I could have gotten

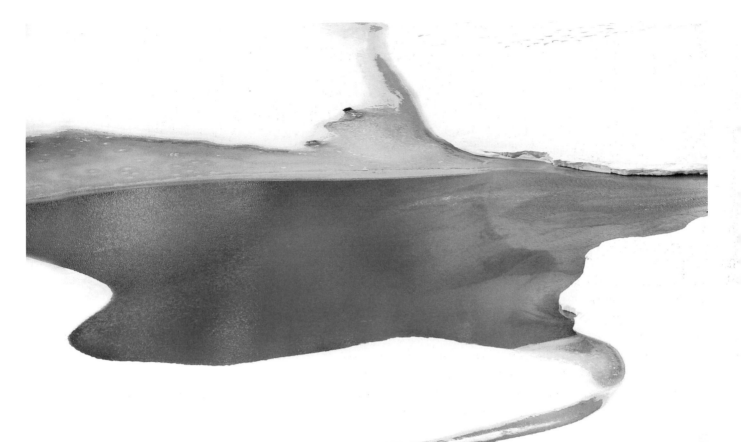

▲ Lake Louise
Two image stitch on the Sony 707, it has sold well. Makes you think, yes?

away with my 70-200 zoom and a 1.4 EX teleconverter. Mind you, my 300 mm lens is exceptionally sharp and I'm reluctant to give it up, but in hindsight, it wasn't a wise purchase.

How Good the Equipment?

There are photographers who switch from Canon to Nikon, and back again every few years, as each company moves ahead with new technology. They are always striving to keep up with the best, but at huge financial cost and some considerable cost in getting comfortable and fast with the newest equipment. The cheapest DSLR (digital SLR) is capable of wonderful images, as are a number of the higher-end consumer compact digital cameras. The quality of the image goes up ever so slowly while the cost of the camera rises exponentially. I don't regret purchasing my Canon 1Ds2, as there are times when stitching is impractical due to subject movement, wind, or speed, and the large prints I am able to produce with the camera are something I can sell.

On the other hand, unless you are already selling big prints (24 x 36 inch), just what the heck are you going to do with such large images? Do you really have that much wall space? Can you really afford the $10 in ink it takes

to make just one of these large prints? Of course, it's nice to be able to on occasion, just out of curiosity, but the fact is that many of the images in this book were made with a 6MP DSLR. And, with stitching my images, I can make prints that are more than big enough for 99% of my purposes (never mind someone who isn't selling).

There are times when it can be important to have a camera that is capable of shooting 30 RAW images before running out of buffer space, but is it important to the kind of photography you do? My good camera is in for repair at the moment and I'm shooting with a digicam that takes 3.6 seconds to save each RAW image, which is a little inconvenient. Does it stop me from getting the kinds of pictures I like? Absolutely not!

Try to work around the limitations of your equipment. For example, I built a $10 wooden device for rotating my digicam around the nodal point, both horizontally and vertically, for easy stitching. This way, it makes a pretty darn good replacement for a camera costing ten times as much.

What would new equipment allow you to do that you couldn't do now?

A macro lens would be nice. But, are macros your specialty, or do you have any reason to think it might become yours? Would macro shots fit in with the portfolios you are already creating? If you don't have any portfolios you are working on, then you probably aren't ready for ANY new equipment. You have bigger fish to fry!

Money

Regardless if you are independently wealthy or on a tight budget, there is a certain amount of money you are willing to spend on photography. Think about that amount in terms of percentages. You start out with 100% of your photographic spending budget. Your spending options include new lenses, accessories, a tripod, camera bags, or a whole new camera (or even a new format). Your budget should also include books, magazines, printer purchases, workshops, travel expenses, and consumables such as ink, paper, framing supplies, matte boards, and so on.

If you blow 100% on a new camera, how will you be able to prepare for that show you were offered at the local coffee shop?

Are you more likely to increase your numbers of high-quality pictures with a new zoom, or through purchasing half a dozen books of photographs, or by attending a workshop?

Hobby money is still an investment in image making, so ask yourself, "Where do I get the best bang for my buck?"

Statistics and the Odds of Success

Throughout this book I have supplied strategies for dealing with failures, disappointment, and slumps. It seems to be time to discuss what the reasonable expectations are from your shooting—what should your score be? There are huge variations amongst photographers, formats, and subject matter. A photographer of a football game might fire off as many as a thousand shots to get one really great image for the cover of the sports section of the local newspaper, and he would consider it a good days work.

◄
Roofs from Balloon
As you can see, there are several images from my one balloon trip scattered throughout the book, making it one of my most successful shoots ever. Expensive at the time, but a good investment in the end.

Were you to suggest a one in a thousand success rate for someone shooting ultralarge format (say 8 x 20), he would probably laugh. Rather, he hopes for one good image in ten. Now, that does not mean one perfectly exposed negative in ten–he expects all of them to be technically perfect–but one in ten to be a good photograph overall.

For myself, I find my average is around 1 in 100. My success rate is actually a bit better than that, because probably two out of three shots are for blending exposures or focus changes or stitching. This would equate to a success rate of about 1 in 40 images. That means that 39 times out of 40, when I see something worth photographing, it doesn't work out for some reason. Yesterday, I was photographing at an old machine shop. I was particularly excited about one image of old boxes of welding rods. Despite looking good when I shot the image, when I processed it the result was harsh and the lighting poor. A number of images were basically experiments: I wondered if this or that would make

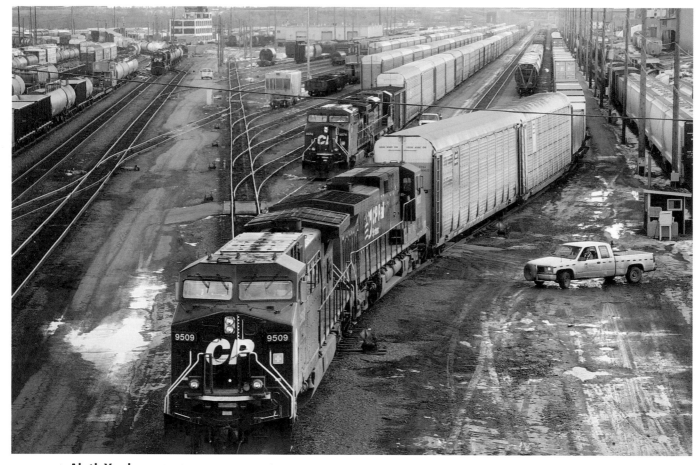

▲ Alyth Yard
Without the truck or the puddles, this image could be very boring. It can be worth returning to a scene if your images don't quite have what's needed.

an interesting image, and while most didn't, a few did.

Do you have any idea what your success rate is? It is worth looking back at how much work you have done and how many keepers you have made, because that means you can predict the odds of success in the near future. If you are like me and get a decent image 1 in 40 times, then to get a single image from a shoot, you had better try 40 setups, on average that is. Sure, sometimes you can make a single exposure and get it right and have a keeper, but other times 100 shots is not going to be enough. This is where working the scene comes in (see page 39). If you simply shoot off

a whole lot of random images, your success rate is probably going to be one in a thousand, or maybe worse. These 40 setups for 1 image each required time and care, repositioning just right, getting knees dirty, waiting for wind to die down and for the light to be just right, or for traffic to clear.

If 1 in 40 images is a keeper, and if a typical day's shooting is 40 distinct shots, then on average, you are going to get a single good shot from a day's shoot. Statistics being what they are, that means sometimes you won't get a shot at all and other times you might get half a dozen, but on average...

You can, therefore, anticipate that some weekends you will not come home with any good images. You should be prepared for that disappointment. You should enjoy yourself while you are out shooting enough that even without an image, you can feel it was time well spent. And, you need to get out and shoot on enough weekends that averages will take effect. Flip a coin once and there is no saying what you will get: Flip it 1000 times and you can reasonably predict a 50:50 ratio of heads and tails.

Therefore, photograph often for success, but don't get too down on yourself if a weekend's shoot doesn't work at all. It is to be entirely expected. The statisticians say so, as do I.

On Negative Thinking

Have you ever talked yourself out of something by convincing yourself beforehand that it is a dumb idea? You might have told yourself any of the following:

1. It won't work.
2. Others have done it better.
3. My camera equipment is not good enough.
4. There's too (much/little) (sun/wind/cloud/etc.) for good photography.
5. There is not enough time.
6. I have been shooting poorly lately, so this will be bad too.
7. I have tried my best, and it just isn't good enough.

There could be any number of other negative self-talk messages.

Arguably, negative self-talk like this is marginally better than the opposite (i.e., "Today I'm going to shoot a masterpiece, a photograph to transcend all others I have ever shot.")

On the one hand, with this type of negativity, you set yourself up to fail or you won't even make an attempt: On the other hand, you set standards that are so high and unrealistic that meeting the standard is extremely unlikely.

Perhaps, a more realistic type of thinking somewhere in between might be best. Even better is to go out with the attitude of, "I will make the best of what I find. I may not make a masterpiece, but I don't even give myself a chance for success if I don't go out and shoot."

Following are some observations:

1. Most photographers get better with time. I have a nice book of Ansel Adams' early mountain work, but frankly, it would never have seen the light of day if he had not already been famous. Trust me—he got better with time.

2. The only way to not make progress is to keep screwing up the same old way. So, get creative! Find some new ways to screw up (and more to the point, stop screwing up the old ways).

3. Most photographers fail for lack of effort or skill, not talent. At workshops, most of the prints fail due to pretty basic reasons (i.e., technical glitches, poor printing, weak composition). It is unusual for them to fail because the photographer had a dumb idea or couldn't find anything interesting to photograph. This means that any lack of perceived success on your part is overwhelmingly likely to result from fairly simple errors due to insufficient skills, which could be overcome with a bit of work.

4. There are more photographs out there waiting to be taken than you have time to shoot. Believing there is a lack of something to photograph is really just laziness

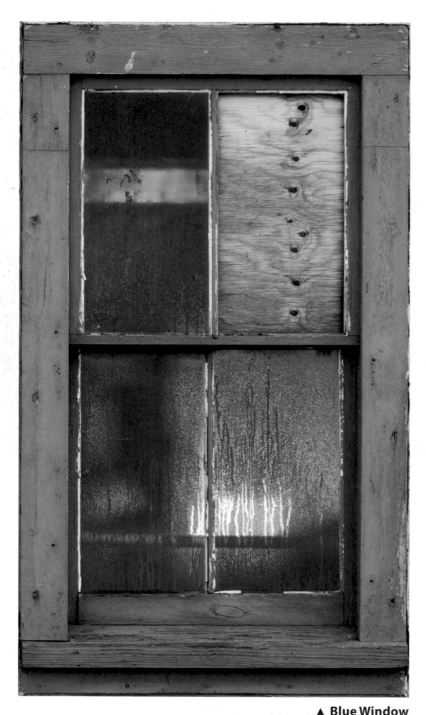

▲ Blue Window

On a workshop and traveling with Bruce Barnbaum—
he concentrated on the whole building sliding into the sea after a
storm, while I put on my longest lens and concentrated on the one
window, tilting the camera to match the falling building.

or pessimism or discouragement. Just get
out there and shoot!

5. Failure to find great images is often a mat-
 ter of not finding what you expected or
 hoped to see, and then not being able to
 shift mental gears into taking advantage
 of what is offered.

6. Sometimes we set ourselves up to fail by
 not getting up early enough to catch the
 best light, or being in a rush, or hoping
 we don't need our tripod when previous
 experience tells us we do, or any number
 of other "fail before we start" issues. My
 friend forgot his camera plate on Friday,
 fortunately he could go home and get it
 and return to the machine shop to photo-
 graph with me. I might have gloated, but
 I've done the same thing myself. (Have
 you ever gone out with a view camera, but
 without a single cable release? I don't rec-
 ommend it!) My friend's mistake was not
 in forgetting the plate (though perhaps a
 checklist would have been a good idea).
 No, his mistake was to take the plate off
 and put it somewhere other than in his
 camera bag: It shouldn't have mattered
 that he took it off. Had he simply put it in
 his bag he would have had it with him any-
 way. His plate tightens with a dime, but
 mine needs an allen wrench, which I keep
 in my camera bag, because one time the
 plate got loose and I had to keep tighten-
 ing it by hand (see dumb ideas!).

The worst mistake I ever made was with my
beautiful new mahogany Wisner 4 x 5. I had
tested it in my back garden, but this was my
first trip out with it. I set up the tripod by the
car, placed the camera on the tripod, mounted
the lens, and swung the combination over my
shoulder ready to head off. The front board
(with the heavy lens on it) rolled out of the

camera base, fell off completely, and "accordioned" towards the road. Having gained a certain amount of momentum, it now had enough force to drag the back standard off the base too, and both headed for the road at high speed, falling from about six feet up. Upon meeting the road, the Wisner turned into a pile of kindling (or perhaps more of a camera kit) with multiple pieces of broken wood, splayed joints, and only by some small miracle, no damage to the lens. The good news is that wooden cameras glue back together very nicely and you would hardly notice all that had happened.

The oddest dumb idea I ever had was when I was photographing some horses. I realized I'd left the dark cloth in the car, so while I went back to get it, I carefully placed the camera over the barbed wire fence so the horses couldn't knock the tripod over. What I hadn't considered is that the horses would reach over the fence and proceed to eat my camera, starting with the bellows. And I thought horses were vegetarian!

It is my policy to always zip up my camera bag after removing a lens, even though leaving it there open would be a lot handier if I need to change lenses again. You might wonder why I implemented this policy. One time when I was in Ontario, I was standing on a concrete bridge base, surrounded by water. I picked up my case after finishing the shot, and you

▲
Leader of the Pack
A safari would be nice, but local farms, ranches, game preserves, and even zoos can be either rewarding in themselves or at least good practice.

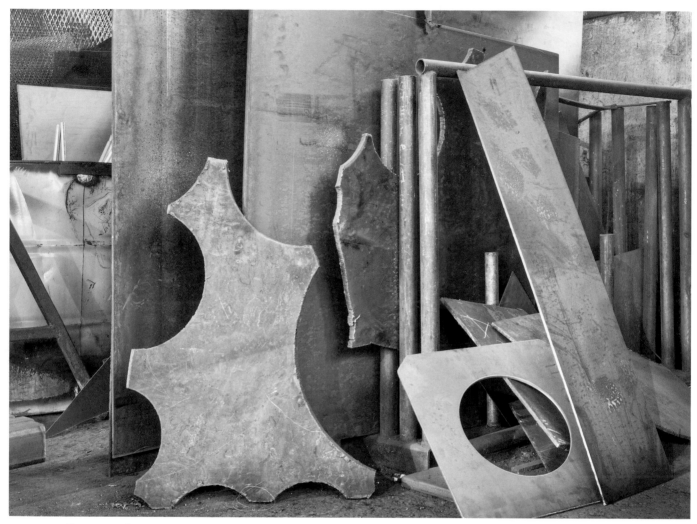

▲ Sheets and Shapes of Steel

I quite like this image, but for me it has one significant flaw. I wonder if you can spot what bothers me (answer on next page). I'd really like to reshoot it but everything has been moved, removed, or changed.

guessed it: The bag was not zipped and out rolled my 70-200, landing on the concrete, but by a miracle, not rolling on into the water. Thankfully, it still worked fine. I now zip the case.

7. If Ansel Adams made 12 great images a year, as often as he photographed, that means he made hundreds of less than great ones, and that because he certainly shot a lot more than a dozen times a year, his odds of a good picture were probably in the order of one great image out of every four expeditions. That being the case, why are you beating yourself up when you don't create good work from almost every trip? Failure is the norm: Greatness is the exception...for all of us. So, what is the solution? Photograph more often! If you don't have the time for big excursions, then find a reason to photograph near your home (such as the machine shop mentioned earlier).

8. If we are going to fail to create a great image more often than not, then we'd better

be enjoying ourselves the other 99% of the time. It is about the journey, not the destination. It is like watching soccer—the near misses are pretty exciting too.

Looking for Perfection—The Price of Experimenting

If there is a hallmark for the frustrated amateur photographer, it is the amount of experimentation that is performed. And, because I'm guilty of this, I do know whereof I speak.

Not only is experimenting time consuming, it often means that even when we aren't conducting an experiment, we are, in fact, using tools we have not yet become skilled with. Any poor results obtained are so tied up with technical aspects that it's hard to know, or at least recognize, that the real problem with the photograph is that you pointed your camera in the wrong direction.

We fuss about excess grain and lack of sharpness; and we worry about lens quality, enough pixels, and which format is right for us. That much worrying surely takes away from the important question of, "How do I make a meaningful photograph?"

Answer from image on previous page—That small square sheet of steel with the circle hole drops out the bottom of the image—if only I'd noticed and stood it up a bit so the bottom corner of it touched the bottom of the image and it lined up with the larger sheet to the right. Oh well... It's all in the details.

Another problem with experimentation is that the average photographer has minimal scientific training, and either hasn't a clue about setting up a useful experiment, or doesn't bother to do so.

I'm a doctor and I treat patients who struggle with depression. Sometimes patients end up taking several medications, as well as going for counseling, and if they continue to struggle, I have to decide what to do next. If I increase drug A at the same time as I reduce drug B, how do I know which made any resultant difference? I have to explain to my patients that we need to make such changes in two steps, and then wait long enough to assess any effect. In photography, we often find ourselves changing many variables at once, (i.e., the new film goes with its own different developer, or a different camera uses another RAW processor).

Often, experiments end up producing results that are hard to assess. Camera A has 20% more pixels, so do you compare to camera B at 100% or in a standard print size? And, if using the latter, what size? One film produces finer grain, but not the same feeling of sharpness as with another. Photography and photographs are full of such compromises.

Another issue in experimentation is that of cause and effect. Were I to put a patient on penicillin for a cold, I could reasonably predict that within a week or so they would be better. Of course, because colds are viral and don't respond to penicillin, the response, in fact, is simple resolution of the infection on its own, and has nothing to do with the penicillin. Colds naturally get better. Yet, it is extremely difficult to persuade perfectly intelligent patients that just because the last three times they took penicillin for a cold, and they got better, there is no justification for giving it this time in the same circumstances.

So, what happens when you change films for a new project and you like the results? Is

the improvement an effect of the film change, is it simply because you are getting better, or is it because this particular film suits the new project? Could it be a change in development time necessitated by the new film? When you change something without running an experiment, you don't know whether there is a relationship at all. To do an ideal experiment you would have to keep the subject matter and lighting the same, and you would have to optimize development for each film before you can even start asking questions.

Few of us have the time, money, or inclination to do the rigorous testing, which would truly show the differences between two products or methods. We read about using high contrast copy film with low contrast developers for the ultimate resolution, but we forget to check to see how many successful photographers use that method (none that I know of). We agonize over the perfect large format camera, even though the majority of successful 4 x 5 landscape photographers use Technikas (Bruce Barnbaum, John Sexton, Craig Richards, etc.). It is true that Technikas are not perfect, and no, they aren't particularly pretty, and some people hate the four knob back tilt system, and using 90 mm (and shorter) lenses is problematic, especially if the lens has excess coverage and you want to take advantage of it. So, we hunt for the ideal camera. We hear that nothing is better than a $5,000 Ebony, so we agonize over how to justify such a huge outlay of cash (and stay married).

If digital, we have to battle with full frame sensors vs. smaller ones, a variety of sharpening algorithms, RAW converters, and whether to edit in Photoshop or LightZone or some other program.

Sometimes, we try to copy the successful photographers in their equipment choices, not realizing that the reasons for their choices may have little, if anything, to do with the quality of the pictures, but more to do with the kinds of pictures they get paid for or the demands they receive for very large prints.

There is little point in drooling over a 16 megapixel camera if the only printer you own prints a maximum size of 8.5 x 11 inches, and you are hoping for 13 x 19 inch printer one of these days. The majority of landscape photographers who use a medium format digital back are people who are rich enough (from other occupations) to afford a luxury item. These are the same people who drive luxury cars, live in big houses, and can afford exotic holidays—and more power to them for having earned that money. But, they aren't like most of us, and they certainly don't account for the majority of successful landscape photographers, most of whom still use 4 x 5, or DSLRs, or even 35mm film, and can't afford to, or don't want to, go to digital medium format.

It is my observation that too many photographers try to hide very ordinary images by photographing them with extreme equipment for the absolute highest quality. Yes, an 8 x 10 contact print looks better than a blow up from 35mm, but not if the image was poorly made. To be fair, the limitations of using large format equipment means that working the camera takes precedence over working the scene, which makes me admire all the more those who do make really strong images with large cameras.

Having examined some of the issues surrounding experimentation and perfection, consider the following:

1. Ask yourself if you are an experimenter or a photographer.
2. If you do decide to experiment, then limit the variables, eliminate the distractions

◄ Legislature Building
A multi-image stitch with the Sony 707. Were I shooting this today, I'd shoot a variety of exposures and blend the result for better shadow detail. Black and white film would have had no problem with this, though color slide film sure would.

(like camera shake), and ask yourself if you can reasonably expect an answer to the question you have asked with the experiment you have designed.

3. Don't do experiments while taking real photographs. Experiments are distracting, you might be on the "placebo" arm of the study, the materials are less familiar to you, and you might be risking your best shot of the year to a new tripod. Not a good idea.

4. Limit the number of experiments you perform, and instead, take as a guide the photographers whose work you admire.

5. Ask yourself sensible questions. For example, asking whether 4 x 5 makes better pictures than 35mm is not the issue: The real question is, which format is best suited to your needs? If you truly hate using a tripod, then use equipment that is well designed for handholding. If you prefer to take pictures only when you happen to see something interesting, rather than deliberately going out shooting, then you need equipment that is easy to carry so you can always have it with you.

6. Instead of experimenting at all, get out and photograph with whatever equipment you have at hand. It doesn't really matter whether it's a Minox or an 8 x 10, a cell phone camera or a full frame DSLR: It can't take good pictures if it isn't being used. (And, using it to photograph brick walls to check resolution doesn't count!)

t was spring in the Rockies and my wife and I were taking a weekend break in Kananaskis Country, an hour west of Calgary. There had been some interesting snow formations along the Kananaskis River, but by this time in the year the snow was dirty and though I tried photographing it, I wasn't too surprised to find it didn't work. I headed south on Highway 40, with no particular expectations, and found this rock cut next to the highway. The shale was wet from thawing, iron from within the rock added some orange color, and there was yellow lichen decorating the rock.

t wasn't especially difficult to find the image as it stood out compared to the surrounding areas. I found this particular framing worked for me, though as it didn't seem to follow any known compositional rules. I couldn't have told you why I thought it would work—it just seemed right. After looking at hundreds of thousands of images over the years, intellect can afford to take a back seat to instinct. That this is still one of my favorite mages suggests that something must have been right.

he photograph was taken with my 70-200 zoom near the shorter end, and it consists of three images stitched, using my homemade wooden nodal point rotator. I found the yellow of the lichen clashed with the orange of the rust, so I warmed up the color of the lichen to fit better. he blue in the wet shale comes from the reflected sky. The lighting was relatively flat, so there has been some increase in contrast. One problem of bright sun is the deep shadows, but there are ways around that (altered ilm development, blended exposures, and so on), but a bigger issue is that surfaces tend to be lacking in texture and you can't easily increase contrast because of the harsh lighting. Diffuse sun or even full cloud cover are better; though if the sky is evenly lit, the images are often extremely flat looking overall, and even image manipulation may not be enough to save them.

A day with a number of passing clouds is a huge blessing, as I can literally stand there and choose exactly the kind of lighting I want. Many are the afternoons I gaze skyward squinting and looking for the sun to just start appearing through the clouds, but not too much now! Of course, just when the sun is right, the wind picks up, but that's another story.

have reshot this image twice in an attempt to be able to make really arge prints, but on neither occasion did it look anything like this—you'd think rock is rock, but with lighting and the wetting just so, the other hots are nice, but they don't replace this one.

Windshield

Just east of Drumheller and the Tyrell Museum of Paleontology lies the Atlas Coal Tipple. This historic site mined coal until the 1970's before finally surrendering to oil and gas for power, and to huge open pit mines for shipping coal to Japan. Located in the Red Deer River Valley, the actual mine goes into the hillside while the tipple and it's equipment sits in the valley. While much of the coal was removed via rail, trucks also hauled a considerable amount of coal and the site has a collection of antique trucks from the 50's and before, including this one.

The cracked windshield was the first thing I noticed; but then I saw the shape of the roof, the diagonal lines of the windshield edge, and the small rectangular vent window. The faded paint of the vehicle was good, the rust adding character and age.

I did have to make one change—that marker light is in fact bright orange in the original image and clashes horribly with the pink/red of the truck. I was able to deemphasize the yellow of the light while increasing the magenta for a better match to the rest of the image. Oddly, I had to do very little to the cracks in the windshield—a minor increase in contrast was all.

When it came to selecting the images for this book, my wife consistently rejected this image and obviously, I overruled her. It's possible that I "see" in this image things which don't actually exist—the whole experience of being at the tipple, the sense of passing time, the weathering. In the end though, I think we have to be true to ourselves, so I was and here it is!

Every time we choose or adjust or search for that which we think others will appreciate, rather than what moves ourselves, we sell off just a little bit of our soul and thereby weaken our photography. One might not force an unpopular image down a client's throat (so to speak), but I might well use it in a portfolio I was hoping to get published, since it is important to me and I can't predict the tastes of the editor. I am making a statement with my work—this is me, this is what's important to me, this is how I see the world.

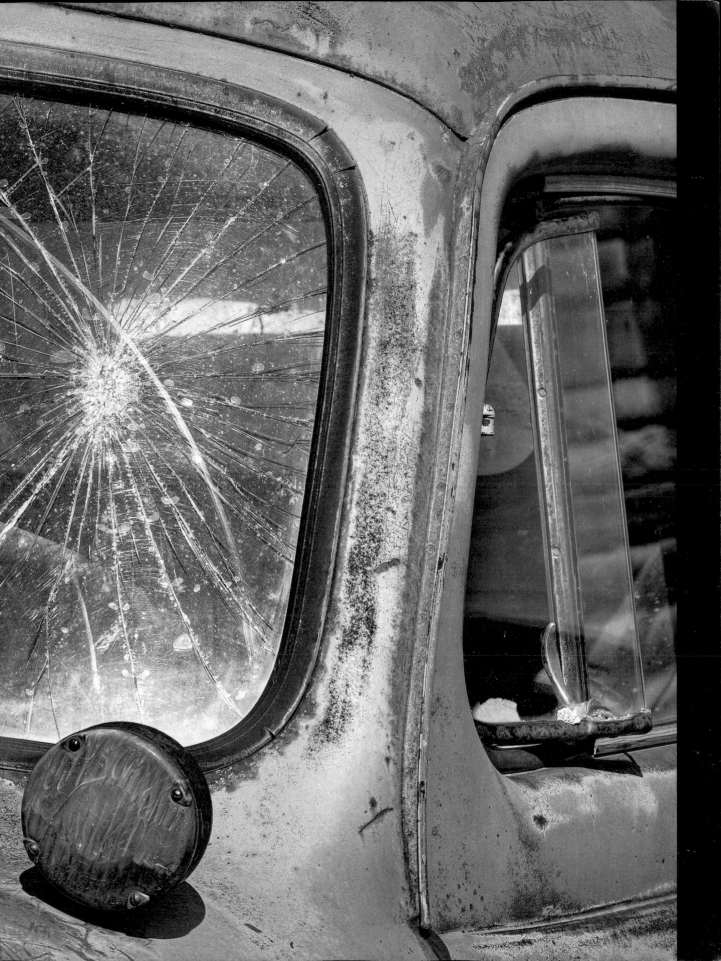

6 Take Your Photography to the Next Level

▲ Sundance Rose

Background is critical to the image. It took some effort to find the right focal length and position from which to photograph that would show the rose against only the colorful rock in the background.

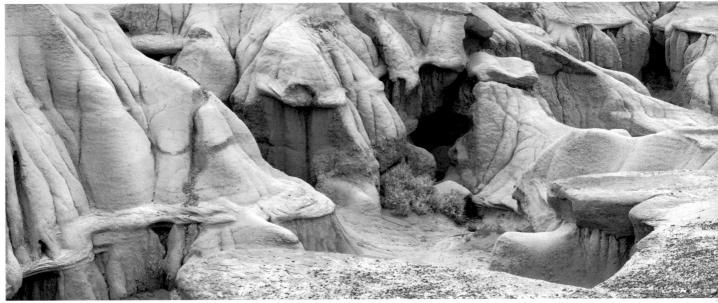

▲ **Bluffs and Bush**
While full sun produces harsh shadows, images taken in flat lighting need considerable editing to restore the three-dimensional effect and to separate layers within the scene.

Introduction

There is a fundamental flaw in the way most of us work toward improving as photographers. We practice what we're good at and we largely ignore the things at which we aren't skilled. For most of us, this means many hours spent agonizing over technical issues (sometimes not even the right ones), while mostly ignoring the aesthetic. It was this premise that spurred me to write many of my essays, but ultimately it was the following three essays found in this final chapter that caused Rocky Nook to contact me and suggest the idea of this book. While the book is focused on the nontechnical side of photography, the three articles that follow here also discuss technical problems. We elected to include those parts, since technical failures are every bit as frustrating. A bad picture is bad regardless of the reasons, and my goal is to help you make wonderful images.

Photographers go through various stages of development, and while we don't all follow the same path, I believe that an understanding of your current level of skill, creativity, and artistry is important. If you know where you currently are and you have an idea of where you want to be, it becomes easier to determine the path from here to there and to take the necessary steps to get there. I suspect that most of you have never systematically worked out where you are in terms of skill, creativity, and artistry, and even if you have, you may not necessarily be a good judge of your own skill and level. More commonly, photographers feel good about their work when things go well, and are very pessimistic when they don't and so assess their levels very differently depending on the day. Thus, identifying your own level is not a trivial process. While gradually and continually striving to improve does, in the end, result in progress, I propose that you find a better, and perhaps more direct route to becoming better photographic artists.

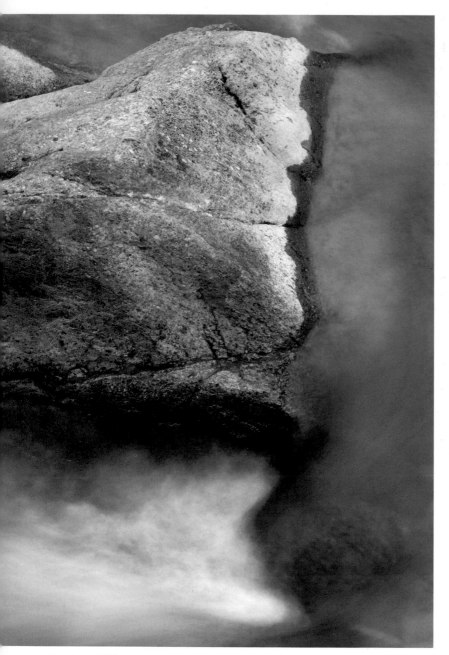

▲ Rock and Wave
You may be frustrated because, in your neck of the woods, there are no grand vistas or dramatic scenery, but small details can be rewarding.

The premise of the following three articles—Finding Your Level, Getting Help To Assess Your Level, and Moving On To Better Images—is that at any given level of skill, there are some things you could do to improve and which are likely to be more effective than others. Furthermore, these things vary with different levels, so knowing your level will help you find the most effective steps you can take to become a better photographer.

Part 1—Finding Your Level

So, how do you assess your current level? What are the levels? Do all photographers go through the same levels in the same sequence? Is it a sequential process or can you skip steps and go back to a previous level? All good questions!

Even if you do understand your level, does that automatically imply you will soon move to the next level, or is there some magic involved, or heaven forbid, some sweat equity required before moving up? I hope to answer these questions in the following sections, starting with this first section, which discusses what the different levels are; in the second section I discuss how to assess what is your current level; and in the third section I discuss how to use this information to move up to the next level.

Before describing the various levels, let me make clear that I don't think this is a linear sequence from neophyte to grand old master—not for an individual photographer and certainly not for all. Depending on how you come into photography, there can be huge differences in the sequence of steps, and steps can be skipped at any point only to be visited

▲ Smithy
Historical parks and museums can provide an interesting variety of subject matter.

later on. That being said, here is a breakdown of the steps photographers often go through.

Rather than define levels by the equipment you use (which has more to do with style, habits, budget, and the desire for toys), I will instead look at the quality of the images you produce. Perhaps this doesn't address the photographers who only publish to the Web and never make prints, but their level can be defined by the kind of prints they are able to make (even if they don't usually make them).

Measuring Print Quality

The quality of prints can be measured in two basic ways; by the technical quality and by the aesthetic quality. I think these two sets of levels definitely do not go hand in hand. Therefore, I am going to describe them separately, and I fully anticipate that most any photographer is likely to find him/herself at different positions down the two lists.

Remember too that not all your images are at the same level. Instead, we are looking to identify the overall average of your skills. A year or so ago I became aware of the photographs of Shaun O'Boyle. He had some interesting ideas and visited some wonderful locations, but for the most part he was still developing his eye at that time. He had a particularly interesting series of images from

an abandoned mental hospital, producing several nice photographs from there, but one particular image was outstanding and I had absolutely no hesitation in suggesting a swap, which fortunately for me, he agreed to. This image of a hallway and repeated doorways is absolutely stunning. I paid a couple hundred dollars to have it professionally framed and have not tired of the image. With that said, this one image, in my opinion, was head and shoulders above the rest of his work at the time. I recently had occasion to return to Shaun's website only to find that his work has improved by leaps and bounds—a lot of recent work in black and white is excellent. I don't know what Shaun did to improve his photography, but he has made amazing strides and is now a force to be reckoned with. Somehow, I don't think he spent the year experimenting with different developers.

Right. Time to make the lists! Let's start with the list that is almost certainly going to be the easiest: that of defining one's technical level. Note that it is possible to be at two different levels of technical ability at the same time, since they sometimes describe different technical issues.

Identifying Your Technical Level

Technical Level 1

Someone who is at Technical Level 1 quite frequently has 4 x 6 inch drugstore prints that are flawed. Many are blurred, others are underexposed, horizons aren't level, heads are cut off, trees stick out of people's heads, and the prints look muddy or sooty or chalky. People and mountains look miniscule. These are the kinds of images that even beginners recognize as flawed. In a set of 20 prints, it is common for 12-15 to be rejected by the

photographer as duds. It's actually hard to be this bad in the age of auto-focus and auto-exposure, but some find a way.

Technical Level 2

At Technical Level 2, drug store prints are starting to look technically fair, if not great. There is a lack of awareness of good lighting and capturing peak moments. The photographer is sometimes disappointed in the results, and other photographers easily spot the flaws. Any print adjustments that are made are not helpful. Careful observation identifies issues with depth of field and accurate focusing, and steadiness remains an issue. Larger prints can't be made due to these shortcomings.

Technical Level 3

For those at Technical Level 3, we're talking self-made 8 x 10's or thereabouts. The prints look OK to your friends and you are starting to garner some nice comments; but when someone with experience looks at them, he/she notes highlights that are blocked or muddy, and shadows that are either solid black or unrelieved gray. Prints often show sharpening artifacts or color that is overly saturated. Print controls are applied with a "six-inch brush" and the images show it. There remain small issues of sharpness and resolution.

Technical Level 4

When one is at Technical Level 4 his/her prints are basically OK. They show proper focus, a steady camera, correct overall tonality, yet they don't have that rich, three-dimensional look that expert prints seem to have. At this level it is getting harder to describe the defects; but when viewed next to good prints, it can be seen that they definitely lack a certain something. Highlights are still not rich

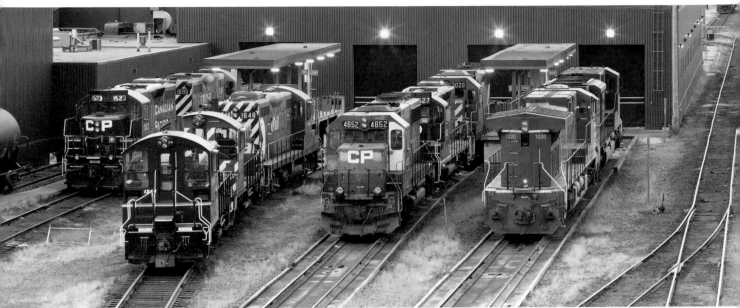

▲ **Engine Shed**
Although railways are rather strict about security and simply wandering onto their property is likely to get you arrested, there are often viewpoints which have public access—in this case an overpass. The image was taken before sunrise.

and shadows lack depth. Local print manipulation is fairly effective, although sometimes there is too much or too little. These prints are adequate for a photo album, but not to hang on the wall.

Technical Level 5

Technical Level 5 is not really a sequential level, but simply a problem commonly seen at workshops. Eight-by-ten prints look terrific and can't be criticized on a technical basis. There are some presentation issues, such as high gloss, plastic prints with scuff marks; unattractive, irregular small borders; borderless prints; and prints that are too large for the equipment used to make them. Photographers at this level often insist on printing larger than the image can bear, relying on trick upresizing (increasing the size of an image by artificially increasing resolution) and sharpening algorithms to save them. They don't succeed!

Technical Level 6

At Technical Level 6 there is nothing to criticize about either the image itself or it's presentation. Print manipulation is competent and invisible. Prints show subtleties and have depth. Tones are rich and absolutely nothing is overdone. Unfortunately, that just leaves the aesthetic issues, which are much more challenging.

And, now, onto the aesthetic levels. Again, keep in mind that levels are not necessarily sequential, and more than one level can apply.

Identifying Your Aesthetic Level

Aesthetic Level A

For those at Aesthetic Level A their images don't seem to have a point, they don't show things to advantage, they don't capture the peak action or the best pose, and they are the kind of pictures that only a generous person would complement. It takes no photographic skill or artistic experience to know these don't

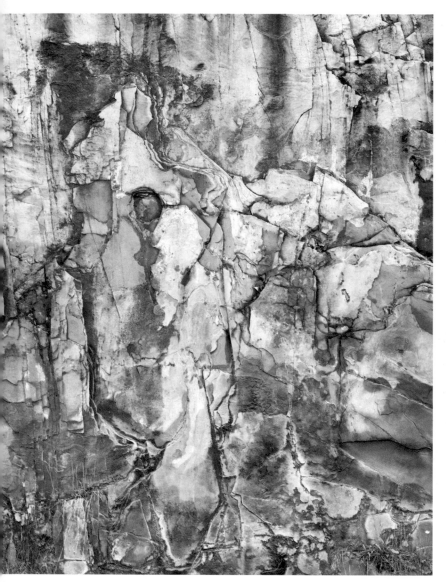

▲ Wet Shale, Version 2
In reshooting one of my favorite images, even
though it's rock, the result is not the same. I like
this version too, so at least I have a choice. This
version is more literal.

The photographer wonders why he bothered to
take the picture.

Aesthetic Level B

Someone at Aesthetic Level B can make de-
cent snapshots. To record memories of events
and people and places, they serve well, even
though they don't excite. There is no wow fac-
tor. The photographer is comfortable showing
the prints to friends who are interested to
know what their holiday was like, but he'd not
likely take them to other photographers. The
images don't reflect the excitement that was
felt at the time of taking the image.

Aesthetic Level C

The Level C photographer's images do gener-
ate admiration by friends, but perhaps not by
photographers or artists. They capture peak
action, best poses, and dramatic lighting. They
begin to show some awareness of composi-
tion and are almost good enough for the New
Sarepta Tire and Girdle Company's annual
calendar. These images have no artistic merit
at this point and can be generally described as
pretty pictures.

Aesthetic Level D

The photographer who is at Aesthetic Level D
has images that are starting to show artistic
value in and of themselves, rather than as a re-
minder of something or someone special. It's
easy to see that some effort was made to com-
pose the picture in ways that are interesting
and that the photographer was being creative.
But, there are elements of the image which
don't quite work, and it is the kind of image
which makes other photographers think that
this would have been a great image if only they
could reshoot it and fix X and Y. Some, but not
all of the compositional elements work. The

shine. We are talking about the typical snap-
shot here that disappoints even the photogra-
pher and often doesn't make it into an album.

▲ Badlands 2
This image happens to be from my 4 x 5, but even in good-sized prints, the image does not look noticeably "different" to my digitally shot badlands images taken more recently.

photographer is within a few feet of the right place and a few hours from the right time. However, the image is not strong and its message is not clear. There are elements in the image which distract from its power.

Aesthetic Level E

If you are at Aesthetic Level E, your images are generally admirable and most photographers would wish they had taken the picture. Composition is spot on, the subject interesting, and the presentation of the subject effective. The only thing missing is an emotional response to the image. The viewer is inclined to say, "Well done" rather than, "Oh my God!" or "Wow!" or "That disturbs me", or some kind of emotional expletive. Your images are starting to work on more than one level. Composition shows careful attention to detail and things are lined up exactly right in several planes. It takes more than 30 seconds to take in all that the image has to offer.

Aesthetic Level F

The images of Aesthetic Level F are very strong—they generate emotional responses. You might not mortgage the house to get one and they don't leave you weak-kneed, but they are wonderful. Most of us would be delighted to get a handful of images a year into this category. These images show us things we didn't know; they make a point, they illustrate and elucidate. Most of the images of the great photographers fall into this category. Responses to these images are "Awesome", "'Right on", "Great", "Damn that's good", and the like. It would be possible to spend 20 minutes looking at a single image and still find new things worth seeing, new connections, new messages.

Aesthetic Level G

The images of Aesthetic Level G are the great images of history—the ones that make you weep or cry out or swear. These are the handful of images that are so exceptional that even the best photographers in history have only been able to make a few at best. Here lies "Pepper Number 30", but not many other Edward Weston images. This level of aestheticism includes the best of Ansel Adams, but not all. It doesn't mean that we mortals can't create an image that fits this category, but we would count ourselves lucky if it happened once. These are the magical images, the ones that glow. They so perfectly get the message across they become icons of photography. They might be "Migrant mother" by Dorothea Lange or the Steve McCurry's Afghan girl portrait, the "Napalmed Girl Running" image, "Winter Storm Clearing" by Ansel Adams, or several Henri Cartier Bresson images.

Finding Your Level

Perhaps by now, you have an idea of your level both technically and artistically, and if so, the next step is to use that information to move up to the next level or even further. Since you can look at the definitions of the two levels, you can quickly get an idea of what it is you need to acquire, practice, learn, improve, and generally brush up on. On the other hand, you might be kidding yourself, or you may simply not be sure, and so the following essay discusses the ways and means to come to an accurate understanding of where you are.

Part 2—Getting Help to Assess Your Level

Assessing Your Technical and Aesthetic Skills

I have discussed the various technical and aesthetic levels that we tend to move through. It would not have been difficult to come up with different definitions for the levels, but I felt that the descriptions were both useful and realistic for many amateur photographers working through the ranks.

Perhaps you already know at what level you are based on the descriptions in the previous article. Just as a quick reminder, here is the Readers Digest condensed version.

Technical Levels

1. 4 x 6 inch prints often have noticeable technical flaws such as focusing, steadiness, and framing.
2. 8 x 10 inch prints show flaws, and print manipulation is either absent or flawed.
3. Prints look good to non-photographers, but not to experienced observers.

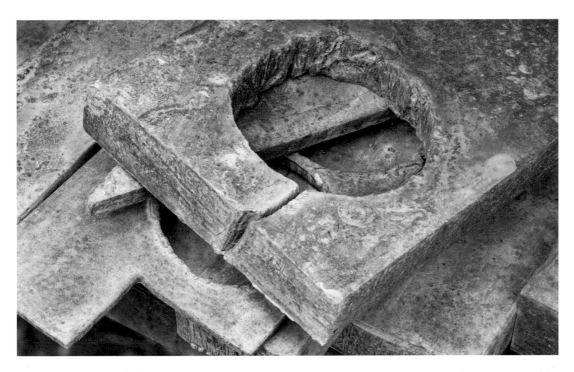

◀ **Hole And Triangle**
Looking like a Picasso painting, it seems only fair that Photography imitate art since sometimes art imitates photography, in this case abstract art.

4. Prints have no obvious flaws, but are not rich, deep, subtle, or three-dimensional.
5. Prints look great though presentation is lacking.
6. Prints look perfect.

Aesthetic Levels

A. Prints don't seem to have a point and don't make good snapshots.
B. Decent snapshots.
C. Friends admire your snapshots.
D. Prints start to have artistic value in themselves.
E. Prints are admirable but not wonderful. They lack emotional impact.
F. Strong images, great composition, making the point. Lovely!
G. The handful of the very best images ever made. The icons of photography.

I have been asked how I would select images upon which to base one's level. I would suggest selecting a portfolio of your top one- to three-dozen images of the last year and use those as a guideline. Your "best evers" could be influenced by luck, but this number of images over a relatively short period should be an accurate reflection for most people. In addition, you could look at all the images from a single shoot to see how consistent the quality of your images is. If you can consistently produce one strong image from a day's shooting, you are doing very well, and the quality of that image tells us more than anything.

Self-Assessment

So, you have gathered together a portfolio of your images and you are trying to see if you can assess your own level of skill. You have a rough idea from the descriptions of the previous section, but you are not sure. How about

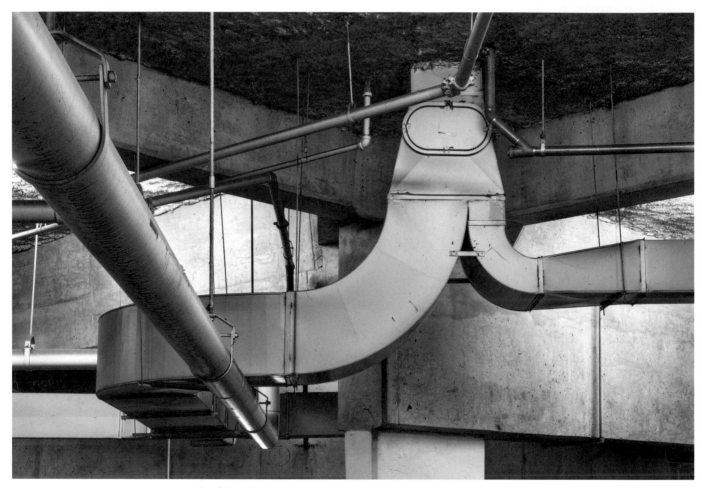

▲ Parking Garage

The oddest subjects can provide fodder for the inquisitive photographer. I was leaving the hospital around midnight and noticed some details in the parking garage. Since I was off the following morning, I decided to return with my camera around 2 AM. I almost got myself hauled away, but my doctor's bag saved me!

finding some published images in a magazine of good reproduction and holding them up next to yours? It might be worth $10 to rip up a copy of Lenswork, Phot'Art, Focus, B&W or another good photography magazine, so you can get a better comparison. Alternatively, look on the Web to compare your images to those of better-known photographers of similar interests. You may not be able to assess things like resolution on the Web, but you sure can look at the more important issues of impact, composition, and overall tonality.

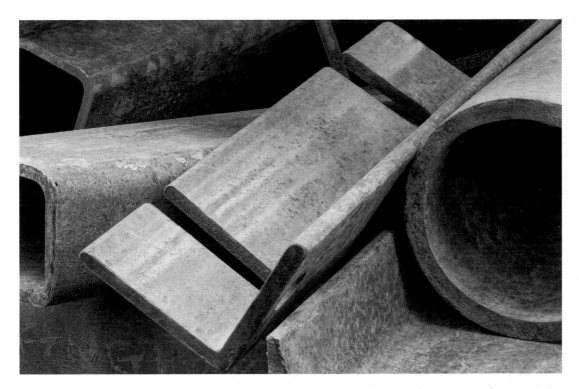

◄ Steel Tubes
Odds and ends lying around a machine shop provide the raw materials to make semi-abstract images.

Getting Help

I would suggest that even if you have a fairly good idea which of the above categories best describes your skills, you would benefit from checking with outside sources to see if your self-evaluation is on the mark.

In this section I'm going to discuss some ways you might be able to do just that. This could be perceived as a little bit scary because, in asking others their opinion of our work, we run the risk they may actually tell us, and heaven forbid, we might not like the answer.

I think a lot of photographers have a split personality. On the one hand we are extremely proud of the images we create and can be overly confident of their value. At the same time, many of us have that nagging doubt about our abilities and are convinced we are going to wake up one of these days to the realization we are crappy photographers who should find another hobby (say, beer-bottle-cap collecting). Unfortunately, what this dichotomy translates into is that we seem to bounce from one view to the other. We make a good image and we think we are the next Ansel Adams; but if we receive one valid, negative comment we are devastated and ready to give up the hobby. A few good shoots and we are on top of the world; one bad one and out come the bottle caps. Maybe I'm the only neurotic one on the block, but I suspect not.

There are discussions on the Internet about the destructive value of negative criticism, and no doubt it's true, but how else are we going to get the feedback and evaluation we need? We are going to have to gird our loins and not only take the feedback, but learn from it. While this may be fast, I didn't say anything about it being painless. The good news is that the pain doesn't last. We don't need regular

flogging—just occasionally, and interspersed with lots of positive feedback.

The Worst Kind of Feedback

Since the publication of the original version of my articles on the Luminous Landscape website, there have been discussions about the problems of "I like it" or "I don't like it" type of advice. That is not advice: That's artistic judgment, and it is extremely personal and quite unhelpful to the photographer. Yesterday, I went with a good friend to see his exhibit of photographs. I could have made comments about the strengths and weaknesses of his images but he hadn't asked for advice. I chose to comment about some of the images that I liked and one in particular that I thought was especially good. I think that was an appropriate response as a friend to being shown his work. Had he asked for my advice on how to improve, to help him assess his level, or to point out what was wrong with his images, that would have been an entirely different conversation—one best undertaken only with the express permission and request of the photographer. That, however, is just the kind of feedback you are going to need to help assess your level.

Obtaining Feedback

Useful feedback can come from a number of sources. Handiest would be feedback from our families. As guides to our levels in the art of photography they almost certainly aren't ideal. They are biased and are in a bind if they really think our work is crap. They are usually uneducated in the art of photography (assuming they didn't listen to all our boring dinner conversations). That said, I frequently have my wife look at my prints. Her responses range from silence to "It isn't one of your better

ones" to "I like that one better" to "Wonderful!" Although she has no photographic skills and wouldn't know a good dodging effort from a poor sharpening one, her immediate emotional response is of value to me. Recently on showing her one photograph, she exclaimed, "Lovely paper!" This was not a good sign. Another response was, "Try it upside down", also not good. Still, helping sort out your better images isn't what is needed here—what we need to know is our overall level. (And it wouldn't hurt to stay married. If you think being married puts a crimp on your budget for photographic gear, wait until you pay for a divorce—your lawyer will certainly be able to afford a new camera!).

The next most convenient people to seek feedback from are our photographic friends. A friend may not be an Ansel Adams, but many at least know what a great print looks like and can point out the flaws of our images even if they can't do any better. Anyone can tell a sour note even if they can't play the violin. Typically, friends don't want to hurt your feelings so the feedback may not be as reliable as you might hope, but the price is right. It is, however, a lot to ask of your friends and perhaps it isn't fair. You would need to explain what feedback you need and it wouldn't hurt to explain why you need it.

Consider joining a local camera club. They often have contests and print critiques with guest experts. Those friends that may be reluctant to criticize your photography individually become more open at a critique and will offer useful comments. The feedback from fellow members of a club reflects upon the quality of their own work, which is usually in the lower to middle levels. Keep in mind that the quality of a critique depends on the skill of the reviewer.

▲ Edworthy Park Steps

Experience tells me that though the steps and railings are gray, with a little bit of work on the image, they can be made to pop out against the darker background, and so I recognized a possible image.

What we need is to invite Ansel's ghost over for a good haunting. Barring the supernatural, however, we could go looking for a photographer whose skill we know to be higher than our own. This could take the form of a local successful fine art photographer. Since we don't actually need his advice on how to get to the next level, the person doesn't even have to be a photographer—he/she just needs to know a lot about fine images. This would open it up to gallery and museum curators, photographic book publishers, editors, and the like. I remember years ago the late Fred Picker offering to perform this service for a very reasonable price per print, and all the proceeds went to charity. He had very few takers. What a waste! For the price of a few boxes of paper, you could have had the opinion of an expert. Fred wasn't famous for his photographs, but he was certainly competent, and he loved and collected photography and would have made a superb reviewer (don't ask

▲ Coal Processor
Good alignment was critical to making this image: moving just an inch in either direction did not work and several elements had to be considered, including shadows.

if I ever sent some prints for review. I didn't. Dumb huh?).

It takes nerve to ask someone you respect or someone in authority to take the time to not only look at your photographs, but also to provide some insightful feedback. Good critiquing is a skill in itself, and being a good photographer doesn't necessarily make one good at providing feedback. You may be able to play the violin, but it doesn't necessarily make you a good teacher.

The single best source of feedback is to attend a workshop which includes print reviews (most do). Workshop instructors who have a good track record have learned to provide useful feedback. For myself, I attended a Fred Picker Zone VI workshop back in the 80's. Fred had some excellent instructors at the workshop and we received a variety of viewpoints. By the end of the workshop we had a pretty darn good idea of where we stood.

Smaller workshops with one or two instructors can also be helpful, however, and you don't have to fly to the Antarctic to attend. I

attended three weekend workshops by Bruce Barnbaum, Craig Richards, and Michael Reichmann, the latter being a Luminous-Landscape weekend in Algonquin in the fall.

Typically, the students at workshops show a variety of levels of skill, and some bring drug store bought 4 x 6 inch prints while others have already had their photographs published. Some are excellent technicians while others bring an artistic background. It was the lady with the 4 x 6's who had a wonderful eye and had some of the strongest images of the entire workshop, and she offered some useful feedback on others' images; feedback far beyond "I think it should be a bit darker".

But I don't Know Anyone

OK, your budget, schedule, or location precludes finding a local gallery owner or attending a good workshop, so what are your options? Actually, they aren't bad. A number of websites offer not only the ability to upload images that others can see, but are organized around critiques and supplying feedback.

▲ Johnston Canyon Snowstorm
Weather can turn an ordinary scene into magic. Just when most people tuck away their cameras is when serious photographers should consider bringing theirs out.

For some time I submitted images to Photo-sig.com. I would submit a photo and over the next few days while it remained near the top of the "in" stack I would receive comments. For a start, the number of comments received gives you some idea of how you are doing. The comments themselves vary from overly nice to detailed and thoughtful; from outright rejection for no apparent reason, to pointed but on-the-mark comments worth a lot.

There are limitations to Photosig (and I assume with other similar sites as well). Firstly, people decide to look at your image based on its thumbnail, and not all good photographs make eye-catching thumbnails.

Secondly, top ranked images tend to be dramatic, very colorful, and a bit calendar-like. Even the popular black and white images tend to be very graphic and bold. Subtle just doesn't cut it on such a website.

The third concern is that the feedback one obtains is most useful to those moving from the beginner to intermediate level or, in other words, for people who find themselves in the first few levels. Technical flaws are easier to deal with and, thus, get the most attention and the most useful feedback. Advice about creativity is much harder to give. Still, we were looking to identify our level more than looking for advice, so give it a shot.

▲ Door and Foundation

Although I wasn't aware of a message, metaphor, or allegory when recording this image, it does now represent to me aging and resistance, stalwart support despite wear and tear. There's nothing wrong with simply being attracted to making an image without knowing why.

One website that offers daily critiques of select images is The Radiant Vista. While the odds of getting even one of your images critiqued in this way isn't great, looking through critiques of others work will give you a sense of the problems with your own work. After listening to a couple dozen critiques, it isn't that hard to apply the same kind of analysis to your own images.

Submitting work for publication, while not usually generating any feedback other than "Yes, we will publish it" or "No, please try again", can at least give you some idea of your position if you are in one of the higher levels, but not quite sure which one. A single image published on a readers gallery suggests you are on the right track.

There are formal reviews of work available. One of the most prominent is Review Santa Fe in which hundreds of photographers submit 20 images each and 90 photographers are selected to come to Santa Fe (at the photographer's expense, plus a hefty review fee of $595). They then receive nine formal reviews over two days from a mix of publishers, gallery owners, and museum curators. I understand there are a number of other similar reviews. Clearly, you need to be fairly high up the scale for this to be a viable option. While expensive, feedback from people who have attended indicates that it is a tremendous experience.

For most photographers I still have to strongly recommend the workshop as the single best way to get a sense of your position on the scale.

How to Translate Feedback into Levels

Chances are, no matter who provides the feedback, they aren't going to point to level 3D, and say, "That's you buddy. See you around", and walk off. I think you would be a bit upset if that's all they did, even though the premise of this chapter is that this would be very useful information. No, you are going to have to interpret the comments you receive to determine your level.

I think it's fairly simple to interpret the technical comments and determine your level, so I'm going to concentrate on interpreting the artistic merit comments.

Reviewers are looking for something good to say, and what is said can tell you a lot about the strengths and weaknesses of the print. A comment that an image has a really nice frame is not a good start. If the work is original, interesting, or strong it's likely the reviewer is going to comment on those elements. A lack of such comments should frankly be interpreted as "needs work".

The question, "What were you trying to say?" translates into "I don't see a point to your picture, and if I knew what it was I might be able to help you express it". If the reviewer gets why you took the picture then the message is fairly clear.

A good reviewer is not likely to put a lot of emphasis on what is wrong with your image. Rather, they will talk about how to make it better. Reviewers often look at one image at a time and may not make any comments about the whole collection, and almost certainly won't make any comments about you and your work in general. That said, they could often be cornered later for a more frank discussion of your strengths and weaknesses—while driving for example (not looking at images, please), or during lunch. In my experience, workshop leaders presume that they are at your beck and call over the entire course of the workshop, except for a little sleep. Some people have very fragile egos and workshop leaders learn to tread carefully, but if you ask for them to be frank, they will try to level with you.

Look to the comments of the other students. Do they "get it"? It doesn't take long to learn that some of the participants are very observant and can offer insightful feedback, regardless of the prints they show.

Listening to Your Fellow Participants' Critiques

You might find yourself listening to high praise for an image by another participant and you can't see it—the image is out of focus or badly printed, yet the instructor seems excited. It can be difficult to look past the obvious and see the value in the work; yet recognizing

▲ Whisky Barrels
A clear example of the power of repetition for composing images, combined with the snow which separates the rows nicely.

the value in the work of others is preliminary to finding, selecting, and making images of artistic value for oneself. The instructor may have looked beyond the technical flaws of the image to see what the photographer was trying to do, and found it more interesting to talk about the ideas the photographer had rather than the equipment they used.

The other aspect of a print critique is that of seeing the work of others and comparing it to your own. This is every bit as valuable as the feedback you get about your own prints. It's not difficult to see the flaws in your own prints when they stand up against those of others, both technically and aesthetically. Do your prints look muddy and gray compared to those of other participants, or too contrasty, too dark, or too colorful? Do their images seem to have a point, a center of interest, or a reason for being taken, while it's hard to see these things in your own images? Often, images are put up one photographer at a time, but during a break you could lean some of your work on the wall next to that of someone whose work you liked.

The Virtual Workshop

You can help yourself without even going to a workshop by asking yourself some of the typical workshop questions such as:

- What was I trying to say?
- Did I say it in the strongest way possible?
- Was there a different way to compose the picture to make it stronger?
- Did I eliminate all extraneous features?
- Did I find the best position and the best time to take the photograph?
- Did I make a print that showed the subject to best advantage?

Conclusion

It is really challenging to assess one's level of ability in isolation. We need to look at the work of others. We need to receive feedback about our own work. If you use some of the above tools, it shouldn't be too hard to assess your level of skill. And, identifying your own level is the first step toward actually using this information to move up a level, to make a quantum leap, to take a giant step upwards in your work.

▲ Ice and Post

There was no great skill in making this image, only in seeing it in the first place and editing it in the second. Although this image made very nice silver gelatin prints, the scanned 4 x 5 negative when edited in Photoshop made even better prints.

Part 3—Moving On, Making Better Images

In Part 1 of this chapter we defined the levels. In the second part we discussed how to get the feedback that would help you assess your own level, both artistically and aesthetically. Now comes the payoff. It's time to do something with this information.

It would be presumptuous to suggest that I can give you everything you need to know

to improve your photography all in one easy lesson. Even entire photographic university courses are not sufficient to do that. The rest of this book looks at specific aesthetic issues, but here I'm going to emphasize the most relevant, most critical areas upon which to work, after having found yourself at a particular level. In medicine we refer to "money questions", those questions, the answers to which are critical to making the right diagnosis. Well, what I hope to do is suggest some "money answers", the areas in which effort is going to produce the most result for your efforts.

What I want to do here is to suggest the changes you need to make to move from one level to the next, or beyond. It's up to you to take that information, determine how to acquire the skills, and then to act upon it. Some fixes are simple, for example, holding the camera steadier, which can be done with practice. You can test just what shutter speed is your minimum (with and without coffee) at the beginning of a shoot and at the end. You can read any of a number of technical books, which will teach you how to squeeze off a shot rather than stabbing the shutter release.

On the other hand, if what your images lack is emotional impact, not only is the source of the answer more difficult to find, it might take years of studying good images to figure out how to give your photographs impact. That sounds downright discouraging, but the truth is, if what your images lack is impact, switching cameras, adding pixels, changing raw processors, and trying harder are not going to help one toot. How soon you can learn from looking at good images is going to be a function of how hard you work at it, inherent talent, artistic background, and even more important, finding something to photograph that actually means something to you. Some

can make fundamental leaps within months, for others it takes 40 years, but the point is that I think there are a lot of photographers who are frustrated because they are sneaking up on the 40 years and not seeing the payoff. Ain't that a bummer? Perhaps they have been quite good but they aim for a permanent place in the history of photography. It's also possible that being quite good is all they ever aimed for and they are happy to continue to explore photography within their present skill set. There is absolutely nothing wrong with that. Photography may be an art, but it is also a hobby that may provide entertainment, relaxation, fun, and a little bit of challenge. Mount Everest can be reserved for those with the ambition and energy to climb it.

At first, I thought that a photographer at a given level would not benefit from reading about the problems with earlier levels since, if they are already at Technical Level 3, they have no need of the information about going from Level 1 to Level 2. It occurred to me later that any given photographer has a series of images he or she has taken and they don't all fit in the same level. Had they all been at the same level, we would print every image and have an impossible time making a selection of our more successful, powerful images. This is patently untrue, so there is at least some variation in the level of image; and I would argue (rather strongly) that some are crap, others also-rans, and some are winners, no matter at which level you assess yourself. I am quite convinced that Ansel the Great could have identified quite easily with this.

The secret to moving up an entire level is a careful scrutiny of the differences between the various levels.

◄ Rock Wall, Lundbreeck Falls
I actually was busy photographing the falls, my back to this lovely rock detail, when my wife joined me and pointed out what was just behind me. Seeing is all-important.

The Differences Between Levels

Technical Level 1 to 2

In order to move from Technical Level 1 to Level 2, the major issues are the following:

- **Backgrounds:** Make yourself a list of things to check when taking a photograph: Check the background, what is behind your girlfriend's head?

- **Frame filling:** Are you at the optimum distance from the subject? You may not want to fill the frame, and there is nothing wrong with an environmental portrait. But if it is simply from lack of effort to check the framing, well....

- **Exposure:** With film, either you or a more skilled friend can check your negatives or slides for exposure consistency. If you have problems, there are lots of books with

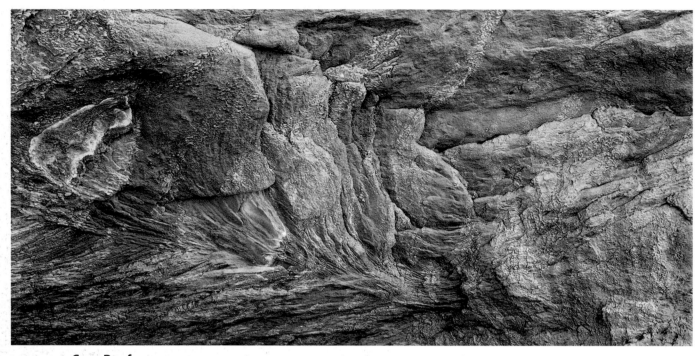

▲ Cave Roof

Although not an especially popular image, it is one of my favorites and has been published a couple of times. Perhaps the public doesn't find it dramatic enough, but are we really photographing to please the public?

information about exposure. If you are shooting digitally, invoking the histogram before (if available) and definitely after the exposure could make all the difference. If you don't know about histograms, find a good book or read some of the articles on Luminous-Landscape.com.

• **Focusing:** Even your camera manual can help here. The classic failure is photographing two people and the camera focuses on the background between them. With the publication of my first article, I received a nice email from someone who was concerned that her images weren't as sharp as mine. (Of course, she was only looking at tiny reproductions on the Web, so how could she be getting fuzzy pictures?) I offered to look at a couple of her images and in one you could see pinpoint water reflections which weren't pinpoint; each one was in fact two with a small streak between—subtle

but easily seen at 100%, and definitely an issue of camera movement. The second photograph was poorly focused; the wall behind the subject was sharp, but the subject was not. The point here is that the end result was poor sharpness, and this photographer was ready to buy a more expensive camera when, in fact, her problems had a much cheaper solution, albeit with two entirely different causes. Sure, a better camera might have fixed some of her images, but she wouldn't have known why and in the end would be doomed to repeated failures even with a fancier camera.

OK, so I have not fixed, shown how to fix, or even shown where to get the information to fix every problem that plagues the beginning hobbyist photographer. But frankly, if this person had 90% good exposures, 95% spot on focus, filled the frame when suitable, and checked the background for major problems,

do you really think his/her images wouldn't take a giant leap forward? Instead of taking the drug store envelop of prints, flipping through them once, and burying the mistakes, now they are emailing the images to the family, they are sticking them in albums, making Christmas cards out of them, and just maybe, starting to think about being creative.

Technical Level 2 to 3

Problems are subtler and often won't show glaringly in a small print, but will do so in a larger one, say a 5 x 7 or an 8 x 10, which is well within the capability of most cameras. Further refinement in focusing and steadiness are issues, so perhaps it's time to break out a tripod. Learning the limitations of yourself and your camera are vital, and doing some basic experimentation could pay high dividends. Do you actually know how much depth of field you have? Are you familiar with what a wide-angle lens does to your boyfriend's nose? (Move over Cyrano!)

Consider the following issues:

- **Critical Focus:** You want to focus on the eyes; preferably the near one, and most cameras won't do that for you so some effort is needed. Do you know about hyperfocal distance and do you understand depth of field?
- **Exposure:** By this time, you need to know the limitations of auto-exposure and about the influence of skies on dull-day exposures. There are lots of good technical books that can really help.

Technical Level 3 to 4

The images (whether prints or on screen) are sharp, but they are either dull or harsh, colors are poorly balanced (too blue or too pink or whatever), and now that prints are larger, you can see areas of unrelieved black that you had

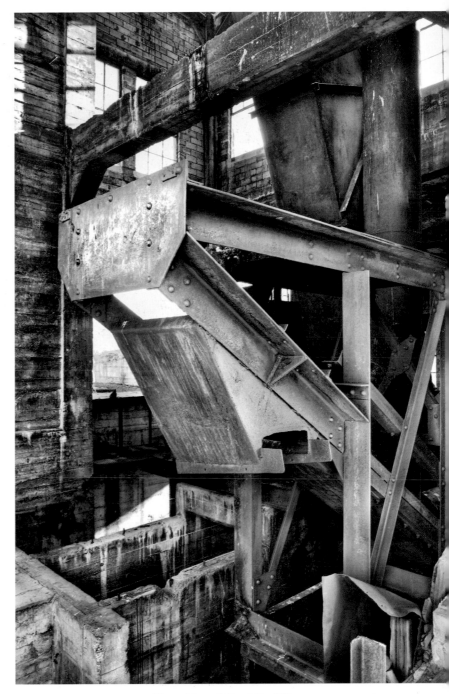

▲ **Abandoned Coal Facility**
Sometimes you are provided with a cornucopia of angles and shapes, textures and tones, and it becomes a challenge to find a position from which to photograph that will tie it all together.

anticipated having detail, or they are dark grey and never reach black. Likewise, highlights are paper white. Here you need advice in using your image editing software, or a book on printing if you are in a darkroom.

For those of you who still make silver gelatin prints, I highly recommend Fred Picker's book *The Zone VI Workshop*. Though Fred is long gone and not everyone agrees with the finer points of his "rules", it's a darn good place to start. I simply say that Fred and his little book did more for the quality of my black and white silver prints than all the other books combined. It really raised me to a whole other level (actually maybe two, as my prints before that were pretty bad).

It is possible that sitting in front of the computer, you have not yet developed the eye for color balance and can't recognize over saturation. Simply living with an image for a while will help. Make the image your screensaver for a few weeks, you'll learn from it, especially if you look at good images.

Technical Level 4 to 5

The differences here are harder to describe, even though they may be easy to see. One print looks rich and three-dimensional; another print is just a print. No quick fixes here. Lighting plays an important part. For example, a dull evenly overcast sky produces light so flat that rich images are hard to come by, and a straight print is going to go from too flat to too contrasty without ever being just right. Skillful, local burning and dodging, and even bleaching (or the digital equivalents) can sometimes save an image like this, but ideally what you would like is some direction to the light source. This happens one of four ways:

1. Before sunrise and after sunset the sky is still bright in one direction, providing the modeling needed.
2. When storm clouds darken part of the sky.
3. When you are photographing in the shade and your subject is lit by reflected light, such as an opposite canyon wall or a building.
4. When the sun is partially obscured by haze or thin cloud.

At least as important though is a thorough familiarity with the tones that make up good images. If you have a good quality monitor, accurate colors management can be done online: If not, well-reproduced magazines can be helpful, specifically *Lenswork* and *Phot'Art*. These two magazines have reproduction that is getting creepily close to good quality prints. They do so in different ways; *Lenswork* still has the edge in black and white reproduction with its duotone inks, while *Phot'Art* is not far behind in some of its glossy reproductions, and the color work is excellent.

Of course, nothing beats looking at good prints. I remember at one workshop a skilled photographer had a nice image up on the board, but when it stood next to one with full use of the paper's capacity, one could see the highlights were dull. Without the comparison, it wasn't easily seen.

One of the problems with moving from Level 4 to Level 5 is that the Level 4 photographer has learned how to use a lot of tools, but hasn't learned to use them with subtlety. There is nothing like using the layers slider in Photoshop to tone down the effect you have just created, without actually having to do it over.

I would encourage photographers who are making this jump in levels to purchase good

prints. Often, well known photographers have print-of-the-month offers, which are very reasonable, and a print need not be large to be good. If images are offered in a portfolio, how about sharing the cost amongst three of you and splitting it up. OK, so you won't be able to retire on it's inflated value in 20 years, but this is about helping YOUR work. Alain Briot offers a print-of-the-month on his website beautiful-landscapc.com. I recently purchased Michael Johnston's print of "Migrant Mother". It is absolutely lovely! Photographers working in traditional silver cannot so easily whip off another print, and so are not in a position to offer bargain prints of the month, but there are lots of good photographers who are excellent printers selling their silver gelatin prints for under $300. Most of us balk at the idea of spending $1000 on prints, while almost casually doing so for a new printer or camera. Yet, those prints could do much more for your work.

Attendance at a workshop may be the crucial step here, selecting an instructor whose medium is the same as yours.

Technical Level 5

This isn't really an incremental level; rather it's simply a problem that is commonly seen at any of the intermediate levels. I've taken some heat for my dislike of glossy prints, which is of course personal taste, but the issue isn't the paper's surface. I'm more concerned about the condition of the prints (glossy surfaces are so easily subject to scuffing and finger prints). More important is over sharpening. Sharpening is not meant to be seen. Over sharpening is something that is often unnoticed, but once pointed out is glaring forever.

▲ **Lillies**
Having seen Mapplethorpe's clean, elegant flower photographs, one might be tempted to feel there is nothing more to be said, but in fact there are a myriad of ways in which flower images can be made.

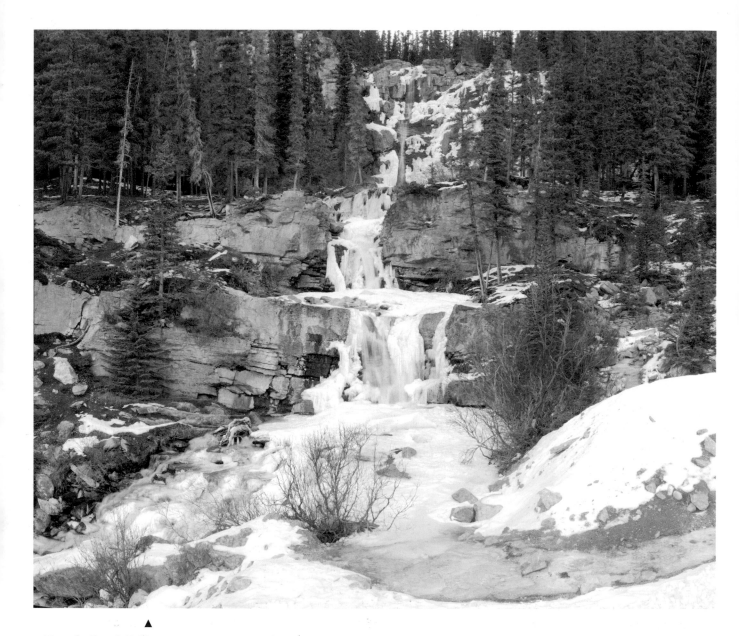

▲

Tangle Creek Falls
I have recorded these falls in warmer weather, minus the ice, and they aren't nearly as nice. Bright sun makes photographing them nigh impossible.

Aesthetic Skills

My goal in offering suggestions to improve the aesthetic qualities of your images is to come up with suggestions that are specific enough to be helpful to the individual, while still being helpful to the majority of photographers at that level.

It makes sense to me to offer advice specific to each level but not necessarily aimed at moving up exactly one level, after all if you can improve several levels, I don't suppose you are going to complain. With that in mind, suggestions for each level follow.

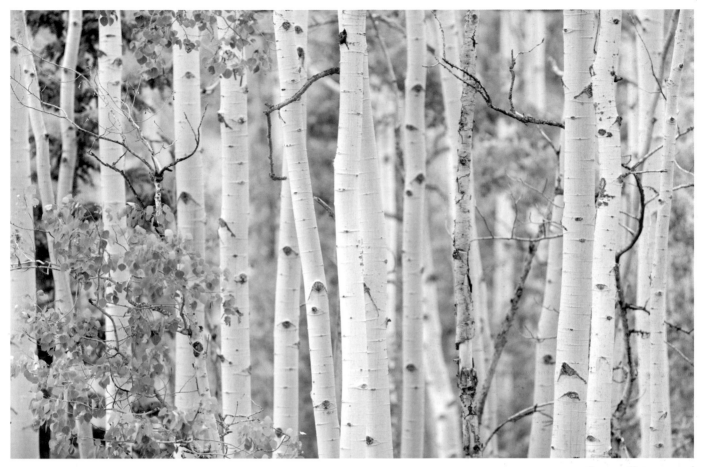

▲ **Aspen Grove**
Hardly an original subject, yet aspens photograph so well that it's hard to resist. Even if it's been done before, so what?

Aesthetic Level A

The essential problem here is that Level A prints don't show what the photographer intended. Pictures of exotic Caribbean islands don't look anything near as nice as you remember the holiday to have been. Family pictures don't show how cute your 3-year-old niece is, mountains look unimpressive, sunsets don't look anything like what was experienced. It's not that the message doesn't come across, but rather that there does not appear to be a message at all. While there are hundreds of helpful photography books, there is one step that could be taken to quickly improve the quality of your images.

Ask yourself the following questions:

1. What would I like the picture to show and what are the odds that if I shoot now, from here, it will show it? It could be that beautiful Caribbean beach you want to show off from your holiday, or it might be your grandchild looking angelic just before dropping off to sleep, or it might simply be how great your roses were this year in the garden.

2. Is there anything I can do right now to show it better? My choices are move left or right, up or down, to or fro (or zoom). Remember that moving left or right, while still aiming at the subject, changes

foreground and background. Could such a change improve the picture? Simply becoming aware of these two picture elements is going to result in improved pictures.

Few snapshots would not be improved by moving in a bit. Partly, it is that the human eye can look at the overall picture or concentrate on a face without moving, while a picture won't show that much detail in the face if covering the whole scene. Also, consumer camera viewfinders often show much less of the scene than is actually captured by the camera. As LCDs are usually accurate, that can be a check on how well the subject fills the frame. Consider shooting the picture first from where you are (after all, if you hesitate you may miss the moment), but then move around and move in and take a second shot after a quick look for an improved position. Sure, this results in 50% wastage of shots, but few photographers ever approach a 50% success rate, and with digital cameras and no film costs, why not experiment?

Aesthetic Level B

Level B images are competent but not dramatic enough to be featured on a calendar. Instead of simply making a nice capture of your two-year-old niece with a nice smile, we are looking to shoot the image that shows her at her cutest, or most vulnerable, or most innocent. Moving beyond Level B involves effort. It means visiting at the right time of day (the crack of dawn until proven otherwise). It means following that two-year old around for months, while getting faster and better at capturing expressions. It means knowing something about our subject so we can capture the peak moment of a football game, for example. And it also means knowing when not to take

some pictures because not enough things come together to make a calendar-worthy image—and that is hard.

It comes down to two things: Effort and practice.

Aesthetic Level C

Level C photographers can take pretty pictures, but moving on means starting to create art; actually putting something of ourselves in the images and making an image which means more as itself than as a great representation of the real world. This means making pictures instead of taking pictures.

Level C images do a great job representing "the thing", yet one would still rather experience the sunset than see the picture of it, or be at the game instead of looking at the picture. We'd like to create a picture that would make the viewer wince with the impact of the tackle—an image that shows football in a way that sitting on the sidelines doesn't. It might show the pain or the skill, the balance or coordination. It opens a little window into what it's like to be part of a football tackle. Somehow, we need to create images that educate, entertain, inform, stimulate, or otherwise create a connection with the viewer.

This is a pretty tall order. It's easy to understand that you would need to know something about football to be able to create that powerful image. In fact, you would most likely have to actually care about football, and almost certainly you'd have to practice for some considerable time to be able to show all this in a single photograph.

Short of signing up for a 4-year fine arts degree, how do you go about making a fundamental difference to your photographs? The traditional method has been practice, practice, practice. I would argue though that we are

looking for a different type of photograph, and practicing the old skill of taking great snapshots just isn't going to cut it, at least not any time soon.

There isn't any simple step or exercise that you can do in a matter of weeks to move up. There are, however, some steps that will help over time. Below are some suggestions:

1. Take a photograph appreciation course, or even an art appreciation course. Many years ago I took such a course at the Edmonton Art Gallery, and while at the time I thought it a bit boring, within six months I couldn't look at photographs the old way. They meant so much more to me and I now appreciated a much wider variety and style of photography, encompassing a much greater range of subject matter. Highly recommended!

2. Study intelligent critiques of photographs—those on The Radiant Vista are generally excellent. And, they spend at least as much time discussing what works as what doesn't, which is extremely important.

3. Get hold of and study books of great photographs. There are books of collections, as well as small, inexpensive, masters of photography books from Aperture and Phaidon, among others. Start with the book Looking at Photographs by John Szarkowski and expand from there.

4. Look at and read books of photographs that provide some good descriptions of what the photographer was doing (e.g., Joe Cornish or Sam Abell), and part-way through the book start making predictions about what the photographer was deliberately doing to make a good photograph, then check your predictions against the text.

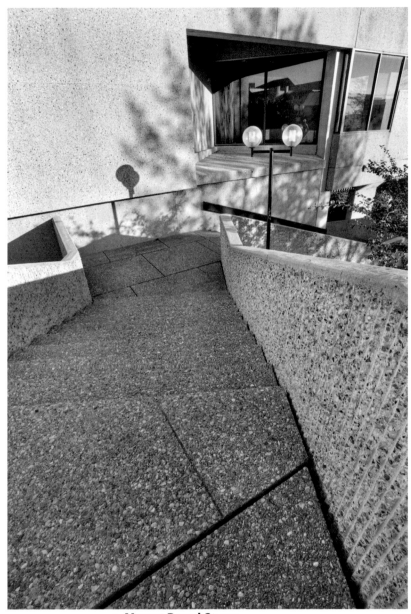

▲ Mount Royal Steps
Architecture and wide angle lenses seem made for each other. Usually, it's desirable to correct for perspective distortion (i.e., buildings falling backwards). But in this case, leaving things as is aids in the composition. While accurate (this is what the eye sees), it's certainly not what the brain perceives, as we translate those angles into verticals and horizontals when actually viewing the scene.

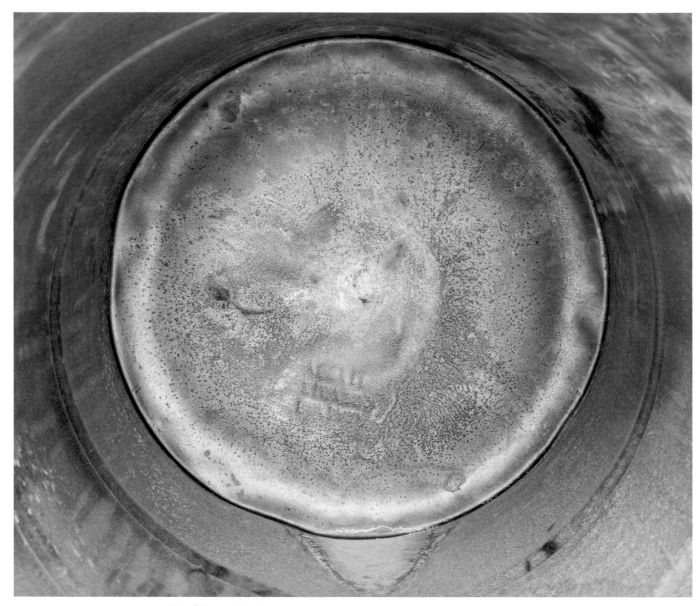

▲ Steel Drum Bottom

Looking more like a pottery wheel creation, the rust at
the bottom of this steel drum becomes an interesting
image. That the edges are out of focus hardly matters
and arguably were they sharp might have distracted
from the rust in the bottom, which is the main feature
of the image. Depth-of-field could never had done this,
though blending multiple exposures with adjusted focus
could have done so. Not always is maximum depth-of-
field either necessary or desirable.

5. Spend some serious time studying a portfolio of your best work of the last year. You are looking for aesthetic issues, not technical, so work with small prints. Ask yourself the following questions:

 a. What was I trying to show?

 b. How effective was I in showing it?

 c. What is there about this photograph that is worthwhile in and of itself, rather than just as a representation of what was photographed (i.e., why would I want the picture instead of the thing?)

 d. What is there about this picture that would make someone else want to look at it?

 e. What would it take to make this photograph worthy of other people looking at it?

Aesthetic Level D

At Aesthetic Level D we are definitely striving to be creative, we have found something that means something to us, but the message we create isn't clear.

I have two suggestions for photographers who find themselves at this level:

1. With the background of all the studying you have done of great images, of compositional advice, and so on, go out and reshoot some of your past images. Do so with the intention of improving composition, lighting, and making a clearer message.

2. Sign up for a photographic workshop from someone whose photographs you admire, but who also has a reputation for being a good instructor. Workshops can last anywhere from a few hours to more than a week; they can be held in the classroom or they can be mostly fieldwork. It has been my experience that more is learned in the classroom than in the field. In the field the students scatter and you are lucky to get advice from the instructor once or twice in a day of shooting, and unless there is processing (digital or chemical), there is generally no feedback from the work you do during the workshop. Therefore, field time, while a lot of fun, isn't particularly educational.

Aesthetic Level E

This level is about going from admirable to wonderful. Problems of composition, lighting, presentation, and so on have all been mastered. Lots of images by the masters of photography are only admirable and not wonderful, so it's no disgrace to find oneself at this level. Yet the question is: Is there anything to be done to create some wonderful images? It's inconceivable that you are going to make the majority of your images wonderful—no one has accomplished that yet, in my opinion. Still, some wonderful images would be terrific!

This raises the question: How can certain types of photography be powerful, emotional, containing a message—after all they are just (and here you can put in whatever kind of photography you think fits)? One might use this argument about a still life, a landscape, or an industrial or architectural photograph. It's easier to imagine a news photograph having this power; certainly advertisers pay big bucks for their ad photos to have this kind of impact.

I think I can persuade you that my favorite image, "Pepper # 30", has such power. The curves and tones of the pepper are sensuous; they curve in ways that remind you of running your hands over the body of a beautiful woman. But, how about a "Rocks and Roots" picture? I think even these could be powerful. I think an image not only can make you

▲

Found on the Floor
Folds in cloth can make very interesting patterns given the right lighting, whether a silk gown or a pair of workpants tossed on the floor.

composition, or closeness. It could be a result of eliminating color and therefore emphasizing shape and form.

So, how do you create wonderful images? You could, for example, go down to skid row and photograph the homeless. But, you wouldn't be the first. You might even get some good images, but probably not. (And, whether you could justify such exploitation is a conversation for another time.) The images might be more meaningful if you spent some time with these people and got to know them and then took their images with their cooperation, perhaps after helping them for some months.

It seems to me that you should look for scenes that have an emotional impact on you. Then you go about trying to somehow show that emotion in your image. If on the other hand, you see something and think it will make an interesting composition, regardless of how carefully you line things up, no matter how subtle the lighting, how fine the detail, or how delicate the shadows, it is unlikely that you will create a reaction in its viewers that you didn't feel first. Thus, you must first find the interest and then you find the picture, not the other way around.

I remember Fred Picker in his newsletter describing being out "cruzin fer snaps", as he called it, and coming across a slate quarry where he found interesting shapes and he became excited by the possibilities. Then the sun came out for a minute and the slate glowed. Picker said it was akin to a religious experience; one which a busload of camera club enthusiasts did not even notice as they watched him rather than the beautiful scene.

Last fall, on my way to Tofino on Vancouver Island, we rounded a corner and came upon some bicyclists, buses, and trucks. Behind them though was this wonderful river weaving

wish you were there; but it can actually make you feel you are there. It can make you feel the weight of the rock, the delicacy of the branches, the power in the waterfall, and the cold in the snowbank. A landscape can convey excitement or tranquility, or even spookiness. An image can show beauty where you wouldn't expect it—in a patch of rust or the underside of a railway bridge. I can think of flower pictures that are more beautiful than the flower itself, where had the flower been in a field, you'd probably walk past without a second glance. This could be due to lighting, framing,

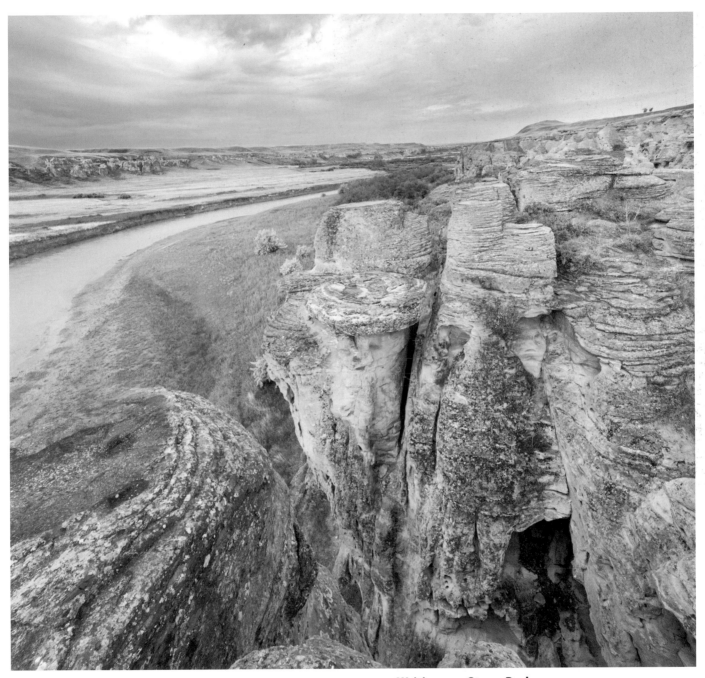

▲ Writing-on-Stone Park
You never know what you are going to find; things
may be much better than you anticipated, as
happened here, or the trip may be a disappointment,
in which case it's important to remember the good
trips and look forward to the next trip.

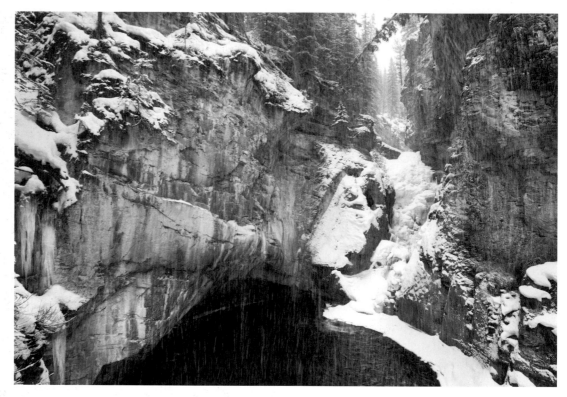

► Johnston's Canyon Lower Pool

In heavy overcast, the lighting is so flat that even when the photographer can see detail in the snow, the camera has great difficulty capturing it. Some method of adjusting local contrast, through film selection or image manipulation, is necessary to give the snow a realistic look. Shadows are opened and color saturation increased to show what could have been seen on a nicer day.

its way through some colorful rocks. I went back later on my own and spent several hours climbing and exploring, hopping over the water, shinnying up rock faces, literally hugging the scenery. It was a wonderful experience. I tried very hard to create an image that expressed how I felt about this area and was met with limited success.

Another time, however, I visited Writing-On-Stone Provincial Park. I had heard it was a nice location, but any images I had seen beforehand were pretty ordinary and I expected to be disappointed. Instead, it was wonderful! I arrived just as it stopped raining and the light was magical. I was able to climb one of the rock pillars and photograph the rock structures, the nearby Milk River, and the last of the storm clouds. I would like to think that

my feelings show in the picture. Certainly, it is one of my more popular images.

Hence, first you find subject matter that is important to you, that you relate to, and that you have some experience with; then you look for the good photograph. Too often you are desperate to take a good photograph so you first look for the good image, and then hope to relate to it and somehow put feeling in the image. With that method, your chances for success are slim.

How you go about putting your emotional experience of the subject into the image is up to you. I like to think that sometimes I can do it, often I can't. I do know that the more often I shoot and the more I practice, the more successful I become.

Aesthetic Level F

Even if I were a photographer who created one or more of the classic iconic images of photography, I suspect I would not know how to tell someone else to do it, never mind how I could repeat the effort. Steve McCurry is a superb photographer, but there is only one "Afghan Girl". Dorothea Lange took a number of powerful photographs; but "Migrant Mother" so perfectly communicates depression/suffering/heat/dust/discouragement, it is the single image everyone remembers. One can only say that the more often one is able to make images with a clear message and emotional impact, the more likely one is to someday create a future icon.

My original essays on taking your photography to the next level were, of course, written before many of the other essays and certainly before the idea of a book was conceived. The suggestions above, particularly the ones on improving one's aesthetic skills, are pretty much a list of what you need to do, but not how to go about doing it. The preceding essays do, on the other hand, fill in a considerable part of that gap with ideas to strengthen your images. I have not tried to expand on the technical matters, feeling that there are many books out there that do an admirable job of the subject.

Hopefully, some of you will come up with your own more applicable methods of moving on after reading this chapter (and the rest of the book). In the end, and even if none of the above advice works for you, I can't help but feel that knowing where you are and where you want to go has to make your journey easier.

▲ **Bow River from Balloon**
Things look very different from above. This island on the Bow River looks more like something from the tropics. This straight-down view was a lot more interesting than looking horizontally.

Windowpane

I had contacted the coal company and received special permission to enter the closed down coal processing plant, located in the Crows Nest Pass of Alberta. MIxed in with large green corrugated buildings from the 50's and later are a number of brick buildings dating from 1914. This particular window was in shade and reflecting the solid blue sky of late morning. Even better, the window on the other side looked out on a sunlit red brick wall, and it was possible to line up the missing panes with the other window to take advantage of this effect.

I have made three versions of this image, each time starting completely over with the stitching process. I thought the first version good, but wondered if it could be better. The third version happened today as I wrote this. I needed to look at the original RAW files to check which lens I'd used and I noted that the color in the red brick was much better in the RAW files than in either version one or two—so back to the drawing board—restitch, minor perspective correction (rotate the image 0.3 degrees and 1% vertical perspective correction). This time I didn't let the contrast run up in the red brick areas while improving the tonality of the cracked windows.

I ended up with an image that was close, but not quite satisfactory. I made a minor adjustment to the white point for maximum sparkle in the broken glass, and a small adjustment in the blue sky reflection in the glass to remove a very slight cyan tone, which didn't look right in the first place and clashed with the red in the second. With the latest in stitching and RAW processing and image editing, the result is noticeably better than I'd achieved previously.

You will notice this is the same image as on the cover of the book, though in that case our cover designer Helmut Kraus did tone the color down a bit to match the background color of the cover and a very nice result he achieved too.

This is one of my most popular images, yet there was no magic in the air at the time of taking the image, no sense of this image being any better than dozens of other images I shot that day, yet it has turned out head and shoulders above all the other shots from that trip. You would think there ought to be bells ringing or fireworks going off or at least an "Ah Hah!" moment, but there wasn't anything like that. Strange but true, and a common experience for me. I cannot readily predict which images are going to be the best.

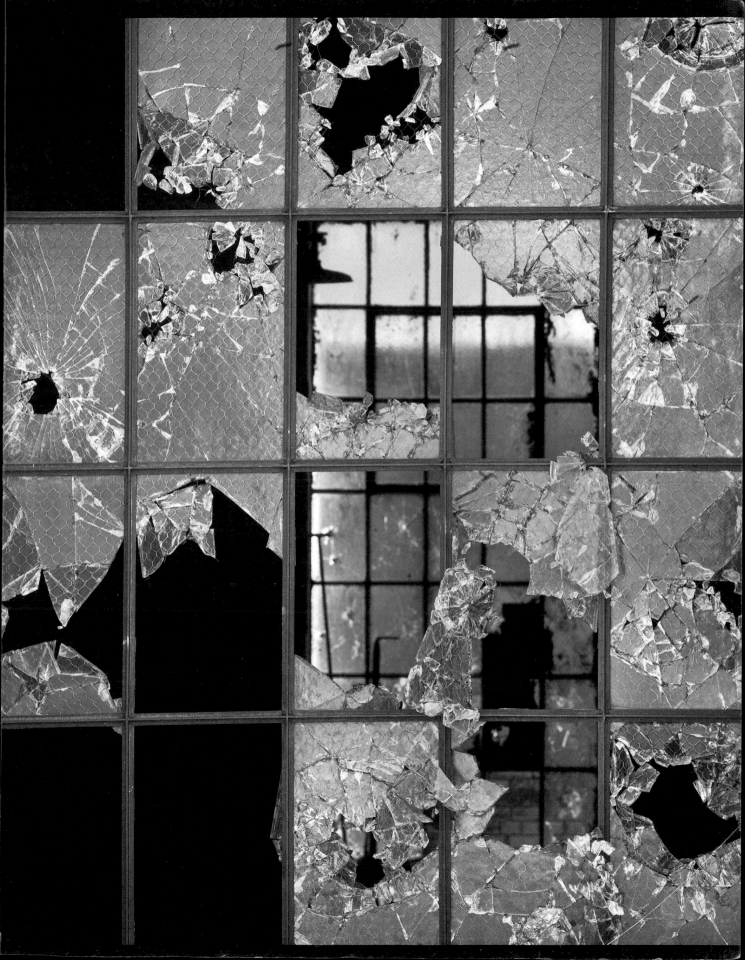

My Equipment and Techniques

I have deliberately avoided discussion of cameras, lenses, shutter speeds and f-stops throughout the book, feeling that such information distracts from the emphasis of the book, which is the creative aspects of image making. That said, I know that I am always curious about just how another photographer makes his/her images and with what equipment; so here, tucked in at the end of the book, is a short description of my own equipment and techniques.

It is now October 2007, and for the past three years I have been shooting almost exclusively with digital equipment. I simply found that for me, the quality I achieve with my digital work is better than what I was obtaining with film. In part, this has to do with the rapid advances in sensors and image processing, and is partly due to my frequent use of stitching to obtain higher quality results. But, mostly it is because since switching to digital, I have become dramatically more productive and successful.

Prior to switching to digital, I was strictly a black and white photographer. Color was for snapshots. Now, if an image doesn't work in black and white, it may still work in color. More importantly, I can deliberately choose to record something that only works in color. This in itself increases my productivity rate at a shoot. Combine this with the speed at which I can make an image and start looking for the next image, or try a slightly different position or focal length (using zooms) for a possibly stronger image, and again my success rate goes up.

With a tripod, careful framing, and using the after-the-fact histogram to adjust exposure, I'm not dramatically faster in taking a single image with the digital camera; but the feedback of that histogram and the ability to check for wind and focus and not having to deal with a flapping dark cloth in the wind do speed things up overall.

The whole process of being reluctant to make minor adjustments and expose another sheet or two of film has meant that, in the past, images more often had minor flaws not noticed at the time.

While the ground glass on a 4 x 5 is lovely and large and the image being upside down doesn't bother me, the fact that I'm 58 and can't see well at close range any more has made working with a ground glass more awkward. I've tried various magnifiers and reading glasses and even custom bifocals without truly solving the problem.

There is a feeling of freedom to shoot more and experiment more when using digital that carries with it an unexpected effect on ones shooting. It was a rare day when I was shooting medium format that I would go through three rolls of 12 exposures of 120 film, whereas now a usual day's shooting is around 100 images. I take more photographs than that; but the extras are for blended exposures or focus checking or for stitching, so those don't really count.

Anyway, it is not my intention to persuade anyone to change from film to digital, rather it is just an explanation of why I made the change. For a dedicated black and white photographer, shooting medium format film (and there are some real bargains in used medium format equipment these days) or even large format is still emphatically a viable proposition, whether the results are scanned for digital printing or kept in the wet darkroom.

The images in this book were shot with a combination of 35mm film, medium format in

a variety of cameras from a 1937 Zeiss Ikonta to Hasselblad to Mamiya Press, and a selection of 4 x 5 cameras. In digital, I started serious shooting with a Sony 707 using stitching, went then to a Canon 10D (usually stitched), and most recently to a Canon 1Ds2 (sometimes stitched), purchased because by then I was selling photographs and making ever larger prints. I have a 17-40, 24-70, 50 macro, 90 ts-e, 70-200 f2.8 IS and 300 f4 lens, all from Canon. My most used lens is the 90 ts-e, and my least used is the 300 f4 (but then I don't shoot sports or wildlife). To my surprise, I have been using extreme wide angle more than I ever thought I would, though largely NOT for the usual near/far type landscapes that are featured on the covers of some of the more popular photo magazines. Still, most of my images fall into the 70-135 mm focal length on a full-frame camera. Even when I shot 4 x 5, I used my 210 mm, 300 mm, and even a 480 mm lens more than my 90 mm.

I use Photoshop for processing my images (the current version is CS3). I have played with LightZone, but while I can see that it would make things easier, I can't see that it would make my images better. For years, all my fine control editing had been done using a mouse but I recently got a graphics tablet, which definitely gives me better control than the mouse. It's not essential, but it is nice!

I print on an Epson 7600 and a Canon iPF 5000, the latter purchased to try using glossier art papers, though I am still not satisfied that I have found the ideal solution there. My usual paper is Moab Entrada bright white matte paper, though my routine printing is done on Epson Ultra Premium matte paper (which used to be called Enhanced Matte and before that Archival Matte). It's a little thin,

a little see-through, and is beige on the back, but it has a smooth, flat surface that makes for nice images and is significantly cheaper than the rag fine art papers (oh, and it machine loads from a bulk tray!).

My tripod is a Gitzo 1348, with a Manfrotto leveling base on top of the column and an Acratech V2 Ballhead, which I prefer to my previous Arca Swiss B1. I have used a wooden Berlebach tripod with great success and incredible durability in the past, and it worked really well when I sat my 4 x 5 right on top of the column. But, when I switched to a ballhead for my DSLR work, the additional height of the ballhead resulted in too much play at the top of the column. I'm very happy with my carbon fiber tripod and I appreciate the extra height available from the four-section legs, as well as the adjustable center column, not withstanding that I realize fewer leg sections and no center column could provide superior stability. I have shots that I could not have taken with a smaller tripod or one without a centre column.

With mixed feelings I use a Lowepro Photo Trekker II backpack. I find the weight of the 1Ds2 means that the Velcro dividers come undone when the pack is anything but full. I have to take the pack off to access lenses and lay the pack down on its straps in the dirt to open it up. If I don't remember to zip it up, picking it up to move even a few feet means lenses fall out, but there is no practical way to carry as many lenses as I have in a manageable shoulder bag. Of course, these issues are not unique to Lowepro but simply are the tradeoff for choosing to carry all that weight in a backpack. When I had a two-lens system, I happily used Lowepro's belt and suspenders system, and although it looked a bit geeky, it

worked really well and nothing had to be laid on the ground. Perhaps I need to consolidate my equipment and go back to that system, but I seem to need an awful lot of stuff from spare batteries to memory cards, nodal sliders, spare electronic cable releases (don't get me started on their reliability and cost), lens and sensor cleaning equipment, and allen wrenches. Maybe I need a trailer or, hey, an assistant! Nah, they'd expect to be fed, or heaven forbid, paid. Maybe I could use a donkey like Ansel did in the early days. Wonder if Lowepro makes packs for donkey....

For a long time, my image stitching was done with a little homemade wooden slider with an Arca-type clamp on the back so that I could rotate the camera under the nodal point of the lens. Now I use one made by Really Right Stuff. In addition, I use their wonderful L brackets on my 1Ds2 for reorienting to vertical format without leaning the camera way over to the side.

I use PtGui for much of the stitching of my multi-images, though for shift stitching done with the 90 t-se, I use Photoshop. I frequently use Akvis Enhancer to increase local contrast in images, though I often tone it down a bit afterwards or use masking to use its effects locally. I have had considerable success blending images in which the focus is gradually changed between images, and the results blended with Helicon Focus create a depth of field not possible any other way (including a full movement 4 x 5).

If I didn't have digital any more, I could comfortably go back to film, probably 4 x 5, and almost certainly entirely black and white. I have thought of doing so and scanning film, or even of doing the opposite and shooting digitally but making enlarged contact negatives for silver printing; but with the quality of the results I'm getting these days, there isn't a lot of reason to go in that direction, and I'd certainly be submitting fewer portfolios for publication, and likely even something like this book would not have been possible.

That said, I do have a slight hankering to try really large format and contact printing. I have been checking out 5 x 12 cameras ever since I saw Tillman Crane use one.

I shoot Canon equipment for the simple reason that at the time that I got my 10D, Canon was way ahead of everyone else. That has changed and there are more options recently with the dramatic and largely unpredicted catch up by Nikon. Even Pentax, and now Sony, have interesting offerings. By the time you read this, who knows who will be on top or what the latest equipment will look like? I have been in photography long enough to remember when auto exposure seemed impossible, never mind auto focus.

In the end though, it's the image that counts and there are wonderful images made with very inexpensive cameras when the person standing behind the camera is thoughtful and creative, sensitive and informed.

Of all the advice in this book, if there were one single suggestion I could make, it would be to study great photographs; to acquire them in whatever fashion possible and to study them, whether in magazines, books, CDs, the Web, or hopefully, as good-quality original prints.

Epilogue

In the essays which comprise the bulk of this book, I have presented a number of ideas for making better images. In the last chapter I outlined a way to self-check your progress and suggested some specific tasks to help you improve based on first identifying your current level. Few of the suggestions are painless or fast and, in fact, many may take years to achieve.

Simply reading this book is not going to make anyone a better photographer. The information needs not only to be applied, it needs to be practiced. Even when you don't have a camera in hand, you can be looking for angles and shapes, and noticing the characteristics of light and surface reflections, checking backgrounds, and looking for compositions. Hours could be spent just examining shadows. You could be applying for a job, for example, yet you could be checking out poses and expressions of your potential boss. Mind you, if you get up and hold a light meter to his chin, he may question your motivation, but you get the idea.

Perhaps, when you are watching Saturday afternoon football on the TV, can you pretend click the shutter at the moment of peak action? Even when watching movies I find myself looking at compositions. There are some very talented cinematographers/directors who could show us still photographers a thing or two about composition. When flipping through magazines, even the ads can show you things about light and composition.

Serious photography is a way of life. It can be both frustrating and extremely rewarding. I'd like to think that the suggestions I have made in the book will help you achieve more of the latter and not too much of the former.

You may want to check out my blog, in which I discuss a variety of topics. I focus mainly on the creative issues, but I tackle some technical and equipment issues as well. I occasionally present examples of the steps I use when working on images in Photoshop. I offer my personal opinions about papers and printers. I also point out the work of other photographers that I think you might enjoy. Hopefully, there won't need to be too many corrections or explanations needed in relation to the book, but that is certainly where you would check if you have concerns. You can contact me either through my website or my blog. I'd really like to hear from you about whether you find the book useful.

George Barr
george.barr@shaw.ca
http://georgebarr.com/
http://georgebarr.blogspot.com

Print Offer

The printing in this book is remarkably good for a book of its type, but there's nothing like having an original print with which to compare your own work, to assess issues like contrast, shadows and highlights, to look at sharpness and sharpening, and other details best seen in a good sized print.

To this end, and remembering the late Fred Picker's Example Prints, I am making the following print offer:

Four Prints
$100

Pick any* **four images** from the book and I will make **8.5 X 11 prints** (1 inch border), on Harman FBAL gloss paper, each image in a mylar envelope, shipping included, air mail, anywhere in the world.
Price in **Canadian Dollars**.

Images will be signed, they are printed on my Canon iPF 5000.
Each is accompanied by an information sheet.
Use the images as examples or frame them as you wish.

**there are a few images in the book which for a variety of technical reasons would not make ideal example prints. Should that happen I will contact you for an alternate choice.*

This offer is open to anyone, however I will not offer a price for fewer prints because of practicalities in shipping—it's 4 or none. Should you choose to split an order with a friend though, I won't know. Specify prints by title and page number.

Payment can be made by Paypal using my email address, via mail and postal money order (no cheques please) or via Visa or Mastercard with the numbers and expiry date split into 2 emails or faxed to (00+1 if overseas)+403+256+4852.
george.barr@shaw.ca

Print Offer Order Form

Fax to (001 if overseas) 403 256 4852

Prints to be ordered:

Print Title Page

1.

2.

3.

4.

Name ..

Address ...

...

...

.. Postal Code

Visa / Mastercard ... Exp. / (mo./yr.)

your email address or ph. #...